NIKO

D510

THE EXPANDED GUIDE

NIKON
D5100

THE EXPANDED GUIDE

Jon Sparks

AMMONITE
PRESS

First published 2011 by
Ammonite Press
an imprint of AE Publications Ltd
166 High Street, Lewes, East Sussex, BN7 1XU, UK

Text © AE Publications Ltd, 2011
Images © Jon Sparks, 2011
Product photography © Nikon, 2011
Copyright © in the Work AE Publications Ltd, 2011

ISBN 978-1-907708-42-8

British Library Cataloging in Publication Data: A catalog record
of this book is available from the British Library.

Editor: Chris Gatcum
Series Editor: Richard Wiles
Design: Richard Dewing Associates

Typefaces: Giacomo
Color reproduction by GMC Reprographics
Printed and bound in China by Leo Paper Group

PAGE 2　　　　　　　**«**
The Nikon D5100 is a highly
capable camera, which matches
the demands of most users.

ISO: 200 *Focal Length:* 90mm
Shutter Speed: 1/80 sec.
Aperture: f/11

Chapter 1
OVERVIEW

1 OVERVIEW

The Nikon D5100 is an advanced "consumer" digital SLR that slots into the company's line-up between the entry-level D3100 and the more sophisticated D7000.

The most obvious difference between the D5100 and other Nikon digital SLRs is its articulating LCD screen. This offers extra flexibility when shooting in Live View mode and will be especially useful to anyone who shoots movies.

The D5100 can be as simple to use as any compact digital camera, but it can also deliver much greater imaging power, with a wide range of advanced exposure modes including the traditional and fully controllable standards of Aperture Priority, Shutter Priority, and Manual. The image quality is outstanding and, with careful use, meets professional standards. This means that the D5100 is a camera that will appeal to the novice user, but still satisfy experienced enthusiasts.

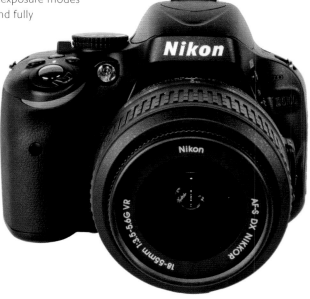

NIKON D5100 »
D5100 front view.

» NIKON DIGITAL SLR HISTORY

Nikon has always valued continuity, as well as innovation. When the key manufacturers introduced their first viable autofocus 35mm cameras in the 1980s, most of them abandoned their existing lens mount, but Nikon stayed true to the tried-and-tested F-mount that it introduced in 1959. As a result, it is still possible to use many classic Nikon lenses with the latest digital SLRs, such as the D5100, although some functions may be lost, most notably autofocus.

The D5100's direct lineage begins with the 2.7-megapixel D1, introduced in 1999. The D1 is arguably the most influential digital camera ever made, and certainly the first digital SLR to match the flexibility and ease of handling of the 35mm SLRs preceding it. Its sensor adopted the DX format that was subsequently used in every Nikon digital SLR until the "full-frame," FX-format D3 arrived in 2008.

In 2004, Nikon introduced its first "enthusiast" digital SLR—the 6-megapixel D70—and this was followed a year later by the D50, which was essentially a simplified variant. In late 2006, Nikon announced the D40, which had been designed from the

ground-up for ease of use, and this evolved into the 10-megapixel D60 in 2008. Later the same year, the Nikon D90 took the megapixel count to 12, as well as introducing a number of significant new features, including Live View, dust removal, a new CMOS sensor, better low-light performance, and a headline-grabbing movie mode. It is hardly surprising that 2009's Nikon D5000 incorporated many of these innovations, as well as adding a foldout LCD screen to its feature list.

A VERSATILE CAMERA »
The D5100 can tackle almost any shooting opportunity.

ISO: 250 *Focal Length:* 38mm
Shutter Speed: 1/200 sec. *Aperture:* f/9

1

› The Nikon line of descent

1999: Nikon D1

The D1 was a rare thing: a truly revolutionary camera that made digital photography a practical, everyday proposition for thousands of professionals, not to mention a good number of amateur "early adopters."

2004: Nikon D70

Nikon scored a huge hit with the D70, a camera that persuaded a host of enthusiasts and many professionals (including the author of this book) to move away from film and take their first step into the world of digital photography.

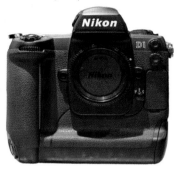

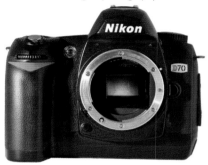

2008: Nikon D90

The D90 was the first digital SLR on the market with the ability to shoot video. This overshadowed its all-round capabilities as an enthusiast-level camera with a professional specification.

2009: Nikon D5000

The most talked about feature on the D5000 was its articulating rear LCD screen, although opinion was split about the wisdom of placing the hinge at the base of the unit, rather than to the side.

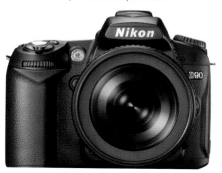

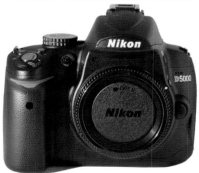

› The Nikon D5100

From the front, the Nikon D5100 shows some resemblance to the D5000, but its overall size and styling have more in common with the D3100. The rear view reveals a fold-out 3-inch rear LCD panel, but whereas the D5000's screen was (controversially) hinged at the base, the D5100's hinges at the left side. This is generally considered more ergonomic and is particularly beneficial when using a tripod. The screen also has a much higher resolution than the earlier cameras.

Internally, major features include a 16.2-megapixel CMOS sensor (the same as that used in the D7000), which has a self-cleaning function; EXPEED image processing; and a maximum shooting rate of 4fps (frames per second).

As with all of Nikon's digital SLRs, the D5100 is part of a vast system of lenses, accessories, and software, and this guide will walk you through all aspects of the camera's operation, as well as its relation to the system as a whole.

NIKON DX FORMAT SENSORS

The DX format sensor, measuring approximately 23.6 x 15.6mm (with variations of around ±0.1mm either way), has been used in the majority of Nikon digital SLRs since it launched the D1 in 1999. Originally, Nikon's DX sensors used CCD (Charge Coupled Device) technology, but, in common with most manufacturers, Nikon has now migrated to CMOS (Complementary Metal Oxide Semi-

conductor) sensors across its range: CMOS imaging chips are cheaper to manufacture and more energy efficient than CCDs.

With the D5100, 16.2 million pixels have been squeezed onto the sensor array, which produces images at a maximum size of 4928 x 3264 pixels. This is enough for large prints, as well as high quality book and magazine reproduction.

1 » MAIN FEATURES OF THE NIKON D5100

Sensor

16.2-megapixel, DX format, RGB CMOS sensor measuring 23.6 x 15.6mm; maximum image size of 4928 x 3264 pixels; self-cleaning function.

Image processor

Uses Nikon's EXPEED 2 image processing system featuring 14-bit analog-to-digital (A/D) conversion.

Focus

11-Point autofocus system supported by Nikon Scene Recognition System: tracks subjects by shape, position, and color. Three focus modes: Single-servo AF (AF-S), Continuous-servo AF (AF-C), and Manual focus (M). AF-A automatically selects from AF-S and AF-C.
Four AF-area modes: Single-point AF, Dynamic-area AF, 3D tracking AF, and Auto-area AF. Rapid focus point selection and focus lock.

Exposure

Three metering modes: matrix metering; center-weighted; and spot metering. 3D Color Matrix Metering II uses a 420-pixel color sensor to analyze scene data, based on brightness, color, contrast, and subject distance from all areas of the frame. With non-G/D Type lenses, Standard Color Matrix Metering II is employed.

Two fully automatic modes: Auto; Auto (flash off).

16 Scene Modes: Portrait, Landscape, Child, Sports, Close-up, Night Portrait, Night Landscape, Party/Indoor, Beach/ Snow, Sunset, Dusk/Dawn, Pet Portrait, Candlelight, Blossom, Autumn Colors, and Food.

Four user-controlled modes: Program (P) with flexible program, Aperture Priority (A), Shutter Priority (S), and Manual (M).

ISO range: 100–6400, extendable to ISO 25,600.

Exposure compensation: ±5EV, with automatic exposure bracketing facility.

Shutter

Shutter speeds from 1/4000 sec.–30 seconds, plus B (Bulb). Maximum frame rate 4fps. Quiet mode.

Viewfinder

Pentamirror viewfinder with 95% coverage and 0.78x magnification.

LCD monitor

Vari-angle 3in/75mm, 920,000-dot TFT LCD display with 100% frame coverage.

Movie mode

Movie capture in .MOV format (Motion-JPEG compression) with image size options of 1920 x 1280 pixels, 1280 x 720 pixels, and 640 x 424 pixels.

Buffer

Buffer capacity allows up to 100 frames
(JPEG Fine/Large) to be captured in a
continuous burst at 4fps; approximately
15 RAW files.

Built-in flash

Manually activated pop-up flash with
guide number (GN) of 39ft/12m at ISO
100. Supports i-TTL balanced fill-flash
for digital SLR (with matrix or center-
weighted metering) and Standard i-TTL
flash for digital SLR (with spot metering).
Up to eight flash-sync modes (dependent
on exposure mode): fill-flash, front-
curtain sync, slow sync, rear-curtain sync,
red-eye reduction, auto slow sync, and
slow sync with red-eye reduction. Flash
compensation from -3EV to +1EV.

Custom functions

20 parameters and elements of the
camera's operations can be customized
through the Custom Setting Menu.

File formats

The D5100 supports NEF (Raw) (14-bit)
and JPEG (Fine/Normal/Basic) file formats,
plus the .MOV file format for movies.

System back-up

Compatible with around 60 current and
many non-current F-mount Nikkor lenses
(functionality varies with older lenses).
Also compatible with SB-series flashguns,
wireless remote control ML-L3, GPS unit
GP-1, ME-1 stereo microphone, and
many more Nikon system accessories.

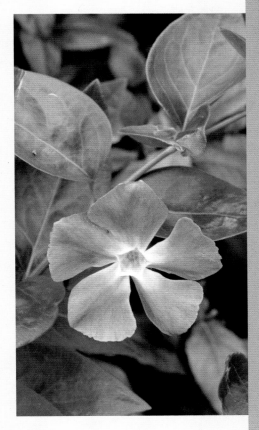

Software

Supplied with *Nikon Transfer* and *Nikon
View NX2*. Also compatible with *Nikon
Capture NX2* (optional) and many third-
party imaging applications.

1 » FULL FEATURES AND CAMERA LAYOUT

FRONT OF CAMERA

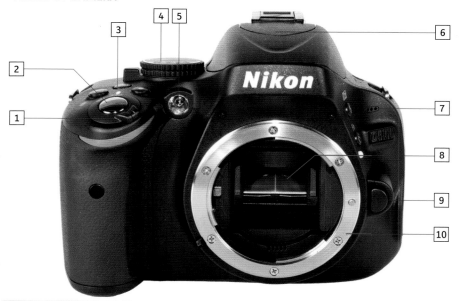

FRONT OF CAMERA

1	Power switch	6	Built-in flash
2	Shutter-release button	7	Microphone
3	Release-mode selector	8	Mirror
4	Mode dial	9	Lens-release button
5	AF-assist illuminator/Self-timer lamp/Red-eye reduction lamp	10	Lens mount

BACK OF CAMERA

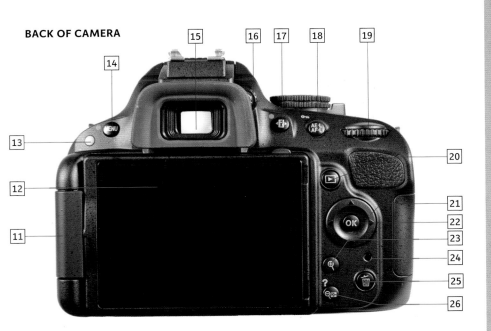

BACK OF CAMERA

11	Connection cover	20	Playback button	
12	LCD monitor	21	Multi-selector	
13	Infrared receiver (rear)	22	OK button	
14	Menu button	23	Playback zoom in button	
15	Viewfinder eyepiece	24	Memory card access lamp	
16	Diopter adjustment dial	25	Delete button	
17	Information edit button	26	Playback zoom-out/Thumbnail/ Help button	
18	AE-L/AF-L/Protect button			
19	Command dial			

1 » FULL FEATURES AND CAMERA LAYOUT

TOP OF CAMERA **LEFT SIDE**

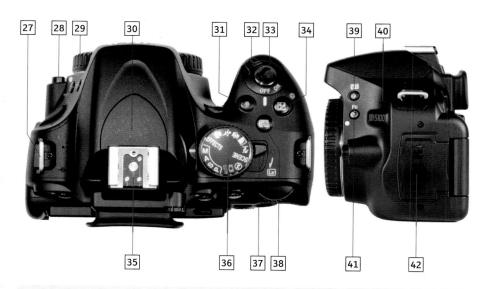

TOP OF CAMERA

27	Camera strap eyelet		36	Mode dial
28	Lens-release button		37	Live View switch
29	Body cap		38	Information button
30	Built-in flash			

LEFT SIDE

31	Movie record button		39	Flash mode button
32	Power switch		40	Microphone
33	Shutter-release button		41	Function button
34	Exposure compensation button		42	Connection cover
35	Accessory shoe			

RIGHT SIDE

BOTTOM OF CAMERA

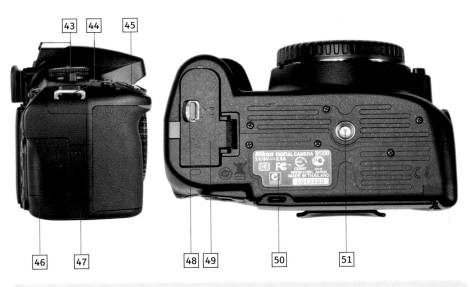

RIGHT SIDE

43	Mode dial
44	Camera strap eyelet
45	Shutter-release button
46	Memory card slot cover
47	Power connector cover

BOTTOM OF CAMERA

48	Battery cover latch
49	Battery compartment
50	Camera serial number
51	Tripod socket (¼in)

1 ›› VIEWFINDER DISPLAY

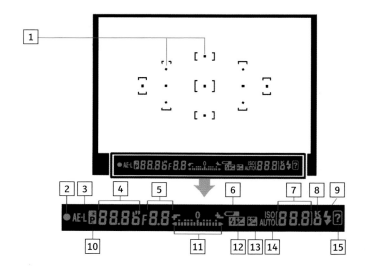

1	Focus points	8	"K" (appears when memory remains for over 1000 frames)
2	Focus indicator	9	Flash ready indicator
3	Autoexposure (AE) lock indicator	10	Flexible program indicator
4	Shutter speed	11	Exposure indicator
5	Aperture (f-number)		Exposure compensation display
6	Battery indicator		Electronic rangefinder
7	Number of exposures remaining	12	Flash compensation indicator
	Number of shots remaining before buffer fills	13	Exposure compensation indicator
	White balance recording indicator	14	Auto ISO sensitivity indicator
	Exposure compensation value	15	Warning indicator
	Flash compensation value		
	ISO sensitivity value		

›› LCD SCREEN

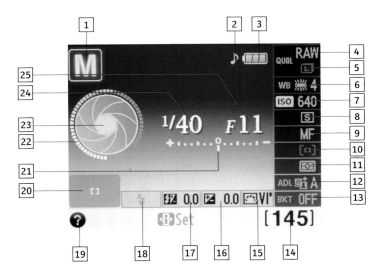

1	Shooting mode	12	Active D-Lighting	20	Auto-area AF indicator
2	"Beep" indicator	13	Bracketing increment		3D-tracking indicator
3	Battery indicator	14	Number of exposures remaining		Focus point
4	Image quality		White balance recording indicator	21	Exposure indicator
5	Image size		Capture mode indicator		Exposure compensation indicator
6	White balance	15	Picture control		Bracketing progress indicator
7	ISO sensitivity	16	Exposure compensation		
8	Release mode	17	Flash compensation	22	Shutter speed display
9	Focus mode	18	Flash mode	23	Aperture display
10	AF-area mode	19	Help icon	24	Shutter speed
11	Metering mode			25	Aperture speed

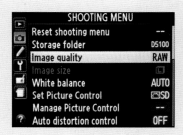

Shooting Menu
> Reset shooting menu
> Storage folder
> Image quality
> Image size
> White balance
> Set Picture Control
> Manage Picture Control
> Auto distortion control
> Color space
> Active D-Lighting
> HDR (high dynamic range)
> Long exposure NR
> High ISO NR
> ISO sensitivity settings
> Release mode
> Multiple exposure
> Movie settings
> Interval timer shooting

Custom Setting Menu
> Reset custom settings

a: Autofocus
> a1 AF-C priority selection
> a2 Built-in AF-assist illuminator
> a3 Rangefinder

b: Exposure
> b1 EV steps for exposure control

c: Timers/AE Lock
> c1 Shutter-release button AE-L
> c2 Auto off timers
> c3 Self-timer
> c4 Remote on duration

d: Shooting/display
> d1 Beep
> d2 ISO display
> d3 File number sequence
> d4 Exposure delay mode
> d5 Print date

e: Bracketing/flash
> e1 Flash cntrl for built-in flash
> e2 Auto bracketing set

f: Controls
> f1 Assign **Fn** button
> f4 Assign *AE-L/AF-L* button
> f3 Reverse dial rotation
> f4 Slot empty release lock
> f5 Reverse indicators

Playback Menu
> Delete
> Playback folder
> Playback display options
> Image review
> Rotate tall
> Slide show
> DPOF print order

Setup Menu
> Format memory card
> Monitor brightness
> Info display format
> Auto info display
> Clean image sensor
> Lock mirror up for cleaning
> Video mode
> HDMI
> Flicker reduction
> Time zone and date
> Language
> Image comment
> Auto image rotation
> Image Dust Off ref photo
> GPS
> Eye-Fi upload
> Firmware version

Chapter 2
FUNCTIONS

2 FUNCTIONS

With its many buttons and dials, the Nikon D5100 naturally appears complex. This may be daunting to users who are more familiar with compact digital cameras, or even 35mm SLRs, but the D5100 can be operated as simply as any point-and-shoot camera.

The D5100 should be ready for such use when you first unpack it, and you can quickly reset it to full auto operation at any time by holding down **MENU** and ◄🎞► for at least 2 seconds.

However, the D5100 also offers far greater flexibility than the average point-and-shoot camera, as well as far superior image quality. Its layout and interface encourage a progressive transition from leaving everything to the camera to taking full control of its key functions. Indeed, leaving the camera at its default settings misses out on much of its imaging power.

The intention of this chapter is to provide a step-by-step introduction to the D5100's most important features and functions. Even in a much longer book it would be impossible to fully explore every last detail, so we will concentrate on those aspects that will be most relevant to the majority of photographers.

Nikon's evolutionary approach to camera design means that the D5100 will feel familiar to anyone used to previous Nikon digital SLRs, but it could be a mistake to start using the D5100 in exactly the same way as previous models, without exploring its new features.

»

FAMILIARIZATION
When you unpack a new camera, it is tempting to start shooting right away—and taking pictures is the best way to learn. However, it makes sense to look through this book first, to make sure you don't miss out on any new features and functions.

ISO: 200 *Focal Length:* 34mm
Shutter Speed: 1/50 sec. *Aperture:* f/6.3

» CAMERA PREPARATION

Some basic operations, such as charging the battery and inserting a memory card, are essential before the camera can be used. Others, such as changing lenses, may seem trivial, but it can be important to be able to perform them quickly and smoothly in awkward situations or when time is short.

› Attaching the strap

To attach the strap, start by making sure that the padded side will face inward (so the maker's name faces out). Next, attach either end to the appropriate eyelet at the top left and right of the camera, loosen the strap where it runs through the buckle, and then pass the end of the strap through the eyelet and back through the buckle. Bring the end of the strap back through the buckle and under the first length of strap already threaded, as shown in the accompanying photograph (right). Repeat the operation on the other side. Adjust the length as required, but make sure that at least 2 inches (5cm) of strap extends beyond the buckle on each side to avoid

> **Note:**
> This method is not the same as the one outlined in the Nikon manual, but it is both more secure and neater.

any risk of it pulling through. When you are satisfied with the length, pull it firmly to seat it securely within the buckle.

> ### *Tip*
>
> *The D5100 provides on-screen help during shooting and when using the menus—just press* ? *to bring up information relating to the item currently selected on the screen. You cannot access this during playback though, as in playback mode the button has a different function.*

THE STRAP ⁂
The strap is shown threaded but not tightened.

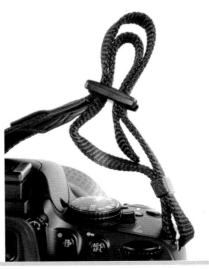

The D5100 offers dioptric adjustment, between −1.7 and +0.7m^{-1}, to allow for individual variations in eyesight, and you should make sure that this is optimized for your eyes (with glasses or contact lenses if you normally use them). Generally this is a one-time operation.

The diopter adjustment dial is to the right of the viewfinder. With the camera switched **ON**, rotate the dial until the viewfinder readouts and focus points appear sharpest. Supplementary viewfinder lenses are available if this adjustment proves insufficient.

ATTACHING A LENS ⌃

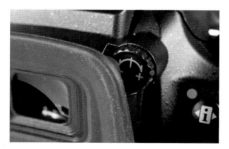

DIOPTER ADJUSTMENT ⌃

Caution

Avoid touching the electrical contacts on the lens and camera body, as dirty contacts can cause a malfunction. To help avoid this, always replace the lens and/or body caps as soon as possible.

› Mounting lenses

Whenever you change lenses you should first switch the camera **OFF**. Remove the body cap or the lens already mounted. To remove a lens, press the lens-release button and turn the lens clockwise (looking from the front of the camera).

To mount a lens, remove the rear lens cap and align the white index mark on the lens with the one on the camera body. Insert the lens gently into the camera and turn it counter-clockwise until it clicks home. Do not use force: if the lens is aligned correctly it will mount smoothly.

› Inserting and removing memory cards

The D5100 stores its images on Secure Digital (SD) memory cards, which also includes SDHC and SDXC cards. To insert or change a memory card:

1) Switch the camera **OFF** and check that the green access lamp on the back of the camera is not lit.

2) Slide the card slot cover on the right side of the camera toward the rear. It will spring open.

3) To remove a memory card, press the card gently into its slot and it will spring out slightly, allowing you to pull the card gently from its slot.

4) Insert a card with its label side toward you and the rows of terminals along the card edge facing into the slot. The "cut-off" corner of the card will be at top left.

INSERTING A MEMORY CARD ❯❯

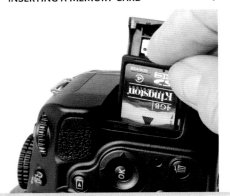

Push the memory card into the slot, without excessive force, until it clicks home. The green access lamp will light briefly as the camera recognizes the card.

5) Close the card slot cover.

Warning!

Inserting the memory card incorrectly may damage the camera.

Do not open the card slot cover or remove the battery when the access lamp is lit or blinking.

› Formatting a memory card

New memory cards, or cards that have been used in another camera, should always be formatted before use with the D5100. Formatting is also the quickest way to erase any existing images, but make sure that your images have been saved elsewhere before you do.

To format a memory card
1) Press **MENU** and then select the Setup menu 🔧 from the left of the screen.

2) Select the **Format memory card** option and press (**OK**).

3) Choose **Yes** and press (**OK**).

› Inserting the battery

The Nikon D5100 is supplied with an EN-EL14 li-ion rechargeable battery. This needs to be fully charged before first use.

Once the battery is charged, turn the camera upside down and locate the battery compartment below the handgrip. Release the latch to open the compartment. Insert the battery, contacts first, with the flat face facing toward the lens. Use the battery to nudge the orange-colored battery latch aside, and then slide the battery gently down until the latch locks into position. The green access lamp on the camera

Warning!

Always make sure the camera is switched off before removing or replacing the battery.

back illuminates briefly. Shut the battery compartment cover, making sure that it clicks home.

To remove the battery, switch the camera **OFF** and open the compartment cover as above. Press the orange latch to release the battery and pull it gently out of the compartment.

› Battery charging

Only use the supplied MH-24 Charger to charge the battery. Remove the terminal cover (if present) from the battery and insert the battery into the charger with the maker's name uppermost and the terminals facing the contacts on the charger. Press the battery gently, but firmly, into position and plug the charger into a power outlet.

The Charge lamp will blink while the battery is charging, and shine steadily when charging is complete. A completely discharged battery will take around 90 minutes to recharge fully.

《
INSERTING THE BATTERY

› Battery life

Various factors determine how long the battery can last before it needs recharging. The working temperature can be critical and Nikon do not recommend use at temperatures below 32°F (0°C) or above 104°F (40°C). Other factors that can reduce battery life include heavy use of the LCD screen (reviewing every image, for example), extensive use of the built-in flash, and Live View or movie shooting.

Under standard CIPA test conditions the D5100 delivers 660 shots from a fully charged battery; careful use can double this figure, while heavy use can reduce it. The Information Display and viewfinder give an approximate indication of how much charge remains: these icons blink when the battery is exhausted. For information on alternative power-sources, see *Accessories & Camera Care*, Chapter 8.

> **Tip**
>
> *The D5100's battery charger can be used in most countries. Do not attach a voltage transformer as this may damage the unit.*

› Switching the camera on

The power switch, surrounding the shutter-release button, has two settings:

OFF The camera will not operate.
ON The camera operates normally.

POWER SWITCH AND SHUTTER-RELEASE BUTTON ⌃

> **Tip**
>
> *If the power switch is turned OFF while the camera is recording image file(s), the camera will finish recording before turning off.*

2 » BASIC CAMERA FUNCTIONS

With the strap, lens, battery, and memory card fitted, the D5100 is ready to shoot. The camera arrives with its articulating LCD screen stowed away and set to Auto mode. The D5100 can shoot indefinitely in this configuration, but as soon as you want to change any settings, review or playback your shots, use Live View, or shoot movies, you will need to use the screen.

In beginning to explore a wider range of options, the key controls are the shutter-release button, Mode Dial, Command Dial, and multi-selector, along with the release mode selector. Settings that are affected by these controls are shown in the Information Display on the rear LCD screen. Some are also displayed in the viewfinder.

› Using the LCD screen

To use the D5100's rear LCD screen, grasp the tabs at the top right and bottom right corner, and ease it away from the camera. The screen can be angled and rotated into a wide range of positions, but it is more vulnerable to damage when opened out.

For normal use, open the screen, rotate it through 180° (by pushing the top away from you), and then fold it back against the camera body until it clicks into place. It is often most convenient to leave the screen in this position, but it is a good idea to get into the habit of stowing the screen away when you are transporting or storing the camera, to prevent accidental damage.

THE SCREEN STOWED AWAY ⌄

THE SCREEN FOLDED OUT ⌄

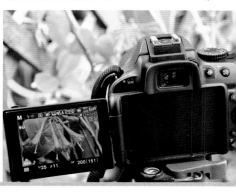

› Operating the shutter

The D5100's shutter-release button operates in two stages. Pressing it lightly, until you feel initial resistance, activates the metering and focus functions. This half pressure also cancels any active menus or image playback, making the D5100 instantly ready to shoot. Pressing it fully makes the exposure.

› The Mode Dial

The Mode Dial has 13 positions, split into four groups: Full Auto modes, User-control modes, Scene Modes, and Effects.

THE MODE DIAL ❯❯

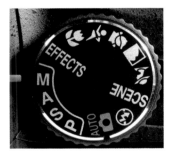

Tip

The rear LCD screen can be hard to see clearly in bright sunlight, but screen-shades are available that will help.

› The Command Dial

The Command Dial falls naturally under the right thumb when the D5100 is in the shooting position and is fundamental to the operation of the camera. Its function is flexible, and varies according to the operating mode at the time, but while the multiple options may appear daunting at first, in practice it is far more intuitive than a description in print might suggest.

In Shutter Priority (**S**) or Manual (**M**) mode, rotating the Command Dial selects the shutter speed, while in Aperture Priority (**A**) mode it selects the aperture. In Program mode (**P**) it engages flexible program, changing the combination of shutter speed and aperture. For more detailed descriptions of these modes see pages 49–53.

The Command Dial is also used to select from the more specialized Scene

THE COMMAND DIAL ❯❯

modes when the Mode Dial is set to **SCENE** and the Information Display is active. Other than this, the command dial has no direct effect when shooting in Full Auto or Scene modes.

› The multi-selector

The other principal control is the multi-selector. Its main use when shooting still images is to select and change settings in the Active Information Display. The (OK) button at its center is used to confirm settings. The multi-selector is also used for navigating through menus and through playback images—each of these uses will be introduced in the relevant sections.

THE MULTI-SELECTOR ⌄

› The Information Display

The Information Display is central to using the Nikon D5100. If you are familiar with traditional camera control through buttons and dials, it may seem strange at first, but it quickly proves to be a straightforward means of accessing a range of functions. To activate the Information Display, either:

- **Half press and release the shutter-release button** *(if you maintain pressure the Information Display will not appear)*

- **Press the info button on the top of the camera**

- **Press the button on the rear of the camera**

Doing any of these will bring up a display showing the selected exposure mode, the aperture and shutter speed, and a range of other details. This screen can be displayed in a choice of two formats: **Graphic** or **Classic**.

The **Graphic** format is active by default and uses icons and pictures to illustrate the effect of various camera settings. The **Classic** format presents the information in a more traditional fashion, using text and numbers. In both instances, the color scheme can be changed; these options are exercised through the Setup Menu.

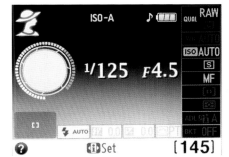

THE INFORMATION DISPLAY (GRAPHIC FORMAT) ≫

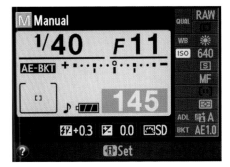

THE INFORMATION DISPLAY (CLASSIC FORMAT) ≫

› The Active Information Display

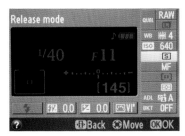

THE ACTIVE INFORMATION DISPLAY ≫
WITH RELEASE MODE HIGHLIGHTED

The initial Information Display is passive, in that it displays many settings, but does not allow them to be changed. To make changes possible, press ◄⬛► while the Information Display is visible (if the screen is blank, press the button twice). The screen changes to the Active Information Display, and the multi-selector can now be used to move quickly through the various settings. To make changes, press (OK), and the range of options for that setting appears. Use the multi-selector to move through these options; when the one you want is highlighted, press (OK) again to select it.

> **Note:**
> The term "Active Information Display" is not used in Nikon's own manual, which instead refers to "placing the cursor in the Information Display."

2 » RELEASE MODE

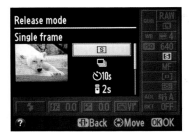

"Release mode" may seem an obscure term, but it determines whether the camera takes a single picture or shoots continuously, as well as allowing the shot to be delayed. The release mode can be selected through the Shooting Menu, but is more usually selected from the Active Information Display.

1) Activate the Active Information Display and highlight the **Release Mode** to the right of the screen. Press (OK) to reveal a list of six release modes that can be selected, as outlined in the grid below.

2) Highlight the desired release mode and press (OK) to activate it. The chosen option is shown in the Information Display.

RELEASE MODE OPTIONS	
Setting	**Description**
[S] Single frame	The camera takes a single shot each time the shutter-release button is depressed fully.
Continuous	The camera fires continuously for as long as the shutter-release button is depressed fully. The maximum frame rate is 4fps (frames per second).
Self-timer	The shutter is released a set interval after the shutter-release button is depressed fully. Can be used to minimize camera shake and for self-portraits. The default interval is 10 seconds, but this can be changed to 2, 5, or 20 seconds using Custom Setting c3.
Delayed remote	Requires the optional ML-L3 remote control: the shutter fires 2 seconds after the remote control is triggered.
Quick response	Requires the optional ML-L3 remote control: shutter fires immediately when the remote control is triggered.
[Q] Quiet shutter release	Similar to Single frame, but the mirror remains up and the shutter is not reset until the shutter-release button is released, making operation almost silent.

Several other "release mode" options can be accessed by other means, such as Live View mode, which is activated at any time with the **LV** switch on top of the camera. Following on from this, the D5100's Movie mode is entered by pressing **● Rec** when the camera is in Live View mode, as outlined in Chapter 6. Finally, and most obscurely, there is also an Exposure Delay mode that can only be activated through the Custom Setting Menu.

> **Note:**
> When the shutter-release button is *not* depressed, the figure at the bottom right of the viewfinder shows the total number of images that can be stored on the memory card using the current size/quality settings.

› The buffer

Images are initially transferred to the camera's internal memory (its "buffer") before they are written to the memory card. The maximum number of images that can be recorded in a continuous burst therefore depends on how much space is available in the buffer, as well as the file quality, release mode, and even the memory card.

The figure for the number of burst frames that can be recorded using the current camera settings is shown in the viewfinder when the shutter-release button is pressed half way. If **0** appears, this means that the buffer is full, and no more shots can be taken until enough data has been transferred from the buffer to the memory card to free up space. This normally happens very quickly, but you may need to release pressure on the shutter-release button momentarily.

SELF-TIMER **»**
Self-timer mode comes into its own when shooting solo. The 20-second delay was very useful here!

ISO: 250 *Focal Length:* 18mm
Shutter Speed: 1/160 sec.
Aperture: f/11

2 » EXPOSURE MODES

Exposure modes, selected from the Mode Dial, are fundamental to the camera's operation. Which one you choose can make a significant difference to the amount of control you can—or can't—exercise. The D5100 has a very wide choice of exposure modes, but they fall under three main headings: Full Auto, Scene, and User-control modes. There is also an **EFFECTS** position on the Mode Dial for more "creative" results.

In the Full Auto and Scene Modes, the camera controls the majority of settings. These go beyond basic shooting settings (such as shutter speed and aperture) to include options such as the release mode, whether or not flash can be used, and how the camera will process the shot. The main difference between the two modes is that the Full Auto modes use "compromise" settings to cover most eventualities, while the Scene Modes are tailored to particular shooting situations. User-control modes, by contrast, give you the freedom to control virtually everything on the camera.

Note:
In all exposure modes, if the camera detects that the light levels are too low or, more rarely, too high to produce an acceptable exposure, a warning will be displayed in both the viewfinder and the Information Display. The viewfinder display flashes and a blinking question mark is shown, while the Information Display will also display a flashing question mark along with a warning message. The camera will still take pictures, but the results may be unsatisfactory.

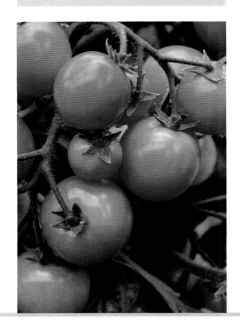

CHOOSING EXPOSURE MODES »
Food mode is a better choice than Close-up here, as it makes sure the flash stays off.

ISO: 400 *Focal Length:* 105mm
Shutter Speed: 1/200 sec. *Aperture:* f/8

MODE GROUP		EXPOSURE MODE	
Full Auto modes	AUTO	Auto	Leaves all decisions about
		Auto (Flash Off)	settings to the camera.
Scene Modes (Directly selectable via the Mode Dial)		Portrait	
		Landscape	
		Child	
		Sports	
		Close-up	
Scene Modes (Accessed via **SCENE** on the Mode Dial)		Night Portrait	You choose the mode that
		Party/Indoor	is most suitable for the
		Beach/Snow	subject and the camera
		Sunset	employs the most
		Dusk/Dawn	appropriate settings.
		Pet Portrait	
		Candlelight	
		Blossom	
		Autumn Colors	
		Food	
Special Effects (Accessed via **EFFECTS** on the Mode Dial, in conjunction with the Information Display)		Night Vision	
		Color Sketch	
		Miniature Effect	Use for more extreme
		Selective Color	pictorial effects.
		Silhouette	
	Hi	High Key	
	Lo	Low Key	
User-control modes	P	Program	
	S	Shutter Priority	Provides control over the
	A	Aperture Priority	full range of camera settings.
	M	Manual	

2 » FULL AUTO MODES

Nikon calls these "point and shoot" modes, which is probably a fair reflection of the type of photography for which they are likely to be used. Most of the time, Full Auto works well, and you will hardly ever get a shot that doesn't "come out" at all.

However, you may find that the results are not always exactly what you were aiming for, as it is the camera, not you, that is deciding what kind of picture you are taking and how it should look.

There is only one difference between the D5100's pair of Full Auto modes: in AUTO Auto mode the built-in flash will pop up automatically if the camera determines light levels are too low, and can only be turned off via the Active Information Display, while in Auto (Flash Off) mode, the flash stays off, no matter what. This is useful when flash is banned or would be intrusive, or you just want to discover what the D5100 can do in low light.

AUTO **«**

Full Auto is ideal when shots need to be grabbed quickly, but it can diminish the photographer's sense of control and creativity.

ISO: 320
Focal Length: 105mm
Shutter Speed: 1/250 sec.
Aperture: f/14

» SCENE MODES

The Nikon manual calls these Creative Photography modes, which is a debatable tag given that they still take many decisions out of your hands. However, newcomers to digital SLR photography will find that Scene Modes are an ideal way to discover how the camera can interpret the same scene in a different way, which makes them a great stepping-stone from Full Auto to the more advanced options offered by the D5100.

Five Scene Modes can be selected directly on the Mode Dial, with 11 more selectable by setting the Mode Dial to **SCENE** and rotating the Command Dial. When you do this, the Information Display activates, showing a "virtual mode dial," with the current mode's icon highlighted and its name shown also. A thumbnail image gives an example of an appropriate subject and the way it should turn out when this mode is used. This disappears after a few seconds, but you can reactivate it by rotating the Command Dial again.

Scene Modes control basic shooting parameters such as how the camera focuses and how it sets the shutter speed and aperture. If you are shooting JPEG images they also determine how the image is processed by the camera. In 👤 Portrait mode, for example, the camera applies a Portrait Picture Control, which gives natural color rendition and is particularly kind to skin tones. Therefore, one of the first steps is to understand how the various Scene Modes work and to recognize their impact on the resulting images.

2 › Portrait

› Child

In Portrait mode the camera sets a relatively wide aperture to reduce the depth of field and help a portrait subject stand out from the background. The camera also selects the focus point automatically (presumably using Face Detection technology), and you cannot override this selection unless you focus manually. The flash will automatically pop up if the camera determines that the light levels are too low, but it can be turned off via the Active Information Display. Attaching a separate flashgun will also override the built-in flash, and usually improves results.

Child mode is broadly similar to Portrait mode, but the camera tends to set faster shutter speeds—presumably because children are less likely to sit still. Colors are also handled slightly differently to produce results that are more vivid overall, but still give natural skin tones. You can, of course, use this mode for adult portraits if you prefer a more vibrant result or the subject is active. The flash activates automatically, but can be turned off via the Active Information Display.

CHILD MODE ⌄

Turning the flash off is often better for spontaneous shots.

ISO: 320 *Focal Length:* 21mm
Shutter Speed: 1/80 sec. *Aperture:* f/6.3

PORTRAIT MODE ⌄

Using a separate flash unit and bouncing the light gave more natural-looking lighting in this shot.

ISO: 640 *Focal Length:* 135mm
Shutter Speed: 1/250 sec. *Aperture:* f/4

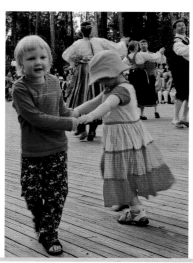

› Landscape

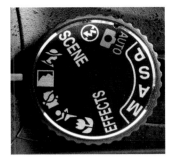

In Landscape mode, the camera sets a small aperture to maximize the depth of field. A small aperture means that the shutter speed can be slow, so a tripod is often advisable. The camera also selects the focus point automatically (although this can be overridden) and applies a Landscape Picture Control to give vibrant colors. The built-in flash remains off, even in low lighting conditions, and while you cannot activate the flash manually, you can use a separate flash unit.

LANSCAPE MODE ⌄
Landscape mode aims to keep both the foreground and background sharp, as well as giving vibrant colors.

ISO: 320 *Focal Length:* 16mm
Shutter Speed: 1/500 sec. *Aperture:* f/9

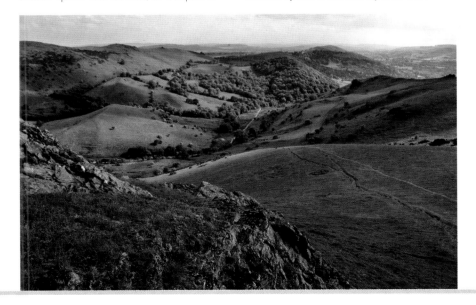

› Sports

› Close-up

Sports mode is not just intended for shooting sports, but for other fast-moving subjects as well, such as wildlife. The camera will set a fast shutter speed to freeze movement, which usually implies a wide aperture and a shallow depth of field. The camera initially selects the central focus point, but if it detects subject movement it will track it using the other 10 focus points. The flash remains off, even in low light, and the only way of overriding this is to attach a separate flash unit.

Close-up mode is intended for shooting at close range, with the camera setting a medium-to-small aperture to improve depth of field. A tripod is often useful to avoid camera shake, and the built-in flash will activate automatically in low light. This can be turned off via the Active Information Display, which is often the best solution, as the built-in flash is a poor choice for most close-up shots. The camera automatically selects the central focus point, but this can be overridden with the multi-selector.

SPORTS MODE
Fast shutter speeds are often used in an attempt to freeze action.

ISO: 1600 *Focal Length:* 47mm
Shutter Speed: 1/1000 sec. *Aperture:* f/6.3

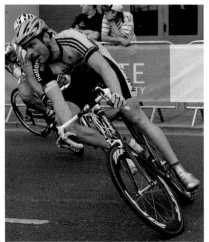

CLOSE-UP MODE
The built-in flash is not ideal for close-up shots, so is best deactivated in Close-up mode.

ISO: 200 *Focal Length:* 105mm
Shutter Speed: 1/200 sec. *Aperture:* f/11

› Night Portrait

In most respects, Night Portrait mode is similar to the regular Portrait mode. The main difference is that when the ambient light is low, Night Portrait uses long shutter speeds so that the background is exposed correctly. For this reason, a tripod or other solid camera support is recommended. The built-in flash operates automatically, but can be turned off, or an accessory flash attached. Red-eye reduction mode is employed, giving a noticeable delay between pressing the shutter and the image being captured, although the flash mode can be changed via the Active Information Display.

NIGHT PORTRAIT ❮
A separate flash provided more natural-looking lighting for this night-time portrait.

ISO: 1600 *Focal Length:* 35mm
Shutter Speed: 1/30 sec. *Aperture:* f/4.5

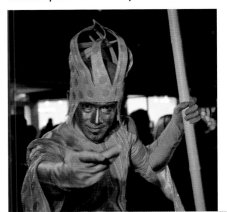

› Night Landscape

Night Landscape mode allows long exposures to be used, so a tripod is strongly recommended. The built-in flash remains off, but an accessory flash can be used. Images are processed to reduce noise and preserve color, including the varied colors of artificial light. When exposure times exceed 1 second, long exposure noise reduction is applied automatically, which means there is a delay before another shot can be taken. The maximum exposure time in this mode is 30 seconds: if a longer exposure is required you will need to use Manual (**M**) mode instead.

NIGHT LANDSCAPE ❮
Allows long exposure times for low-light shots.

ISO: 100 *Focal Length:* 14mm
Shutter Speed: 20 seconds *Aperture:* f/11

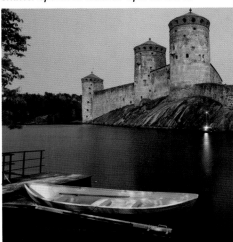

2

› Party/indoor 🎊

› Beach/snow ⛄

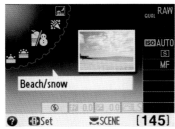

This mode appears similar to Night Portrait, in that it is intended to record both people and their background, but it does not allow such long exposures to be set. Red-eye reduction is employed, complete with its associated shutter delay, but the flash mode can be changed via the Active Information Display.

Beach and snow scenes are notorious for disappointing results: the subject is full of bright tones and yet pictures often turn out relatively dark. The D5100's Beach/snow mode aims to counteract this, partly by applying exposure compensation, and partly through the image processing. The flash remains off.

PARTY/INDOOR ⚡

Red-eye reduction flash means that holding a "spontaneous" pose can be a bit of a strain.

ISO: 1600 *Focal Length:* 58mm
Shutter Speed: 1/60 sec. *Aperture:* f/5

BEACH/SNOW ⚡

This mode preserves the overall lightness of beach and snow scenes.

ISO: 1250 *Focal Length:* 41mm
Shutter Speed: 1/125 sec. *Aperture:* f/11

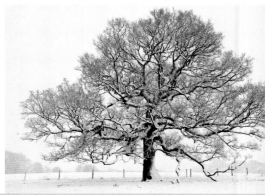

› Sunset ☀

Sunset mode is broadly similar to Night Landscape: the built-in flash remains off; long exposure times are possible; and a tripod is recommended. Unlike Night Landscape, however, the white balance is predetermined, in order to preserve the vivid tones of the sky.

SUNSET �≈
Sunset mode would be the obvious choice for this warm, colorful shot.

ISO: 400 *Focal Length:* 85mm
Shutter Speed: 1/250 sec. *Aperture:* f/10

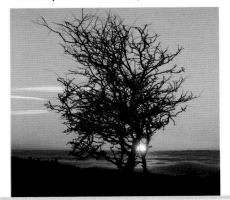

› Dusk/dawn ☀

Dusk/dawn mode allows for the more muted colors and lower contrast that are usually experienced before sunrise and after sunset. The white balance is preset, rather than automatic, and the flash remains off.

DUSK/DAWN ☈
This Scene Mode suits the softer light of dusk and dawn.

ISO: 1600 *Focal Length:* 60mm
Shutter Speed: 1/100 sec. *Aperture:* f/10

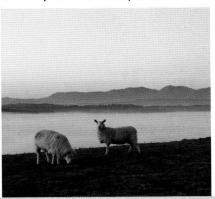

› Pet portrait 🐾

Recommended for portraits of active pets. The built-in flash will fire automatically in low light, but the AF-assist illuminator is turned off, presumably to avoid disturbing the animal before the shot. In most respects, this mode is very similar to Child. The flash can be turned off via the Active Information Display.

PET PORTRAIT
Not exactly a pet, but the effect is the same.

ISO: 500 *Focal Length:* 28mm
Shutter Speed: 1/60 sec. *Aperture:* f/13

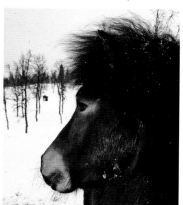

› Candlelight 🕯

Recommended for portraits and other subjects that are lit by candlelight. Because this light is quite weak, the exposure times are usually long and a tripod is essential. The subject will need to keep still as well. The white balance is preset to allow for the very red hue of the candlelight, so while this mode could be used for other low-light shooting situations, the colors of other light sources may appear excessively blue.

CANDLELIGHT
This mode does not completely neutralize the warm glow of the candlelight.

ISO: 1600 *Focal Length:* 62mm
Shutter Speed: 1/8 sec. *Aperture:* f/5.3

› Blossom

Use this mode for trees in blossom, fields of flowers, and similar subjects. Because the colors are often intense and petals can reflect a lot of light, detail is often lost with this type of subject. The D5100 uses Active D-Lighting to help prevent this, while the image processing aims to keep colors vivid, without becoming garish.

BLOSSOM

Blossom mode would retain detail in the petals of this Red Campion (*Silene dioica*), but it was windy and I needed to set a fast shutter speed. Instead, I used Manual mode, and shot in Raw, which was equally effective.

ISO: 500 *Focal Length:* 105mm
Shutter Speed: 1/800 sec. *Aperture:* f/7.1

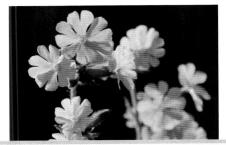

› Autumn colors

This mode aims to preserve the colors in fall/autumn foliage, with the in-camera processing favoring the red and yellow parts of the spectrum. You could try using this mode with other subjects where these colors are paramount.

AUTUMN COLORS

Autumn colors can be appreciated on a small scale, as well as in wider views.

ISO: 1250 *Focal Length:* 24mm
Shutter Speed: 1/20 sec. *Aperture:* f/8

2 › Food 🍴

Food

? **Set** **SCENE** **[145]**

Recommended for detailed and vivid photos of food. This mode is unique among the D5100's Scene Modes in that the built-in flash has to be activated manually. Because food photographs are naturally taken at a close range, the built-in flash may produce unwanted shadows, meaning it is usually better to use a separate flash or to employ a tripod.

FOOD

This mode is a good choice for close-up subjects when flash is not required.

ISO: 200 *Focal Length:* 200mm
Shutter Speed: 1/400 sec. *Aperture:* f/10

› Taking the picture

Picture taking is essentially the same in all of the Full Auto and Scene Modes:

1) Select the desired mode.

2) Frame the picture

3) Half press the shutter-release button to activate the focusing and exposure systems. The focus point(s) will be displayed in the viewfinder, and the shutter speed and aperture settings will appear below the viewfinder image.

4) Fully depress the shutter-release button to take the picture.

› Special effects

The **EFFECTS** modes are a new feature in the D5100, although some were formerly available as Scene Modes and others could (and still can) be replicated through the Retouch Menu. It is hard to avoid words such as "gimmicky" when discussing these modes, and it is fair to say that most photographers will use them sparingly, if at all. For this reason we will deal with them fairly briefly, starting on page 89.

» USER-CONTROL MODES

The final four exposure modes will be familiar to any experienced photographer: Program (**P**), Aperture Priority (**A**), Shutter Priority (**S**), and Manual (**M**).

As well as allowing direct control over the aperture and/or shutter speed (even in **P** mode through flexible program), these modes all give full access to controls such as white balance, Active D-Lighting, and Nikon's Picture Controls, providing you with a wide influence over the look and feel of your images.

CREATIVE CONTROL ⹖
User-control modes are best when you need full creative control. (Stockholm, Sweden)

ISO: 100 *Focal Length:* 80mm
Shutter Speed: 1/800 sec. *Aperture:* f/8

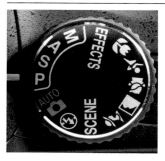

In **P** mode the camera sets a combination of shutter speed and aperture that will give a correctly exposed result. The same is true of the Full Auto and Scene Modes, but **P** mode lets you adjust numerous parameters to suit your own creative ideas, and it also allows manual selection of the ISO. You can change things even further through options such as flexible program, exposure lock, exposure compensation, and auto bracketing, with complete freedom over the use—or not—of flash.

1) To switch to Program, rotate the Mode Dial to position **P**.

2) Frame the picture.

3) Half press the shutter-release button to activate the focusing and exposure systems. The focus point(s) are displayed in the viewfinder along with the shutter speed and aperture settings.

4) Press the shutter-release button fully to take the picture.

Flexible program

Without leaving **P** mode you can change the combination of shutter speed and aperture by rotating the Command Dial. While flexible program is in effect, the **P** indicator in the Information Display changes to **P***, and the shutter speed and aperture combination can be seen to change in the viewfinder. This does not change the overall exposure, but it does allow you to choose a faster shutter speed to freeze action, or a smaller aperture to increase depth of field, for example, giving you similar control to the **S** or **A** modes.

PROGRAM «

This mode allows you to tailor the camera settings to suit your own creative ideas.

ISO: 250 *Focal Length:* 30mm
Shutter Speed: 1/60 sec. *Aperture:* f/10

› Shutter Priority (**S**)

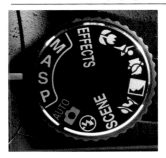

Control of the shutter speed is critical for photographing moving subjects. In Shutter Priority (**S**) mode, you control the shutter speed while the camera sets the appropriate aperture to give you a correctly exposed result. Shutter speeds of between 1/4000 sec. and 30 seconds can be set, with fine-tuning of the exposure possible through exposure lock, exposure compensation, and auto bracketing.

1) To switch to Shutter Priority mode, rotate the Mode Dial to position **S**.

2) Frame the picture.

3) Press the shutter-release button to activate the focusing and exposure—the active focus point(s) and the shutter speed and aperture settings will appear at the bottom of the viewfinder. Rotate the Command Dial to alter the shutter speed: the aperture will adjust automatically.

4) Press the shutter-release button fully to take the picture.

Scene Modes and shutter speed
Some Scene Modes provide rudimentary control over the shutter speed—Sports Mode aims to set a fast shutter speed, for example. This is fine up to a point, but it does not give the direct and exact control that **S** mode does. Shutter Priority also allows you to shift quickly to a much slower speed.

SHUTTER PRIORITY **«**
Shutter Priority enabled me to set a slow shutter speed to smooth the falling water.

ISO: 400
Focal Length: 18mm
Shutter Speed: 3 seconds
Aperture: f/22

› Aperture Priority (**A**)

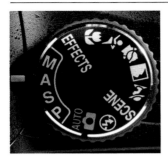

In Aperture Priority (**A**) mode, you control the aperture while the camera sets an appropriate shutter speed. Control of the aperture is particularly useful for regulating the depth of field, but it is important to note that the range of apertures that you have available is limited by the lens that is fitted, and not by the camera. As with Shutter Priority mode, you can fine-tune the exposure using exposure lock, exposure compensation, and auto bracketing.

1) To activate Aperture Priority mode, turn the Mode Dial to **A**.

2) Frame the picture.

3) A half press of the shutter-release button will activate the focusing and

exposure systems, with the active focus point(s), aperture, and shutter speed being displayed in the viewfinder. Use the Command Dial to change the aperture, and the shutter speed will adjust automatically. The Information Display (in Graphic format) also shows a visual representation of the aperture.

4) Press the shutter-release button fully to take the picture.

APERTURE PRIORITY **»**
This mode is ideal for controlling the depth of field in an image.

ISO: 200 *Focal Length:* 11mm
Shutter Speed: 1/60 sec. (tripod) *Aperture:* f/11

› Manual (M)

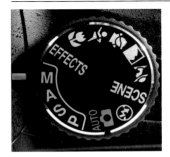

In **M** mode, you have full control over both the shutter speed and the aperture for maximum creative flexibility. Manual mode is probably best employed when shooting without the pressure of time and/or when you are in fairly constant light conditions. There are some experienced photographers who use it habitually, enjoying the feeling of complete control. In Manual mode the D5100 allows you to use its **B** (or "Bulb") setting, in which the shutter remains open for as long as the shutter-release button is held down. This is not available in any mode except **M**.

1) Rotate the Mode Dial to **M**.

2) Frame the picture.

3) Press the shutter-release button half way to activate the focusing and exposure. Check the analog exposure display at the center of the viewfinder readout and, if necessary, adjust the shutter speed, aperture, or both, to achieve the correct exposure.

4) Rotate the Command Dial to alter the shutter speed, or hold [±] and rotate the Command Dial to change the aperture.

5) Press the shutter-release button fully to take the picture.

Using the analog exposure displays
In Manual mode an analog exposure display appears in the viewfinder, as well as the Information Display (if it is active). This shows whether the photograph would be under- or overexposed at the current settings. The aim is to adjust the shutter speed and/or aperture until the indicator is aligned with the **0** mark in the center of the analog exposure display.

> ### Tip
>
> *In all of the User-control modes, it is helpful—time permitting—to review the image and check the histogram display after taking a shot. You can then make further adjustments, if necessary—either for creative effect or to correct the camera's recommended exposure. This process is known as "chimping."*

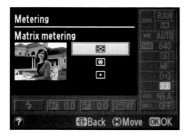

SELECTING METERING MODE IN THE ⌃
ACTIVE INFORMATION DISPLAY

Measuring the light levels (or "metering") to make sure that your images are exposed correctly is a vital function. The D5100 provides you with three different metering modes, which should cover any eventuality. In the User-control modes, you can switch between them using the **Metering** option in the Active Information Display, but in other exposure modes Matrix Metering is selected automatically.

› 3D Color Matrix Metering II

Using a 420-segment color sensor, 3D Color Matrix Metering II analyzes a scene based on brightness, color, and contrast. When using Type G or D Nikkor lenses, the system also uses the distance to the subject. Matrix Metering is recommended for the vast majority of shooting situations and will nearly always produce excellent results.

› Center-weighted metering

This is a very traditional form of metering that will be familiar to most photographers with experience of 35mm SLR cameras. The camera meters from the entire frame, but gives greater weight to a central circle, making it useful for subjects such as portraits, where the key subject often occupies the central portion of the frame.

› Spot metering

Spot metering takes a reading from a small, circular area. With the D5100, this circle is centered on the current focus point, allowing you to meter from an off-center subject (unless Auto-area AF is in use, in which case the spot metering point is the center of the frame).

Spot metering is useful when an important subject is much darker or lighter than the background and you want to be sure that it is correctly exposed. However, making good use of it does require some experience, as you need to be careful to meter from a midtone area. If you meter from a point that is too dark or too bright then over- or underexposure is likely.

SPOT METERING
Contrast was very high and spot metering helped give a sense of both shadows and highlights. (Bled, Slovenia)

ISO: 200 *Focal Length:* 80mm
Shutter Speed: 1/640 sec.
Aperture: f/7.1

2 ›› EXPOSURE COMPENSATION

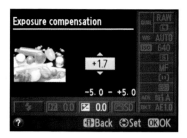

**SETTING EXPOSURE COMPENSATION IN ⌃
THE ACTIVE INFORMATION DISPLAY**

The D5100 will produce accurate exposures under most conditions, but no camera is infallible, and nor can it read your mind or anticipate your creative intent. All metering systems are at least partly based on the assumption that key subject areas have a mid tonal value and should be recorded as a midtone. This can have unwelcome consequences with non-average subjects, with snow scenes

> **Tip**
>
> *Exposure compensation is only available in **P**, **A**, and **S** modes. In **M** mode, ⊞ controls the aperture, but you can "compensate" by setting the exposure so that the analog exposure display shows a + or - value. Exposure control is fully automatic in the Full Auto and Scene Modes.*

appearing unduly dark, for example. This is because normal metering is programed to reproduce all scenes as a midtone, so snow scenes will appear overly dark. Conversely, predominantly dark scenes or subjects will tend to be reproduced lighter than they should be.

The D5100's Beach/Snow mode allows for this by applying automatic exposure compensation. However, digital cameras allow instant feedback so, if there is time, it is always helpful to check the image after shooting, and study the histogram to see when exposure compensation is needed. With growing experience you can begin to anticipate this need.

The basic principle is very simple: to make the image lighter, give it more exposure by applying positive (+) compensation, and use negative (-) compensation to give less exposure and make the image darker.

EXPOSURE COMPENSATION BUTTON ⌄

Using exposure compensation

1) Press and rotate the Command Dial to set the compensation required (between -5EV and +5EV). Alternatively, use the Active Information Display.

2) The chosen exposure compensation value is shown in the Information Display. In the viewfinder, the **0** at the center of the Analog Exposure Display flashes while exposure compensation is in effect.

3) Take your photograph as normal. If time allows, use the histogram to check that the result is satisfactory.

4) To restore normal exposure settings, repeat step 2 until the displayed exposure value returns to **0.0**.

Remember to reset exposure compensation when you no longer need it. Exposure compensation is cancelled when you switch to one of the Full Auto or Scene Modes, but the D5100 remembers the compensation setting and restores it when you revert to a User-control mode: it does not reset automatically, even when the camera is switched off. However, as with many other settings, it will be restored to its default by a two-button reset (see pages 74-75).

EXPOSURE COMPENSATION ❯❯
Exposure compensation is a useful standby for tricky scenes.

ISO: 160 *Focal Length:* 40mm
Shutter Speed: 1/60 sec. *Aperture:* f/14

› Exposure lock

Exposure lock is another way to fine tune the camera's exposure setting and it is very quick and intuitive. It is useful when very dark or light areas (especially light sources) within the frame could influence the exposure. Exposure lock allows you to meter from a midtone area—by pointing the camera in a different direction or stepping closer to the subject—and hold that exposure while you reframe the shot.

Using exposure lock

1) Aim the camera (or zoom the lens) to exclude potentially problematic dark or light areas.

2) Set the exposure by pressing *AE-L/AF-L*.

3) Keep *AE-L/AF-L* pressed as you reframe the image and shoot in the normal way.

By default, *AE-L/AF-L* locks focus as well as exposure, but this can be changed using Custom Setting f2. There are several options, but the most relevant for using exposure lock is **AE Lock only**.

You can also opt for **AE Lock (hold)**. In this case you can release *AE-L/AF-L* after step 2 and the exposure will remain locked until you press *AE-L/AF-L* again or the meter turns off.

› Exposure bracketing

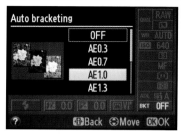

A long-standing method for making sure that you capture a correctly exposed image is to take several frames at differing exposure values, and select the best one later. This is known as exposure bracketing. The D5100 allows you to bracket three frames automatically, with up to 2EV between each.

1) Check that Custom Setting e2 is set to **AE bracketing** (this is the default setting).

2) In the Active Information Display, highlight **BKT** and press ⓞⓚ. Use the

> ### Tip
>
> *The D5100 offers other forms of bracketing that can be chosen using Custom Setting e2. The options are AE (exposure) bracketing, White Balance bracketing, and Active D-Lighting bracketing.*

multi-selector to choose the exposure increment between each shot in the sequence and press (OK) again. The chosen increment is shown in the Information Display. In the viewfinder, the 0 at the center of the Exposure Display flashes.

3) Frame, focus, and shoot normally. The camera will vary the exposure with each frame. Continuous release mode is useful for this, and the camera will pause at the end of the three-shot sequence.

4) To cancel bracketing and return to normal shooting, repeat step 2 and select **OFF** from the list of options.

If your memory card becomes full before the bracketed sequence is complete, the camera will stop shooting. Replace the card or delete images to make space, and the camera will resume where it left off. Similarly, if the camera is switched off mid-sequence it will resume the sequence when it is next switched on.

> ### Tip
>
> *Avoid using exposure bracketing while shooting moving subjects as it is unlikely that the best exposure will coincide with the subject being in the best position.*

EXPOSURE BRACKETING ⌄
Exposure bracketing covering a 3-stop range. From left to right: -1EV, 0, and +1EV.

ISO: 400 *Focal Length:* 32mm
Shutter Speed: various *Aperture:* f/11

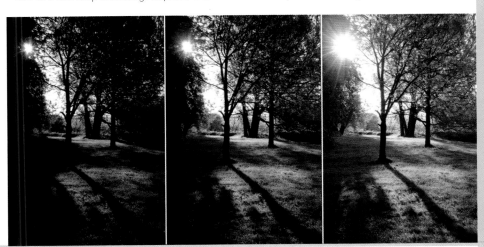

Focus mode
Manual focus

AF-A
AF-S
AF-C
MF

Back Move OK

FOCUS MODE SELECTION

Focusing is not simply about making sure that your picture is "in focus." It is quite difficult—and sometimes impossible—to get everything in an image appearing sharp, so the first step is to check that the camera focuses on the desired subject, or the right part of the subject. Control of depth of field will then help to determine how much of the rest of the image will also appear sharp.

To secure focus on the desired subject, the D5100 has flexible and powerful focusing capabilities, offering manual focus as well as a range of autofocus modes. To choose the focus mode, use the Active Information Display and select the focusing option (by default this reads **AF-A**). Press (OK), select from the available options, and then press (OK) again to confirm the selection and return to shooting mode.

If the camera is in a Full Auto or Scene Mode, then only two focusing options are offered: manual focus can always be selected, but the only autofocus option is AF-A. In **P**, **A**, **S**, or **M**, four options are available, as outlined here.

> **Note:**
> This section only deals with focusing in normal shooting. Focusing in Live View works differently (see pages 76–79), and it is also different when shooting movies (see Chapter 6).

› **Auto-servo AF (AF-A)**

By default the camera is set to AF-A in all exposure modes. AF-A means that the D5100 automatically switches between two autofocus modes: Single-servo AF and Continuous-servo AF.

› **Single-servo AF (AF-S)**

In AF-S mode, the camera focuses when the shutter-release button is pressed halfway. Focus remains locked on this point for as long as you maintain half pressure. The shutter cannot release to take a picture unless focus has been acquired (*focus priority*). This mode is recommended for accurate focusing on static subjects.

› Continuous-servo AF (**AF-C**)

Continuous-servo AF is recommended for moving subjects, as the camera continues to seek focus for as long as the shutter-release button is half pressed. If the subject moves, the camera will refocus, but it is able to take a picture even if perfect focus has not been acquired (*release priority*).

The D5100 employs predictive focus tracking in this mode, so if the subject moves, the camera will analyze the movement and attempt to predict where it will be when the shutter is released.

› Manual focus (**MF**)

When a camera has sophisticated AF capabilities, manual focus might appear redundant, but many photographers still value the extra control and involvement. There are also certain subjects and circumstances that can confuse even the best AF systems. Manual focusing is a straightforward process, which hardly requires description: simply set the focus mode to **MF** and use the focusing ring on the lens to bring the subject into focus.

> ### *Tip*
>
> *Many lenses have an A/M switch: setting this to **M** will automatically set the camera's mode to MF.*

CONTINUOUS-SERVO AF
AF-C is the recommended focusing mode for moving subjects.

ISO: 320 ***Focal Length:*** 300mm
Shutter Speed: 1/640 sec. ***Aperture:*** f/11

MANUAL FOCUS
Autofocus kept trying to focus on the figure, so I focused manually on the grasses.

ISO: 800 ***Focal Length:*** 70mm
Shutter Speed: 1/640 sec. ***Aperture:*** f/14

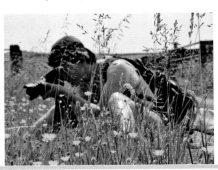

Focus confirmation

Providing an appropriate focus area has been selected, the D5100 offers focus confirmation when focusing manually, as if you were using autofocus. When the subject under the active focus point is in focus, a green dot appears at the far left of the viewfinder data display.

You can obtain further assistance with manual focus by switching the rangefinder **ON** in Custom setting a3. This enables the analog exposure display in the viewfinder to show whether the focus point is in front of, or behind the subject, and by how much. This is not available in Manual (**M**) exposure mode, as the exposure indicator is needed for its primary purpose.

Note:
The D5100's rangefinder effectively uses the autofocus system to support manual focusing. It is usually quicker to use autofocus, and the results should be exactly the same, but the rangefinder is helpful if you are using a manual focus lens.

AF-Area modes

The D5100 has eleven focus points covering much of the frame. When using autofocus, the AF-area mode determines which of these focus points will be used by the camera: Auto-area AF is the default setting in most shooting modes, but it can always be changed. However, the camera only "remembers" this selection in **P**, **A**, **S**, or **M** modes—if you change the default setting in any of the Full Auto or Scene Modes it will remain in effect only as long as you remain in that exposure mode. For example, if you switch from Portrait mode to Landscape mode, and then back again, the camera will revert to its default setting.

› Auto-area AF **AF-A**

In Auto-area AF mode, the camera selects the focus point automatically so, in effect, the camera is deciding what your intended subject is. When Type G or D lenses are used, Face Recognition allows the D5100 to distinguish a human subject from the background. Many photographers prefer to make their own selection, though—determining what the subject is seems a pretty basic decision!

› Single-area AF [⊏⊐]

In Single-area AF mode you select the focus point using the multi-selector. The chosen AF point is illuminated in the viewfinder. This mode is best suited to relatively static subjects and marries naturally with the AF-S autofocus mode.

› Dynamic-area AF [⊡]

Dynamic-area AF is available when you are using AF-C mode. The initial focus point is still selected by the user (as in Single-area AF), but if the subject moves, the camera will employ other focus points to maintain focus. This mode is best suited to moving subjects, especially those that remain generally in line with the initial focus point.

› 3D-tracking (11 points) [■]

3D-tracking mode is available when using AF-C. Again, the initial focus point is still selected by the user, but if the subject moves, 3D tracking uses a wide range of information, including subject colors, to maintain focus as long as you keep the shutter-release button half pressed. This mode is best for subjects that are moving across the field of view.

Focus point selection

1) Make sure that the camera is set to an AF-area mode other than Auto-area AF.

2) Press the shutter-release button half way to activate the autofocus system.

3) Using the multi-selector, select the desired focus point (pressing (OK) jumps directly to the central focus point). The chosen focus point is illuminated briefly in red in the viewfinder and then remains outlined in black.

4) Press the shutter-release button half way to focus at the desired point, and then depress it fully to take your shot.

FOCUS POINT SELECTION　⌄

I already had plenty of conventional walking images, so I made a point of focusing on the lichen to try and add some variety.

ISO: 320　*Focal Length:* 34mm
Shutter Speed: 1/250 sec.　*Aperture:* f/10

› Focus lock

Although the D5100's 11 focus points cover a wide area, they do not extend to the edges of the frame. Sometimes you may need to focus on a subject that does not naturally coincide with any of the focus points. To do this, the simplest procedure is as follows:

1) Adjust the framing so that the subject falls within the available focus area.

2) Select an appropriate focus point and focus on the subject in the normal way.

3) Lock focus. In Single-servo AF mode, this can be achieved by maintaining half pressure on the shutter-release button or by pressing the **AE-L/AF-L** button. An **AE-L** icon appears in the viewfinder. In

Continuous-servo AF, only **AE-L/AF-L** can be used to lock focus.

4) Reframe the image as desired and press the shutter-release button fully to take the picture. If half pressure is maintained on the shutter-release button (in Single-servo AF), or **AE-L/AF-L** is kept under pressure (in either AF mode), the focus will remain locked for further shots.

> **Note:**
> By default, **AE-L/AF-L** locks the exposure as well as focus, but this can be changed using Custom Setting f2.

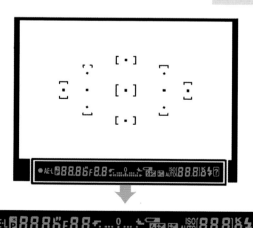

D5100 VIEWFINDER **«**
The viewfinder displays the focus points as well as an in-focus indicator at the left of the menu bar.

› The AF-assist illuminator

» IMAGE QUALITY

An AF-assist illuminator—a small lamp—is available to help the D5100 focus in dim light when certain exposure modes are in use. It requires the camera to be in Single-servo AF mode and the central focus point must be selected (or Auto-area AF must be engaged). Subject to these conditions, the AF-assist light will come on automatically when required.

This does not apply in Live View or Movie mode shooting, and the lamp is also disabled in a few Scene Modes, such as Pet Portrait 🐈. For effective operation, the lens should have a focal length in the range 18–200mm and the subject distance should be 1ft 8in–9ft 10in (0.5–3m). The AF-assist illuminator can be turned off using Custom Setting a2.

The D5100's image quality settings are not a shortcut to great pictures; that is still—thank goodness—the photographer's responsibility. Instead, "image quality" refers to the file format, which is the way in which the image data is recorded.

The D5100 offers a choice of two file types: NEF (Raw) and JPEG. The essential difference is that JPEGs are processed extensively by the camera to produce files that should be usable immediately (for direct printing from the memory card, for example), with little or no need for further processing on a computer.

JPEG quality refers to the amount of compression applied when the file is saved, with a greater level of compression producing smaller file sizes, but with a reduction in image quality. The D5100 offers three image quality options: **Fine**

AF-ASSIST ILLUMINATOR ⯆

Tip

*The default JPEG image quality setting is **Normal**. Unless you need to fit huge numbers of images onto a single memory card, or you are certain that none of your images will ever be made into large prints, it is a good idea to change this setting to **Fine** and leave it there.*

Setting image quality

produces the largest files, but best quality; **Basic** produces the smallest files and lowest quality; **Normal** is between the two.

Raw files record the raw data from the camera's sensor "as is," leaving you to undertake further processing on the computer to achieve the desired result. Because they preserve the "raw" data, the generic term for this kind of file is Raw— NEF is a specific file format used by Nikon for its Raw files.

The D5100 also allows two versions of the same image to be recorded at the same time—one Raw and one JPEG. The JPEG can be used as a quick reference for immediate needs, while the Raw version can be processed for the best quality.

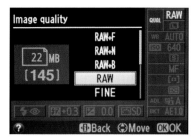

SETTING IMAGE QUALITY IN THE ACTIVE INFORMATION DISPLAY

1) In the Active Information Display, select **Image quality.**

2) Press (**OK**) to bring up the list of options. Using the multi-selector, highlight the required setting and press (**OK**) to make it effective.

Image quality options	
RAW	14-bit NEF (Raw) files recorded for the ultimate quality and creative flexibility.
FINE	8-bit JPEG files recorded with a compression ratio of approx. 1:4. Suitable for tabloid-/A3-sized prints, or larger.
NORM	8-bit JPEG files recorded with a compression ratio of approx. 1:8. Suitable for modest-sized prints.
BASIC	8-bit JPEG files recorded with a compression ratio of approx. 1:16. Suitable for transmission by email or web use, but not recommended for printing.
RAW + F RAW + N RAW + B	Two copies of the same image are recorded simultaneously, one NEF (Raw) and one JPEG (Fine, Normal, or Basic).

› Image size

For JPEG files, the D5100 offers three image size options, in addition to the image quality settings. **Large** is the maximum available size from the D5100's sensor, producing images measuring 4928 x 3264 pixels; **Medium** is 3696 x 2448 pixels (roughly equivalent to an 8-megapixel camera); and **Small** is 2464 x 1632 pixels (roughly equivalent to a 4-megapixel camera).

Even **Small** images exceed the maximum resolution of most computer monitors and high definition televisions, and can yield reasonable prints up to around 12 x 8 inches (at 200dpi). Raw files are always recorded at the maximum size.

Setting image size
1) In the Active Information Display, select **Image size**. If **Image quality** is set to Raw you will not be able to select this.

2) Press **OK** to bring up the list of options and, using the multi-selector, highlight the required setting. Press **OK** again to make it effective.

SHOOTING RAW ⌄
Shooting Raw (NEF) files gives the maximum control over the final image.

ISO: 160 *Focal Length:* 125mm
Shutter Speed: 3 seconds *Aperture:* f/11

Natural and artificial light sources vary enormously in color. The human eye and brain are very good (although not perfect) at compensating for this and seeing objects in their "true" colors, so we almost always see grass as green, the sky as blue, and so on.

The sensor in a digital camera has a fixed response to color, but thanks to its white balance system it also has the capacity to compensate for the varying colors of light. Used correctly, the D5100 can produce natural-looking colors under almost any conceivable conditions, with an automatic white balance system that produces very good results most of the time. For greater control, the D5100 also offers a range of user-controlled settings, but these are only accessible when using **P**, **A**, **S**, or **M** modes.

> ### Note:
> When shooting Raw images, the white balance can be adjusted during post-processing using suitable software.

WHITE BALANCE »
These images were taken with flash to show the effect of different white balance settings. The background is a photographic gray card that is designed to be perfectly neutral:
1) Flash; **2**) Incandescent; **3**) Cool-white fluorescent; **4**) Direct sunlight; **5**) Cloudy; **6**) Shade.

Warning!

If your images consistently appear to have a color shift when you view them on your computer screen, do not try and compensate by adjusting the camera's white balance: the problem is more likely to be the computer screen's color settings.

› Setting the white balance

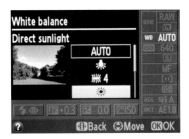

There are two ways to set the white balance:

Using the Active Information Display
1) In the Active Information Display, select WB and press (OK) to reveal a list of options.

2) Use the multi-selector to highlight the required setting, and press (OK) to accept it.

Using the Shooting Menu
This is a slower method, but makes extra options available.

1) Press **MENU**, select the **Shooting Menu**, and navigate to **White Balance**.

2) Press (OK) to reveal a list of options.

3) Use the multi-selector to highlight the required setting, and then press (OK).

4) In most cases, a graphical display appears. Using this, you can fine tune the setting using the multi-selector, or just press (OK) to accept the standard value. When you select **Fluorescent**, a sub-menu appears from which you can select an appropriate variety of fluorescent lamp.

> *Note:*
> *If you use the Active Information Display to select **Fluorescent**, the precise value will be whatever was last selected in the sub-menu under the Shooting Menu. (The default is **4: Cool-white fluorescent**.)*

ICON	MENU OPTION	COLOR TEMP.	DESCRIPTION
AUTO	**AUTO**	3500–8000K	Camera sets the white balance automatically.
☀	**Incandescent**	3000K	Use under incandescent (tungsten) lighting, such as household bulbs.
	Fluorescent *(submenu offers seven options)*:		
	1) Sodium-vapor lamps	2700K	Use under sodium-vapor lighting, often used in sports venues.
	2) Warm-white fluorescent	3000K	Use under warm-white fluorescent lighting.
	3) White fluorescent	3700K	Use under white fluorescent lighting.
☀	4) Cool-white fluorescent	4200K	Use under cool-white fluorescent lighting.
	5) Day-white fluorescent	5000K	Use under daylight white fluorescent lighting.
	6) Daylight fluorescent	6500K	Use under daylight fluorescent lighting.
	7) High temp. mercury-vapor	7200K	Use under high color temperature lighting, such as mercury-vapor lamps.
☀	**Direct sunlight**	5200K	Use for subjects in direct sunlight.
⚡	**Flash**	5400K	Use with built-in flash or separate flash unit.
☁	**Cloudy**	6000K	Use in daylight, under cloudy/overcast skies.
🏠	**Shade**	8000K	Use on sunny days for subjects in shade.
	Choose color temp.	2500K–10000K	Select color temperature manually.
PRE	**Preset manual**	n/a	Derive white balance direct from subject, light source, or existing photo.

› Preset manual white balance

By taking a reference shot of a neutral white object you can set the white balance to precisely match any lighting conditions. This is a complicated procedure that few people will ever employ (see the Nikon Reference manual for details—it takes two full pages). It is usually much easier to shoot Raw files and adjust the white balance later.

Note:
*Energy-saving bulbs, which are replacing traditional incandescent (tungsten) bulbs in domestic use, are compact fluorescent units. Their color temperature varies, but many are rated around 2700K, which is equivalent to **Fluorescent 1: Sodium-vapor lamps**. With any unfamiliar light source it is always a good idea to take test shots if possible, or allow for adjustment later by shooting Raw files.*

Tip

The endpapers of this book are designed to serve as "gray cards," which are ideal for white balance reference photos.

› Color space

Color spaces define the range (or gamut) of colors that can be recorded. In keeping with most digital SLRs, the Nikon D5100 offers a choice of **sRGB** and **Adobe RGB**.

sRGB (the default setting) has the narrower gamut of the two color spaces, but images often appear brighter and punchier. It is also the standard color space on the Internet and in photo printing stores, so is a safe choice for images that are likely to be used or printed straight off, with little or no post-processing.

Adobe RGB has a wider gamut and is commonly used in professional printing and reproduction. It is a better choice for images that are destined for professional applications or where significant post-processing is anticipated. However, images straight from the camera may look flat and dull on most computers and Web devices, or if they are printed without full color management. To select the color space, select **Color space** from the Setup Menu.

» ISO SENSITIVITY

The ISO setting governs the D5100's sensitivity to light: at higher ISO settings, less light is needed to capture an acceptable image. As well as allowing you to shoot in low light levels, higher ISO settings are also useful when you want to use a small aperture for increased depth of field or a fast shutter speed to freeze rapid movement. Conversely, lower ISO settings are useful in brighter conditions, and/or when you want to use wide apertures or slow shutter speeds.

The D5100 offers "native" ISO settings from ISO 100 to ISO 6400. In addition, there are expanded, **Hi** settings beyond the standard range, although noise is more obvious. These settings are **Hi0.3** (ISO 8000 equivalent), **Hi0.7** (ISO 10,400), **Hi1.0** (ISO 12,800), and **Hi2.0** (ISO 25,600).

› Auto ISO

By default, the D5100 sets the ISO automatically. It is possible to change to a manual setting in most exposure modes, with the exception of AUTO, ⚡, and 🌄.

This new setting will continue to apply if you switch exposure modes. However, if you switch to **P**, **A**, **S**, or **M**, and then back to a Scene Mode, the camera reverts to Auto-ISO. The D5100 only permanently "remembers" manual settings in **P**, **A**, **S**, or **M** modes.

Setting the ISO

SETTING THE ISO IN THE ACTIVE ⌃
INFORMATION DISPLAY

The usual way to set the ISO is through the Active Information Display:

1) Select ISO on the right side and press (OK) to reveal a list of options.

2) Use the multi-selector to highlight the required setting and press (OK) to accept it.

Tip

Variable ISO is one of the great advantages of digital capture over film, as anyone who's ever struggled with a 35mm camera and the wrong speed film will appreciate. Being able to vary the ISO at any time gives you terrific flexibility and many digital photographers change it almost as frequently as they do the aperture and the shutter speed.

Alternatively, you can select **ISO sensitivity settings** in the Shooting Menu, or assign **ISO sensitivity** to the **Fn** button using Custom Setting f1. If this is done, pressing **Fn** highlights **ISO** in the Information Display and rotating the Command Dial changes the setting. For those who change ISO settings regularly, this option is well worth considering.

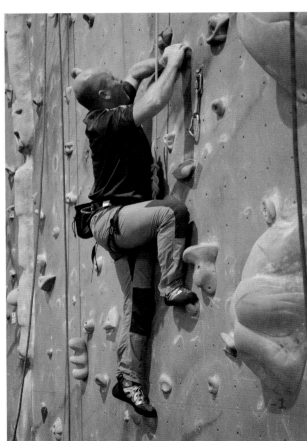

HIGH ISO »
Good image quality at higher ISO setting helps avoid the use of flash.

ISO: 3200
Focal Length: 42mm
Shutter Speed: 1/100 sec.
Aperture: f/4.8

2 » TWO-BUTTON RESET

The D5100 offers a quick way to reset a large number of camera settings to their default values, as listed below. To do this, hold down both **MENU** and **◄🗗►** together, for at least two seconds. The Information Display will blank out briefly while the reset is completed.

RESET SHOOTING OPTIONS

ITEM	DEFAULT SETTINGS	
Image quality	JPEG Normal	
Image size	Large	
Release mode	Single frame (Continuous in 🏃 and 🐱)	
ISO sensitivity	Auto and scene modes	Auto
	User-control modes	100
White balance	Auto (fine-tuning off)	
Nikon Picture Controls	Standard settings only	
Autofocus mode	AF-A	
Autofocus mode (Live View)	AUTO🖻, 🚫, 🎭, 🏔, 🌆, 💐, 🌼, 🎆, 🏖, 🕯, 🎉, ✿	Face-priority AF
	🏃, 🌆, 🐱,	Wide-area
	P, A, S, M	
	🌷, 🍴	Normal area

AF-Area mode	🌷, 👤, 🍴	Single Point
	🏃, 🐾	Dynamic Area
	AUTO 📷, 🚫, 🏔, ⛰, 🌅, 🎇, 🎆, 🌆, 🌃, 🌄, 🍃, ✿, ❀, P, A, S, M	Auto-Area
Focus point	Center	
Metering	Matrix	
AE/AF lock hold	Off	
Active D-Lighting	Auto	
Flexible program	Off	
Exposure compensation	Off	
Flash compensation	Off	
FV lock	Off	
HDR mode	Off	
Multiple exposure	Off	
Bracketing	Off	
Flash mode	AUTO 📷, 🌅, 🌷, 🌄, 🐾	Auto
	🌅★	Auto slow sync
	🎆	Auto with red-eye reduction
	🍴, P, A, S, M	Front-curtain sync

Live View mode enables users to frame pictures using the D5100's LCD screen rather than its viewfinder, just as many compact digital camera users do. However, on a digital SLR, Live View is an adjunct to the viewfinder, not a substitute for it: an SLR is essentially designed around the viewfinder and this is the superior option for the majority of situations.

Live View can prove invaluable under certain conditions though, notably where it's awkward to use the viewfinder—when working very close to the ground or above head height, for example. In these cases the D5100's foldout screen adds extra flexibility, while Live View can also score when ultra-precise focusing is required. In addition, Live View is a fundamental start point for shooting movies with the D5100 (see Chapter 6), so familiarity with it is an advantage if you intend to shoot movies.

LIVE VIEW ACTIVATION SWITCH ⌃

Using Live View

Live View is activated (and deactivated) with the **LV** switch on top of the camera. When you switch Live View on, the camera's mirror flips up, the viewfinder blacks out, and the rear monitor screen displays a continuous live preview of the scene. A range of shooting information is displayed at the top and bottom of the screen, partly overlaying the image. Pressing **info** changes this information display, cycling through a series of screens as outlined below. A further press returns you to the starting screen.

LIVE VIEW INFO	DETAILS
Show indicators (default)	Information bars superimposed at the top and bottom of the screen.
Hide indicators	Top information bar disappears, but key shooting information is still shown at the bottom.
Framing grid	Grid lines appear, which are useful for critical framing.

To take a shot in Live View mode, you press the shutter-release button fully, as you would when shooting normally. There is a sequence of sounds as the shutter closes to end the Live View preview, then opens and closes to take the picture, and finally opens again to resume Live View. As a result, the response is slower than normal shooting, which is one reason why Live View is often unsuitable for moving subjects. On the plus side, the mirror stays up, meaning there is less vibration, which helps to preserve critical sharpness for static subjects.

In continuous release mode, the mirror stays up, and the monitor remains blank between shots, making it hard to follow moving subjects.

> Focusing in Live View

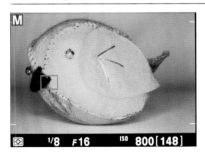

FOCUSING IN LIVE VIEW
The focus area (red rectangle) can be positioned almost anywhere on screen.

Because the mirror is locked up for Live View shooting, the usual focusing sensor is unavailable, so the D5100 takes its focus information from the main imaging sensor. This is slower than normal AF operation (further handicapping Live View for fast-moving subjects), but it is highly accurate. Live View has its own set of autofocus options, with two AF modes and four AF-area modes.

> Live View AF mode

The AF-mode options are Single-servo AF (**AF-S**) and Full-time servo AF (**AF-F**). AF-S is the same as AF-S in normal shooting: the camera focuses when the shutter-release button is pressed halfway, and focus remains locked for as long as the shutter-release button remains pressed.

AF-F corresponds to AF-C in normal shooting, and the camera continues to seek focus as long as Live View remains active. However, when the shutter-release button is pressed halfway, the focus will lock, and remains locked until the shutter-release button is released, or a shot is taken.

Selecting the Live View AF mode
1) Activate LIve View with the **LV** switch.

2) Press ◄**ℹ**► to engage the Active Information Display and select between **AF-S** and **AF-F** (about half-way down the right-hand side).

3) Press ◄**ℹ**► again to return to Live View.

2 › Live View AF-area mode

AF-area modes determine how the focus point is selected in either AF-S or AF-F. There are four Live View AF-area modes, and these are different to those used in normal shooting.

AF MODE	DESCRIPTION
😊 Face-priority AF	Uses face detection to identify people. A yellow border appears, outlining faces. If multiple subjects are detected the camera focuses on the closest. This is the default setting in most Scene Modes.
🔲WIDE Wide-area AF	The camera analyzes focus information from an area that is approximately ⅙ the width and height of the frame. This area is shown by a red rectangle. Wide-area is the default AF-area mode in 🌷 and ¶¶.
🔲NORM Normal-area AF	The camera analyzes focus information from a much smaller area, shown by red rectangle. This is useful for focusing precisely on small subjects and is the default mode in 🏃, 🏞, 🐾, ⛰, 🌄, and 🌃.
⊕ Subject-tracking AF	Camera follows the selected subject as it moves within the frame.

› Using Live View AF

Face-priority AF 😊

When this mode is active, the camera automatically detects up to five faces and selects the closest—the selected face is outlined in yellow. You can override this and focus on a different person by using the multi-selector to shift the focus point. To focus on the selected face, press the shutter-release button halfway.

Wide-area AF 🔲WIDE/Normal area AF 🔲NORM

In both of these AF modes the focus point (outlined in red) can be moved anywhere on the screen, using the multi-selector. Pressing 🔍 zooms the screen view—press repeatedly to zoom closer. Helpfully, the zoom centers on the focus point. This allows for ultra-precise focus control, which is best exploited when you are using a tripod and is excellent for macro

photography. Once the focus point is set, autofocus is activated by half pressing the shutter-release button. The red rectangle turns green when focus is achieved.

Subject-tracking AF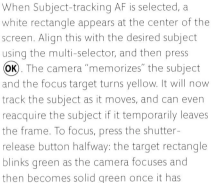

When Subject-tracking AF is selected, a white rectangle appears at the center of the screen. Align this with the desired subject using the multi-selector, and then press (OK). The camera "memorizes" the subject and the focus target turns yellow. It will now track the subject as it moves, and can even reacquire the subject if it temporarily leaves the frame. To focus, press the shutter-release button halfway: the target rectangle blinks green as the camera focuses and then becomes solid green once it has

NORMAL-AREA AF ⌄

Normal area AF is the best choice for precision and accuracy.

ISO: 320 *Focal Length:* 105mm
Shutter Speed: 1/640 sec. *Aperture:* f/8

locked on. If the camera fails to focus, the rectangle will blink red instead. Pictures can still be taken, but focus may not be correct. To end Subject-tracking press (OK) again.

Manual focus

Manual focus is engaged as in normal shooting, but the Live View display continues to reflect the selected Live View AF mode. It is helpful to have Wide-area AF or Normal-area AF selected, as the display will show a red rectangle of the appropriate size. You do not have to focus manually on this point, but if you zoom in for more precise focusing, the zoom centers on the area defined by the rectangle.

Because the display reflects the aperture that was set before entering Live View, it provides a rough depth of field preview. For precise manual focusing you should set the widest possible aperture to minimize the depth of field shown on screen and then, after focusing, reset the aperture if required. The Live View display won't immediately change to reflect this, but the new aperture will be used when the shot is taken and the Live View display will update when it resumes.

> ## Warning!
>
> *The D5100's Subject-tracking AF cannot keep up with rapidly-moving subjects: using the viewfinder is much more effective for these.*

The D5100's large, bright LCD screen makes image playback a pleasure, and it is also highly informative. At the camera's default settings, the most recent image is displayed automatically after it has been taken, as well as whenever is pressed. In continuous-release mode, playback only begins after the last image in a burst has been captured—images are then shown in sequence. This default behavior, as well as many other playback options, can be changed through the Playback Menu.

Viewing additional pictures

To view the images on your memory card, other than the one most recently taken, scroll through them using the multi-selector. Scroll right to view images in the order of capture, or scroll left to view them in reverse order ("go back in time").

Viewing photo information

The D5100 records masses of information (metadata) about each image you take, and this can also be viewed on playback, using the multi-selector to scroll through up to seven pages of information. However, by default, just two pages are available: a full-screen image view and an overview page that includes basic information and a simplified histogram.

To make other screens available select **Playback display options** in the Playback menu, check the required options, and then scroll up to **Done** and press (**OK**).

To make three detailed pages of Shooting Data available, check **Data**; to make the RGB histogram display available, check **RGB histogram**; and if you want to make the Highlights display available, check **Highlights**. An eighth page of GPS data is also available if a GPS device was connected to the camera during shooting.

THE HIGHLIGHTS DISPLAY ⁇

This image is taken from Adobe Lightroom, and shows the clipped highlights in red: on the D5100 they flash black.

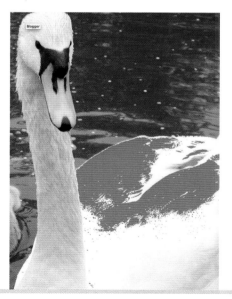

Highlights

On this optional screen, the D5100 displays a flashing warning for any areas of the image with "clipped" highlights, where no detail has been recorded. This is another indicator of whether an image is correctly exposed or not, and more objective than simply looking at the image on the monitor.

RGB HISTOGRAM DISPLAY ⚞

Histogram displays

The histogram is a graphic depiction of the distribution of tones in an image, from light to dark. As a way of assessing whether images are correctly exposed it is far more precise than just looking at the full-frame playback, especially when bright sunlight makes it hard to see the on-screen image. A single histogram is always available in the overview page during playback, but checking **RGB histogram** in the **Playback display options** adds a more detailed display with individual histograms for each color channel (red, green, and blue). The histogram display is the single most useful feature of image playback and it is normally the first thing I look at: learning to interpret the histogram is a massive help in getting the best results from your D5100.

CHECKING HIGHLIGHTS »
I wanted the image to sparkle, but did not want to clip the highlights, so I checked the highlight display after the first shot to be sure.

ISO: 100 *Focal Length:* 80mm
Shutter Speed: 1/320 sec.
Aperture: f/8

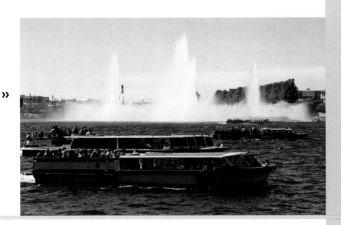

› Playback zoom

To assess sharpness, or for other critical viewing, it is possible to zoom in on a section of an image. For Large JPEG images and Raw files, the maximum magnification is approximately 31x.

1) Press ⊕ to zoom in on the image currently displayed (or the selected image in thumbnail view). Press ⊕ repeatedly to increase the magnification, and press ⊖▓ to zoom out again. A small navigation window appears briefly, with a yellow outline indicating the area currently visible in the monitor.

2) Use the multi-selector to view other areas of the image.

3) Rotate the Command Dial to view corresponding areas of other images at the same magnification.

4) To return to full-frame viewing, press (OK), or exit playback by pressing ▶ or the shutter-release button.

Viewing images as thumbnails

To view more than one image at a time, press ⊖▓ once to display 4 images, twice for 9 images, and a third time for 72 images. Use the multi-selector to scroll up and down to bring other images into view—the currently selected image is outlined in yellow. To return to full-frame view, press ⊕ as many times as is required.

VIEWING IMAGES AS THUMBNAILS ⌃

Tip

The camera can detect up to 10 faces in your photographs during playback zoom; any faces detected are outlined in white in the navigation window. Press ◀🗗▶ and use the multi-selector to scroll quickly between faces. If only one face is detected, this procedure centers the zoom area on that face.

Calendar View

CALENDAR VIEW ⌄

Calendar View can display images grouped by the date when they were taken. Having displayed 72 images in thumbnail view, press Q ▦ once more to reach the first calendar page.

Initially, the most recent date will be highlighted, and thumbnail pictures from that date are shown in a vertical strip to the right. The multi-selector can be used to navigate to different dates.

Tip

If you press (OK) *in either variant of Calendar View you get a full-frame view of the selected image. Pressing* (OK) *again takes you to the Retouch options screen, but there does not seem to be a quick way back to Calendar View.*

If you press Q ▦ again, you enter the thumbnail list and can then scroll through pictures taken on the selected date; press Q ▦ again to go back to the calendar page. Press ⊕ to see a larger preview of the currently selected image.

Deleting images

To delete the current image—or the selected image in thumbnail view—press 🗑. A confirmation dialog appears. To proceed with deletion press 🗑 again or press ▶ to cancel.

In Calendar View (date view) you can also delete all images taken on a selected date. Press 🗑 and, when the confirmation dialog appears, press 🗑 again to delete or ▶ to cancel.

Protecting images

To protect the current image, or the selected image in thumbnail view, against accidental deletion, press *AE-L/AF-L* . To remove protection, press *AE-L/AF-L* again.

Warning!

Protected images **will** *be deleted when the memory card is formatted.*

2 » IMAGE ENHANCEMENT

The D5100 allows you to adjust and enhance your images in a variety of ways in-camera. These adjustment options are divided into two types: settings that are applied before shooting an image and affect how the camera processes the image, and changes that can be made to images that are already on the memory card. The second type of change does not alter the original photo, it creates a retouched copy.

› Pre-shoot controls

Many user-controlled settings, such as exposure and white balance, affect the qualities of the final image. The D5100 has further options that can change the look of the picture, including Picture Controls and Active D-Lighting. However, these can only be accessed when shooting in **P**, **A**, **S**, or **M** mode—in the Full Auto and Scene Modes, Active D-Lighting is automatic and Picture Controls are preset.

> **Note:**
> *Because it affects the base exposure, Active D-Lighting has an impact on Raw files as well as JPEGs.*

Active D-Lighting

Active D-Lighting is designed to enhance the D5100's ability to capture detail in highlight and shadow areas in scenes with a wide range of brightness (high dynamic range). In simple terms, it reduces the overall exposure in order to record detail in the brightest areas, while the midtones and shadows are subsequently lightened when the camera processes the image.

SETTING ACTIVE D-LIGHTING IN THE ACTIVE INFORMATION DISPLAY ⌃

1) In the Active Information Display, select **ADL** and press ⓞⓚ. Alternatively, in the Shooting menu, select **Active D-Lighting**.

2) Select the strength of the effect (the default setting is **Auto**) and press ⓞⓚ.

ADL bracketing

If you are not sure whether to use Active D-Lighting or not, or simply want to see what effect it is having, you can set the camera to take two shots—one with Active D-Lighting off and one with it on.

1) Set Custom Setting e2 to **ADL bracketing**.

2) In the Active Information Display, highlight the **BKT** item and press (OK).

3) Select **ADL** and press (OK).

From now on, alternate shots will be taken with and without Active D-Lighting, until bracketing is cancelled. To cancel, repeat steps 2 and 3, selecting **Off** in Step 3.

Tip

There is potential confusion between the D5100's Active D-Lighting and D-Lighting options. Active D-Lighting is a pre-shoot option that affects the image at the time of capture, while D-Lighting is a post-shoot adjustment that is accessed from the Retouch Menu.

ACTIVE D-LIGHTING

The contrast was very high here, but Active D-Lighting helped to retain shadow and highlight detail.

ISO: 125 *Focal Length:* 18mm
Shutter Speed: 1/60 sec. *Aperture:* f/13

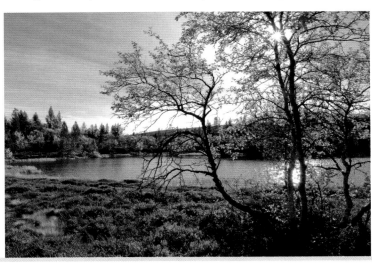

Picture Controls influence how JPEG images are processed by the camera, affecting qualities such as contrast, color balance, and color saturation. The D5100 offers six preset Picture Controls.

Neutral and **Vivid** are self-explanatory, and **Monochrome** even more so. **Standard** gives a compromise setting that works reasonably well in a wide range of situations. **Portrait** delivers slightly lower contrast and saturation, with a color balance that is kind to skin-tones, while **Landscape** produces higher contrast and saturation for vibrant images.

You can fine tune the settings for each of these Picture Controls, and you can also create and save custom Picture Controls, either in-camera or using the *Picture Control Utility* in *Nikon View NX2*.

PICTURE CONTROLS　　　　　　　☆

A Neutral Picture Control was applied to produce a natural-looking shot.

ISO: 320　*Focal Length:* 300mm
Shutter Speed: 1/800 sec.　*Aperture:* f/11

Selecting Nikon Picture Controls

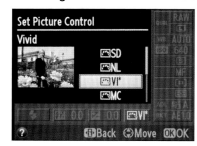

SETTING PICTURE CONTROLS IN THE　　☆
ACTIVE INFORMATION DISPLAY

1) In the Active Information Display, highlight 🖼️ **Set Picture Control** and press **OK**. Alternatively, choose **Set Picture Control** from the Shooting Menu.

2) Use the multi-selector to highlight the required Picture Control and press **OK**.

> ### Tip
>
> The **Sharpening, Saturation**, and **Hue** controls are always available, but **Contrast** and **Brightness** can only be changed if Active D-Lighting is set to **Off**.

Modifying Picture Controls

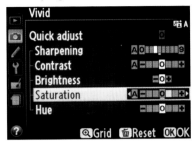

MODIFYING A PICTURE CONTROL

Nikon Picture Controls can be modified in-camera, using either **Quick Adjust** to make swift, across-the-board changes, or by adjusting the parameters individually.

1) From the Shooting Menu, select **Set Picture Control**.

2) Use the multi-selector to highlight the required Picture Control and press ▶.

3) Scroll up or down with the multi-selector to select **Quick Adjust** or one of the specific parameters. Use ▶ or ◀ to change the value as desired.

4) When all parameters are as required, press (OK). The modified values are retained until that Picture Control is modified again.

Creating custom Picture Controls

You can create up to nine additional Picture Controls, either in-camera or using *Picture Control Utility*. Custom Picture Controls can also be shared with other Nikon digital SLRs. For further details see the D5100 manual and the Help pages within *Picture Control Utility*.

In-camera custom Picture Controls

1) From the Shooting Menu, select **Manage Picture Control**.

2) Select **Save/edit** and press ▶.

3) Use the multi-selector to highlight an existing Picture Control and press ▶.

4) Edit the Picture Control (as described under Modifying Picture Controls). When all parameters are as required, press (OK).

5) On the next screen, select a destination for the new Picture Control. By default, its name derives from the existing Picture Control on which it is based, plus a 2-digit number (VIVID-02, for example). You can use the multi-selector to apply a new name up to 19 characters long.

6) Press (OK) to store your new Custom Picture Control.

› HDR (high dynamic range)

The D5100 is the first Nikon digital SLR that can create high dynamic range images in-camera. It does this by combining two separate shots with different exposures; one for the shadows and one for the highlights. HDR can be combined with Active D-Lighting for an even greater dynamic range, but this is only available when the Image Quality is set to JPEG (not Raw or Raw+JPEG).

1) From the Shooting Menu, choose **HDR (high dynamic range)**, select **On**, and press ▶. If you shoot HDR images regularly you can use Custom Setting f1 to assign **Fn** to this function.

2) Choose the exposure increment between the two exposures: **Auto** allows the camera to determine this automatically, or you can select **1EV**, **2EV**, or **3EV**.

3) Next, choose the smoothing level. This influences the blending between the two source

images. If extraneous bright or dark "halos" appear in the final image, try again with a higher smoothing level.

4) Shoot as normal. The camera will automatically make two exposures in quick succession. It then takes a short amount of time to combine them and display the results. During this interval **Job Hdr** appears in the viewfinder and you cannot take further shots.

5) HDR shooting is cancelled automatically once the two shots have been combined, so to shoot more HDR images, you need to repeat the process.

HDR **»**
An HDR image and two (simulated) source frames.

ISO: 400
Focal Length: 18mm
Shutter Speed: 1/15 sec.
Aperture: f/11

› Special effects

The D5100's Effects Modes are new features for Nikon. These modes can perhaps be considered as "extreme" Picture Controls as they process JPEG images to produce striking effects. The built-in flash does not operate (except in ![icon] Color Sketch); a separate flash can be used, but this will often undermine the effect. Some of these effects can also be applied to existing images through the Retouch Menu.

Effects Modes can be used in Live View or Movie Mode, hich will give a preview of the effect. This is helpful, but the screen refreshes more slowly and movies may play back jerkily.

To use Effects Modes:

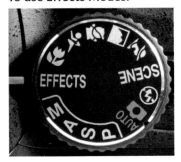

1) Set the Mode Dial to **EFFECTS**.

2) Rotate the Command Dial to select the required option on the screen (this is the same as selecting Scene Modes when the Mode Dial is set to **SCENE**).

Available Effects Modes

Night Vision Uses ISO settings from ISO 6400 upward (to a maximum of ISO 102,400) and produces monochrome images. Autofocus is nominally available in Live View only (but is not guaranteed) so manual focus may be required.

Color Sketch Turns a photograph into something resembling a colored pencil drawing.

Miniature Effect Mimics the in-vogue technique of shooting images with an extremely small and localized depth of field, making real landscapes or city views look like miniature models.

Selective Color Select particular color(s) to retain and other hues will be rendered in black and white.

Silhouette The camera's metering favors bright backgrounds such as vivid skies, while foreground subjects record as silhouettes. Most effective for subjects with interesting outlines.

High Key Produces images filled with light tones, usually with no blacks or dark tones at all, but should retain highlight detail better than simply overexposing the shot.

Low Key Low Key is the opposite to High Key, but usually has small areas of relatively bright tone; these highlights retain good detail and do not "burn out" to pure white.

2 » USING THE D5100'S MENUS

The options that you can access through the D5100's buttons, dials, and Active Information Display are just the tip of the iceberg. By delving into the menus, you have even more ways to customize the camera to your exact requirements.

The D5100 has six main menus: Playback, Shooting, Custom Setting, Setup, Retouch, and Recent Settings. The menu screen also shows a **?** icon, but there is not a separate Help menu; instead you access help from within the other menus by pressing **?** .

The Playback Menu, underlined in blue, covers functions relating to image (and movie) playback, including viewing, naming, or deleting images.

The Shooting Menu, underlined in green, covers shooting settings such as ISO speed and white balance, as well as Picture Controls and Active D-Lighting.

The Custom Setting Menu, underlined in red, is where you can fine tune and personalize many aspects of the camera's operation.

The Setup Menu, underlined in orange, is used for functions such as LCD brightness, plus others that you may touch only rarely.

The Retouch Menu, underlined in purple, is used to create modified copies of images on the memory card.

Recent Settings is underlined in gray and allows access to favorite or recently-used items from any of the other menus.

Navigating the menus

The general procedure for navigating and selecting items from the menus is the same throughout:

1) To display the menu screen, press **MENU**.

2) Scroll up or down with the multi-selector to highlight the different menus. To enter a menu, press ▶ or (OK).

3) Scroll up or down with the multi-selector to highlight the different menu items. To select a particular item, press ▶ or (OK). This will take you to a further set of options.

4) Scroll up or down with the multi-selector to choose the desired setting. To select, press ▶ or (OK). In some cases it is necessary to select **DONE** and then press (OK) to make the changes effective.

5) To return to the previous screen, press ◀. To exit the menu without affecting any changes, press **MENU**.

› The Playback Menu

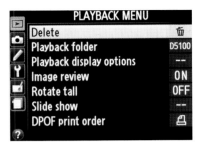

The D5100's Playback Menu contains seven different options that affect how images are viewed, stored, deleted, and printed.

Delete

Allows images stored on the memory card to be deleted, either singly or in batches. If you choose **Selected** from the menu options screen, images can be viewed full screen (press ⊕) and tagged for deletion (press ⊖❚❚); when a number of images has been tagged the images can be deleted together.

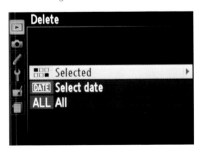

If you choose **Select date** you can review images and tag specific date(s) for deletion. Finally, you can select **Delete all**, to delete all images on a card, although it is generally quicker to format the card instead if this is your intention. A significant difference, however, is that **Delete all** does not delete protected or hidden images, but formatting the card does.

Note:
Individual images can be deleted using the playback screen, and this is usually more convenient than using the Playback Menu. In Calendar View you can delete all images from a particular date.

Playback folder

By default, the D5100's playback screen only displays images in the current folder (chosen through the Shooting Menu). If multiple folders exist on the memory card, images in other folders will not be visible. This menu allows you to change this behavior, so the camera will display images in all folders on the memory card.

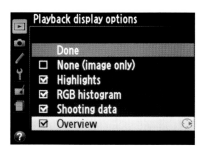

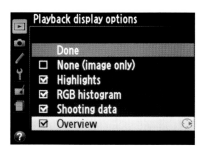

Playback display options

This important menu allows you to choose what information about each image is displayed on playback.

Image review

If Image review is **On** (which is the default setting), images are automatically displayed on the monitor after they have been shot. If this option is set to **Off**, then this is not the case and they can only be displayed by pressing the [▶] button.

Rotate tall

Determines whether portrait format images will be displayed "right way up" during playback. When **Off** (default), this does not happen and you must turn the camera through 90° to view them

correctly. If **On**, these images will be displayed "correctly" but will appear smaller. Turning Rotate tall **On** is useful when you wish to display your images on a television or monitor.

Slide show

Enables you to display images as a standard slide show. All of the images in the current folder will be played in chronological order and you can set the interval between pictures to 2, 3, 5, or 10 seconds. To skip forward or backward while a slide show is playing, press ▶ or ◀ respectively.

If you press ⓞⓚ during the slide show, the slide show is paused; press ⓞⓚ again to resume playback. To change the display mode while a slide show is playing (to see a histogram for each image, for example), press ▲ or ▼.

DPOF Print order

This allows you to select image(s) to be printed when the camera is connected to—or the memory card is inserted into—a printer that complies with the DPOF (Digital Print Order Format) standard. For more on printing see Chapter 8.

› The Shooting Menu

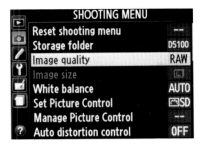

The Shooting Menu contains numerous options, but many of these are also accessible through the Active Information Display and have already been discussed, so will be covered only briefly here.

Reset shooting menu
Restores all Shooting Menu options to their default settings.

Storage folder
By default the D5100 stores images in a single folder (named 100D5100). If this becomes full (when it contains 999 images) the camera will create a new folder, adding 1 to the folder number (101D5100, for example). This menu allows you to manually create new folders if you want specific folders for different shoots or different types of image. Generally, organizing your images on the computer is what counts, but having separate folders on the memory card can help sometimes.

For most purposes, the camera treats all folders with the same name as a single folder, so 100D5100 and 101D5100 appear as a single D5100 folder. To give a folder a separate identity, edit the last five digits. When you have folders with different names on the memory card this menu option also allows you to designate which one you want to be the current folder.

Image quality and Image size
Use these to choose between **JPEG** and **Raw** files, and **Small**, **Medium**, and **Large** JPEG image sizes.

White balance
Use this to set and fine-tune the white balance. This option is only available in **P**, **A**, **S**, and **M** exposure modes.

Set Picture Control and Manage Picture Control
These menus govern the use of Nikon Picture Controls. **Set Picture Control** is only available in **P**, **A**, **S**, and **M** modes.

Auto distortion control
If this is **On**, the D5100 corrects for distortions that arise with certain lenses. It is only applicable with Type G and D lenses (excluding fisheye and perspective control lenses), and only affects JPEG images.

Color space

Allows you to choose between **sRGB** and **Adobe RGB** color spaces.

Active D-Lighting

Governs the use of Active D-Lighting. It is only available in **P**, **A**, **S**, and **M** modes.

HDR (high dynamic range)

Enable and control HDR shooting.

Long exposure NR

Photographs taken at long shutter speeds may exhibit increased "noise." The D5100 offers extra image processing (long exposure noise reduction) to counteract this. If **On**, it is applied automatically to exposures of 1 second or longer.

During processing, **Job nr** appears, blinking, in the viewfinder. The time this takes is roughly equal to the shutter speed in use, and no more pictures can be taken until processing is complete. As this delays further shooting, it is often preferable to tackle noise during post-processing. Long exposure NR is **Off** by default.

High ISO NR

Photos taken at high ISO settings may also display increased noise. High ISO noise reduction is applied during JPEG processing: The default setting is **Normal**, but this can be changed to **Low** or **High**. High ISO NR can also be switched **Off**.

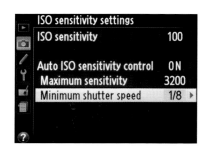

ISO sensitivity settings

Controls ISO sensitivity settings. Generally it is much quicker to change the ISO through the Active Information Display, and quicker still if you assign **Fn** to ISO control. However, this menu also contains options governing the operation of Auto ISO control.

Release mode

Controls the Release mode options, although it is usually faster to change the Release mode through the Active Information Display.

Multiple exposure

When it is so easy to combine images on a computer it might seem that the D5100 scarcely needs a multiple exposure facility. However, the Nikon manual states that its in-camera multiple exposures "produce colors noticeably superior to those in software-generated photographic overlays." This is highly debatable if you shoot individual Raw images to combine

on the computer, but this feature is an effective way to combine images for immediate use.

To create a multiple exposure
1) In the Shooting Menu, highlight **Interval timer shooting** and press ▶.

2) Choose a start time. If you select **Now**, shooting begins 3 seconds after you complete the other settings, and you can skip step 3. To choose a different start time, select **Start time** and press ▶.

3) Set the **Auto gain** (**On** or **Off**) and press ▶.

4) Select **Done** and press (OK).

5) Frame your image and shoot normally. In Continuous release mode, the pictures will be exposed in a single burst. In Single

> **Note:**
> *Auto gain (**On** by default) adjusts the exposure, so that if you are shooting a sequence of three shots, each is exposed at ⅓ the exposure value required for a normal exposure. You could turn Auto gain **Off** when a moving subject is well lit, but the background is dark, to keep the subject well exposed and avoid lightening the background.*

frame release mode, one image will be exposed each time the shutter-release button is pressed. The maximum interval between shots is usually 30 seconds, but this can be extended by setting a longer monitor-off delay in Custom Setting c4.

Movie settings
Used for key movie settings.

Interval timer shooting
The D5100 can take a number of shots at predetermined intervals.

1) In the Shooting Menu, highlight **Interval timer shooting** and press ▶.

2) Choose a start time. If you select **Now**, shooting begins 3 seconds after you complete the other settings, and you can skip step 3. To choose a different start time, select **Start time** and press ▶.

3) Use the multi-selector to set the desired time (check the camera's clock is set correctly!) and press ▶.

4) Use the multi-selector to choose the interval between shots. Press ▶.

5) Choose the number of intervals (up to 999) and the number of shots to be taken at each interval (up to nine). The total number of shots is also displayed. Press ▶ to complete setup.

6) Highlight **Start > On** and press (OK).

› The Custom Setting Menu

The Custom Setting Menu allows many aspects of the camera's operation to be fine-tuned to your individual preferences. There are six subdivisions, identified by key letters and a color:

a: Autofocus (Red)
b: Metering/Exposure (Yellow)
c: Timers/AE lock (Green)
d: Shooting/Display (Light blue)
e: Bracketing/Flash (Dark blue)
f: Controls (Lilac)

There is also an option to **Reset custom settings**, which restores the custom settings to their default values.

To choose a custom setting

1) Press **MENU** and scroll up or down to the Custom Setting Menu. Press ▶.

2) Use ▲ ▼ to scroll to the desired settings group and press ▶.

3) Use ▲ ▼ to highlight the desired setting and press ▶ to display the available options.

4) Highlight the option you want to change and press ⊙**K**.

5) Where there are multiple options that you would like to adjust, repeat step 4 for each. When you are finished, select **DONE** and press ⊙**K**.

Notes:
Although the custom settings are organized into six main groups, they appear as a continuous list, so you can scroll from a3 to b1, and so on. If you scroll in the opposite direction you will go from a1 to f5.

The custom setting identifier code (a3, for example) is shown in the appropriate color for that group. If the setting has been changed from its default value, an asterisk appears over the initial letter.

› a: Autofocus

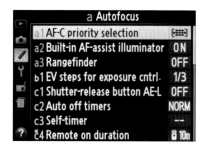

a1 AF-C priority selection

In Continuous-servo AF mode (AF-C), the camera is usually able to take a picture even if focus has not been acquired—this is known as **Release priority**. This menu

allows you to choose **Focus priority** instead, meaning that pictures can only be taken once focus is acquired.

a2 Built-in AF-assist illuminator

Governs whether or not the AF-assist illuminator operates when lighting is poor.

a3 Rangefinder

Allows the exposure indicator to be used to assist with manual focusing.

› b: Exposure

b1 EV steps for exposure control

Set the increments the camera uses for setting the shutter speed and aperture, and also for bracketing. The options are ½EV or ⅓EV.

› c: Timers/AE Lock

c1 Shutter-release button AE-L

Governs whether exposure is locked by half pressure on the shutter-release button. By default the shutter-release button locks focus only, while exposure can only be locked using the *AE-L/AF-L* button. Change this to **On** to allow the shutter-release button to lock both focus and exposure.

c2 Auto off timers

Sets the interval before the monitor, playback display, and viewfinder displays switch off when idle—a shorter delay improves battery life. There are **Short**, **Normal**, and **Long** presets, setting standard times for each of the displays, while **Custom** allows you to set the timings for each display individually. Note that the meters will not turn off automatically when the D5100 is connected to a power outlet.

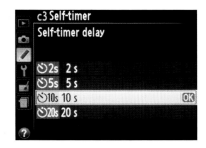

c3 Self-timer

Determines the delay in standard self-timer operation (2, 5, 10, or 20 seconds). **Number of shots** allows multiple shots to be taken after the set delay, at 3-second intervals.

c4 Remote on duration

When using the optional ML-L3 remote control, this function sets how long the camera will wait for a signal from the remote control before reverting to normal shooting mode. The choices are 1, 5, 10, or 15 minutes.

› d: Shooting/Display

d1 Beep

Governs the volume of (or turns off) the beep that normally sounds when the self-timer operates, and when focus has been acquired in AF-S mode.

d2 ISO display

By default, the figure at the bottom right of the LCD screen and viewfinder displays shows the number of exposures remaining, but this custom setting can be used to show the selected ISO instead.

d3 File number sequence

Controls how file numbers are set. If **Off**, file numbering is reset to 0001 whenever a memory card is inserted/formatted, or a new folder is created. If **On**, numbering continues from the previous highest number used. **Reset** creates a new folder and begins numbering from 0001.

d4 Exposure delay mode

Use this to create a shutter delay of 1 second when the shutter-release button is pressed. The mirror also flips up, making this a possible alternative to using the self-timer or a cable release to reduce vibration when shooting on a tripod. **Off** by default.

d5 Print date

Governs whether the date, or the date and time are imprinted on photos (JPEG only)

as they are taken. The **Date counter** can be set to imprint the number of days to or from a selected date.

› e: Bracketing/Flash

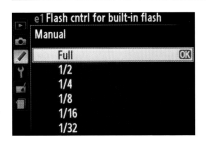

e1 Flash cntrl for built-in flash

Determines control of the built-in flash: **TTL** means that the flash output is regulated automatically, while **Manual** means that you set it manually, using a sub-menu. The power output options are Full, ½, ¼, ⅛, ⅟₁₆, and ¹/₃₂.

e2 Auto bracketing set

Allows you to decide which settings are bracketed when auto bracketing is activated: **Exposure** (default), **White Balance**, or **Active D-Lighting**. White balance bracketing creates three JPEG images with different color temperatures, while Active D-Lighting bracketing takes two photographs; one with Active D-Lighting switched off, and a second with it turned on.

› f: Controls

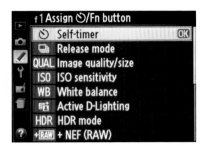

f1 Assign **Fn** button

Various functions can be assigned to the **Fn** button, and in most cases you then use the Command Dial to choose between options (to set the ISO, for example). Judicious selection of the assigned function can save much time in the Active Information Display and/or Shooting Menu. Some of these functions (such as White balance) are only available in **P**, **A**, **S**, or **M** modes. Functions that can be assigned to the **Fn** button are:

Self-timer
Release mode
Image quality/size
ISO sensitivity
White balance
Active D-Lighting
HDR mode
+NEF (Raw)
Auto bracketing

f2 Assign *AE-L/AF-L* button

By default, pressing the *AE-L/AF-L* button locks both exposure and focus. Use this menu to set it to lock exposure only, or focus only. In addition, you can select **AE lock (hold)**, so the exposure remains locked after the button is released and you need to press the button again to unlock it. The final option is **AF-ON**: when this is selected, only the *AE-L/AF-L* button can be used to initiate autofocus, not the shutter-release button.

f3 Reverse dial rotation

Use this to reverse the normal rotation of the Command Dial.

f4 Slot empty release lock

The shutter cannot usually be released when there is no memory card present, but this option can change that. This is useful when the camera is on display (at a retailer or a trade show), but there is no obvious application for everyday use.

f5 Reverse indicators

Governs how the exposure displays in the viewfinder and Information Display are shown: you can have overexposure to the left or right, for example.

2

› The Setup Menu

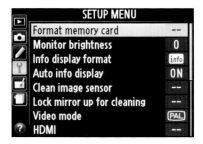

The Setup Menu controls many important camera functions, although in many cases you will access them rarely, if at all.

Format memory card
The one item in this menu that you will probably employ most regularly.

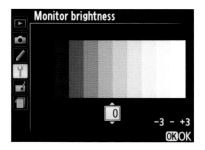

Monitor brightness
Allows you to change the brightness of the LCD display. Should be used with care as making images appear brighter on screen does not change the brightness of the images themselves.

Info display format
Choose between **Graphic** (default) and **Classic** modes for the Information Display. You can also select different background colors for each display mode.

Auto info display
Choose whether the Information Display appears automatically when the shutter-release button is half pressed. It can also be displayed immediately after a shot is taken, as long as Image Review is set to **Off.**

Clean image sensor
The D5100 has an automated dust-removal procedure, which works by vibrating the low-pass filter in front of the sensor. You can disable it, if desired, or actuate the dust-removal procedure at any time through this menu.

Lock mirror up for cleaning
Allows access to the low-pass filter for manual sensor cleaning.

Video mode

You can connect the camera to a television to view images; this menu sets the camera to **PAL** or **NTSC** standards to match the device you're connecting to. NTSC is used in North America and Japan, while PAL is used throughout most of the rest of the world.

HDMI

When connecting to an HDMI (High Definition Multimedia Interface) TV, use this option to set the camera's output to match that of the HDMI device.

Flicker reduction

Some light sources, such as fluorescent lamps, can produce a visible flicker in the Live View screen image and during movie recording. To minimize this, use this menu to match the frequency of the local power supply: 60Hz is common in North America, while 50Hz is normal in Europe.

Time zone and date

Set the date, time, and time zone, and specify the date display format (Y/M/D, M/D/Y, or D/M/Y). It is a good idea to set your home time zone first, and then set the time correctly. Then, if you travel to a different time zone, you can simply change the time zone and the time will be updated automatically.

Language

Set the language that the D5100 uses in its menus and other displays.

Image comment

You can append brief comments to images that will appear in the photo info display and can be viewed in *Nikon View NX2* and *Nikon Capture NX2*. To attach a comment, select **Image comment** and press ▶. Use the multi-selector to input text and when you are finished press ⊕. Select **Attach comment**, then **Done**, and press **(OK)**. The comment will be attached to all subsequent shots until it is turned off.

Auto image rotation

If set to **On** (default), information about the orientation of the camera is recorded with every photo taken. This makes sure that your pictures appear the right way up on playback, both in-camera and when they are viewed on your computer.

Image Dust Off ref photo

Nikon Capture NX2 features automatic dust removal, which uses a reference photo that maps the dust on the sensor. If you know there are stubborn dust spots that don't succumb to normal sensor cleaning, this can save a lot of retouching work. You do need the optional *Capture NX2* software.

To take a dust-off reference photo

1) Fit a CPU lens with a focal length of at least 50mm.

2) Locate a featureless white object, such as a sheet of plain paper, that is large enough to fill the frame.

3) In the Setup Menu, select **Dust off ref photo** and press ▶.

4) Select **Start** or **Clean sensor** and then **Start** and press (**OK**). (Select **Start** if you have already taken the picture(s) from which you want to remove spots.)

5) When the camera is ready, **rEF** appears in the viewfinder.

6) Frame the white object at a distance of about 4 inches (10cm) and press the shutter-release button half way. The focus is automatically set at infinity, which creates a soft white background against which any dust spots will stand out clearly.

7) Press the shutter-release button fully to capture the reference image.

GPS

Used to set up a connection between the D5100 and a compatible GPS device.

Eye-Fi upload

Set up a Wi-Fi network connection using an Eye-Fi card.

Firmware version

Firmware is in-camera software that controls the D5100's operation. This menu option shows the firmware version that is currently installed, so you can verify whether it is the latest version; Nikon issues updates periodically. When new firmware is released, download it from the Nikon website and use this menu to update the camera.

› The Retouch Menu

The Retouch Menu allows you to make various corrections and enhancements to images that you have already taken, including cropping, color balance, and more. Retouching does not overwrite the original image, but creates a copy to which the changes are applied. Further retouching can be applied to the copy. Copies are always created in JPEG format, but the size and quality depends on the format of the original (with a few obvious exceptions, such as Trim and Resize, which produce copies smaller than the original).

FORMAT OF ORIGINAL PHOTO	QUALITY AND SIZE OF COPY
NEF (Raw)	JPEG: Fine, Large
JPEG	Quality and size match original

From the image playback screen

1) Display the image you wish to retouch.

2) Press (OK) and the Retouch Menu appears, overlaying the image.

3) Select a retouch option and press ▶. If more options appear, make a selection and press ▶ again. A preview of the retouched image appears.

4) Depending on the type of retouching to be done, there may be further options.

5) Press (OK) to create a retouched copy. The memory card access lamp will blink briefly as the copy is created.

From the Retouch Menu

1) In the Retouch Menu, select a retouch option and press ▶. If subsidiary options appear, make a further selection and press ▶ again. A screen of image thumbnails appears.

2) Select the required image using the multi-selector, as you would during normal image playback. Press (OK) and a preview of the retouched image appears.

3) There may be further options, depending on the retouching option.

4) Press (OK) to create a retouched copy.

> **Note:**
> A ⬚ icon in normal image playback indicates a retouched copy image.

D-Lighting

Despite similar names, and broadly similar effects, D-Lighting is not the same as Active D-Lighting: Active D-Lighting is selected before shooting and affects exposure and processing of the original image, while D-Lighting is applied after shooting and creates a retouched copy. Both aim to improve results with high contrast subjects, mainly by lightening darker areas of the image. However, as it takes effect at the time of exposure, Active D-Lighting is the more effective system when it comes to recovering overly bright highlights.

Red-eye correction

Red-eye often appears when using on-camera flash and this is one solution. This option can only be selected for photos taken with flash and the camera analyzes the photo for evidence of red-eye. If none is found then the process will go no further, but if red-eye is detected a preview image appears and you can use the multi-selector and ⊕ to view it more closely. If you've used the zoom, press (OK) to resume full-screen view; press (OK) again to create a retouched copy.

Trim

Use this option to crop image(s), to better fit a print size, for example. When **Trim** is selected, a preview screen appears with the crop area shown by a yellow rectangle. Change the aspect ratio of the crop by rotating the command dial: choose from **3:2** (the same as the original image), **4:3**, **5:4**, **1:1** (square), and **16:9**. Adjust the size of the crop area using ⊖▨ and ⊕ —the dimensions of the cropped image (in pixels) are shown at top left. Adjust the position of the crop area using the multi-selector and press (OK) to save a copy.

Monochrome

This creates a monochrome copy of the original. You can choose from straight **Black and white**, **Sepia**, and **Cyanotype**. If you select **Sepia** or **Cyanotype**, you can make the toning effect stronger or weaker by using ▲ and ▼.

Filter effects

Mimics several common photographic filters: **Skylight** reduces the blue cast that can affect photos taken on clear days with lots of blue sky; **Warm filter** has a warming effect, akin to an 81B or 81C filter; **Red intensifier**, **Green intensifier**, and **Blue**

intensifier are all fairly self-explanatory.
Cross screen is slightly more complex and
creates a "starburst" effect around light
sources and other very bright points (such
as sparkling highlights on water). There are
multiple options within this item, which set
the overall strength of the effect, and the
number, length, and angle of the star-
points. Press **Confirm** to see a preview of
the effect, press ⊕ to see it full-screen,
and press **Save** to complete.

Color balance

Creates a copy with a modified color
balance. When this option is selected,
a preview screen appears and the multi-
selector can be used to shift the colors on
the blue–amber and green–magenta axes.
The effect is shown in a preview image and
RGB histograms, and you can zoom in to
see specific areas more clearly.

CYANOTYPE IMAGE ⌄

Image overlay

Image overlay allows you to combine two existing photos into a new image. This can only be applied to originals in Raw format and Nikon claims (arguably) that the results are better than combining images in applications such as Photoshop because Image overlay makes direct use of the raw data from the camera's sensor.

This is the only Retouch Menu item that allows you to create a new Raw image, and you can also create JPEG images at any size and quality: the output will match the current image quality and size options.

To create an overlaid image

1) Select **Image overlay** and press (OK). A dialog screen appears with sections labeled **Image 1**, **Image 2**, and **Preview**. Initially, **Image 1** is highlighted. Press (OK).

2) The camera displays thumbnails of available Raw images. Select the first image you want to use and press (OK).

3) Select **Gain**: this determines how much "weight" this image has in the final overlay. Use ▲ and ▼ to adjust the gain (the default value is 1.0).

4) Press ▶ to move to **Image 2** and repeat steps 2 and 3.

5) If necessary, press ◀ to return to **Image 1**. You can readjust the gain or press (OK) to change the selected image.

6) Use ▶ to highlight **Preview**. Select **Overlay** and press (OK) to preview the result. If necessary, return to the previous stage by pressing ◉▧ . When satisfied, press (OK) again to save the new, combined image. You can also skip the preview stage by highlighting **Save** and pressing (OK).

NEF (Raw) processing

This option creates JPEG copies from Raw originals. While it is not a substitute for full Raw processing on a computer, it can be useful if you want to create quick copies for immediate use. The processing options give considerable control over the resulting JPEG image, with the screen showing a preview image, with processing options in a column at the right. The options are **Image quality**, **Image size**, **White balance**, **Exposure comp.**, **Set Picture Control**, **High ISO NR.**, and **D-Lighting**. When you are satisfied with the preview image, select **EXE** and press (OK) to create the JPEG copy.

> **Note:**
> *Image Overlay is not available from Image Playback, only through the Retouch Menu. For Side-by-side Comparison the reverse is true.*

Resize

This option creates a small copy of the selected picture(s), suitable for immediate use with various external devices. Five possible sizes are available:

OPTION	SIZE (PIXELS)	POSSIBLE USES
2.5M	1920 x 1280	Display on HD TV and larger computer monitor
1.1M	1280 x 856	Display on typical computer monitor or iPad
0.6M	960 x 640	Display on standard (non-HD) television
0.3M	640 x 424	Display on mobile devices such as iPhone
0.1M	320 x 216	Display on standard cell phone

Quick retouch

Provides basic one-step retouching for a quick fix, boosting saturation and contrast. D-Lighting is applied automatically to retain shadow detail. Use ▲ and ▼ to increase or reduce the strength of the effect, and then press (OK) to create the retouched copy.

Straighten

It is best to get the horizon level at the time of shooting, but this does not always happen. This option allows correction by up to 5° in 0.25° increments: use ▶ to rotate clockwise, ◀ to rotate counter-clockwise, (OK) to create the retouched copy, or ▶ to exit. Inevitably, this also crops the image slightly.

Distortion control

Some lenses create noticeable curvature of straight lines, but Distortion control can be used to create corrected copies. **Auto** allows automatic compensation for the documented characteristics of Type G and D Nikkor lenses, while **Manual** can be applied to any lens: use ▶ to reduce barrel distortion and ◀ to reduce pin-cushion distortion. The multi-selector can also be used for fine tuning after **Auto** control is applied.

> ### Tip
>
> *You can pre-apply distortion control to all JPEG images shot with Type G and D Nikkor lenses using Auto distortion control.*

Fisheye

Instead of correcting distortion, this menu exaggerates it to give a fisheye lens effect. Use ◀ and ▶ to control the intensity.

Color outline

This detects edges in the photograph and uses them to create a "line-drawing" effect.

Color sketch

Turns a photograph into an image that resembles a colored pencil drawing. This is also available as an Effects Mode at the time of shooting.

Perspective control

Corrects the convergence of vertical lines in photographs taken looking up at tall buildings, for example. Grid lines help you assess the effect and you can adjust

its strength with the multi-selector. The effect inevitably crops the original shot, so it is vital to leave space around the subject.

Miniature effect

This option mimics images taken with an extremely localized depth of field, making real scenes appear like models. A yellow rectangle shows the area that will retain sharp focus and you can reposition this using the multi-selector. Press ⊕ to preview the results and (OK) to save a retouched copy. This option is also available as a Special Effect when shooting.

Selective color

Select up to three particular colors—other hues are rendered in monochrome. Also available as an Effects Mode.

« COLOR SKETCH

To apply Selective color:

1) Choose **Selective color** in the Retouch Menu and press ▶.

2) Select an image from the thumbnail screen and press (OK).

3) Use the multi-selector to place the cursor over an area of the desired color and press **AE-L/AF-L** to choose that color.

4) Turn the Command Dial and use ▲ and ▼ to fine-tune the color range so it is more or less selective.

5) To select another color, turn the Command Dial to highlight another "swatch" and repeat steps 3 and 4.

6) To save the image, press (OK).

Edit movie

This item has an inflated title, as it merely allows you to trim the start and/or end of movie clips. It is far short of proper editing, but it still has its uses.

To trim a movie clip:

1) Select a movie clip and begin playback. Pause (press ▼) on a frame you want to use as the new start- or end-point.

2) Press **AE-L/AF-L** to reveal the D5100's Edit movie screen.

3) Select **Choose start point** or **Choose end point** and press ▲.

4) Select **Yes** and press (OK) to save the trimmed clip as a copy.

5) Repeat if necessary to trim the other end of the clip.

Side-by-side comparison

This is only available when a retouched copy—or its source image—is selected, and can only be accessed by pressing (OK) in full-frame playback. Once activated, it will display the retouched copy alongside the original image. You can select either image and press ⊕ to view it full frame. Press ▶ to return to normal playback, or (OK) to return to the main playback screen.

FISHEYE **«**
The Fisheye effect is very obvious with subjects full of straight lines.

The Recent Settings Menu automatically stores up to 20 of your most recent settings, made using any of the other menus. In doing so it provides a quick way to access controls you have used recently.

Alternatively, you can activate My Menu, which is a useful way to speed up access to your "favorite" menu items. Items from any other menu can be added to My Menu to create a handy, customized shortlist, containing up to 20 items.

To activate My Menu
1) In Recent Settings, select **Choose tab** and press ▶.

2) Select **My Menu** and press (OK).

To add items to My Menu
1) In My Menu, highlight **Add items** and press ▶.

2) A list of the other menus now appears. Select the appropriate menu and press ▶.

3) Select the desired menu item, press (OK).

4) The My Menu screen reappears with the newly added item at the top. Use ▼ to move it lower down the list if desired. Press (OK) to confirm the new ordering of the list.

To remove items from My Menu
1) In My Menu, highlight **Remove items** and press ▶.

2) Highlight any listed item and press ▶ to select it for deletion. A check mark appears beside the item.

3) If more than one item is to be deleted, use ▲ or ▼ to select additional items in the same way.

4) Highlight **Done** and press (OK). A confirmation dialog appears. To confirm the deletion(s) press (OK) again. To exit without deleting anything, press **MENU**.

To rearrange items in My Menu
1) In My Menu, highlight **Rank items** and press ▶.

2) Highlight any item and press (OK).

3) Use ▲ or ▼ to move the item up or down: a yellow line shows where its new position will be. Press (OK) to confirm the new position.

4) Repeat steps 2 and 3 to move further items. When finished, press **MENU** to exit.

SOFT LIGHT

Don't discount "dull" days, as soft light works well for many subjects: in this shot, hard shadows would only add clutter and confusion. I like the way that the initial impression of neglect is subverted by an obviously new padlock.

Settings

› *ISO:* 640
› *Focal Length:* 29mm
› *Shutter Speed:* 1/200 sec.
› *Aperture:* f/11

Chapter 3
IN THE FIELD

3 IN THE FIELD

Digital SLR cameras such as the D5100 are so capable that getting the focusing and exposure right is now rarely a major worry. However, there is a big difference between pictures that "come out" and those that turn out exactly the way that you want them to.

Possessing a fantastic camera does not guarantee stunning shots every time, and photography still—thank goodness—offers plenty of scope for individual expression, vision, and skill.

Knowing what you want to achieve with any photograph is the secret of success, no matter what camera you use. The clearer your vision about what you want the photo to say and how you want it to look, the better. If you know why you are taking the shot and what you want it to show (and just as important, what you want to leave out), then the how part will flow much more naturally.

Of course, vision is a personal thing, and the how part is the main concern of this book: understanding how light works, how lenses behave, and how digital images are created all makes it easier to take charge and realize your own vision.

The D5100 does not force you to dive in at the deep end and master all aspects simultaneously. Experimenting with the Scene Modes will show you how the camera can handle shooting opportunities in very different ways, while switching to Program will allow you to make choices

over important settings such as white balance, Picture Controls, and Active D-Lighting while the camera remains in charge of the aperture and shutter speed. Alternatively, advancing to Aperture Priority or Shutter Priority will give you control over these vital parameters, while Manual mode will put you in complete control.

TAKING CONTROL ⌄
Aperture Priority and Shutter Priority modes give tremendous control over the final image.

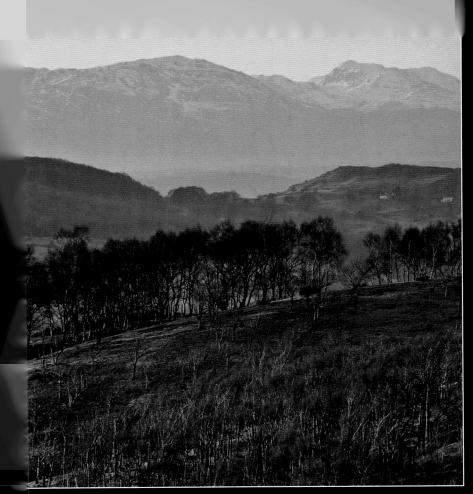

RIGHT PLACE, RIGHT TIME

Camera skills are important, but there is still no substitute for being in the right place at the right time.

ISO: 500 *Focal Length:* 300mm
Shutter Speed: 1/160 sec. (tripod)
Aperture: f/13

3 » FOCUS AND DEPTH OF FIELD

No matter how advanced it is, no camera always sees what the eye sees, and nothing illustrates this better than depth of field. In simple terms, depth of field is the term used to describe what is in focus and what is not, but a more precise definition is that *depth of field is the zone that extends in front of, and behind, the point of focus, in which objects appear to be sharp in the final image.*

The eye scans the world dynamically, so whatever we are looking at—near or far—is normally seen in focus (assuming you have good eyesight or appropriate glasses/contact lenses). This gives us a sense that everything is in focus, which photographs often fail to match.

In landscape photography we might often strive to emulate this "all-in-focus" view of the world by maximizing the depth of field. However, you can always choose to take a different approach: creative intent or simple necessity may lead us to take photos with much narrower depth of field.

Tip

Aperture numbers are fractions, so f/16 is a small aperture, while f/4 is large. This is illustrated clearly by the D5100's Information Display in Graphic mode.

Three main factors determine depth of field: the focal length of the lens, the aperture setting, and the camera-to-subject distance. Focal length and subject distance are often determined by other factors, so this means that aperture is the main depth of field control. The simple rule is: a small aperture equals a big depth of field, and vice versa. Only two of the D5100's exposure modes give you direct control over the aperture: Aperture Priority and Manual.

Long lenses (telephotos) produce less depth of field than wide-angles, and this naturally relates to the camera-to-subject distance, albeit in a slightly complex way. Suppose you are photographing a single subject, such as a tree, for example. To maximize the depth of field you might fit a wide-angle lens, but to fill the frame with the subject you will need to move closer, reducing the depth of field. Conversely, you might move further away to help increase the depth of field, but then you will find that you need to use a longer focal length lens to fill the frame, which will reduce the depth of field.

If you are photographing a broader landscape, you may already have decided on the viewpoint and angle you want (or be restricted to a particular shooting position), in which case changing the focal length may not be an option.

f/5.6

f/11

f/22

DEPTH OF FIELD »

The same setup, focused on the nearest flowers and taken with aperture settings of f/5.6, f/11, and f/22. The effect the aperture has on depth of field is clear, but which shot you prefer is, of course, subjective.

Depth of field preview

When you look through the D5100's viewfinder, the lens is set at its widest aperture: the lens only stops down at the moment the picture is taken if a smaller aperture is selected. As a result, the image in the viewfinder may show a far shallower depth of field than the final shot.

There is no depth of field preview when you are using the viewfinder on the D5100, but there is one—of sorts—when you use Live View. When you switch to Live View, the camera stops down to the current aperture that is set, so you can see the depth of field on the rear screen. It does not readjust this if you change the aperture (it will only reset the aperture if you exit and resume Live View or take a picture), but it is a useful benefit of using Live View, especially for static shots and/or when the depth of field is important.

Hyperfocal distance

When you really need an image to be sharp from front to back, where should you focus? Focusing on the most distant object wastes all the potential depth of field beyond it, while focusing on the closest object wastes potential depth of field in front of it. Clearly you should focus in between, but where, exactly?

If you need depth of field to extend right out to "infinity" (in practical terms, anything at a great distance), the answer is to focus at the hyperfocal distance. This is not fixed, but varies with focal length and aperture, so in an attempt to simplify things you will often see advice to "focus one third of the way into the picture." However, there is a problem: it is impossible to say where one third of the way from "here" to infinity is. Alternative advice, which seems at least equally helpful, is to "focus at the far end of the foreground," or, simpler still: the hyperfocal point is closer than you think.

While depth of field is very important, and the hyperfocal distance is a useful concept, it is easy to become obsessive

Tip

If you want to precisely determine the hyperfocal distance, focus on infinity (in practice, the most distant object in the scene), playback the image, and locate the nearest object that appears sharp: this is at the hyperfocal distance. Refocus on this object/at this distance for maximum depth of field.

about it, and always use the smallest aperture. This may be overkill unless you plan to make big prints, as there is much greater tolerance in images that will be used at smaller sizes. It is also important to remember that not every photograph has to have the maximum depth of field—sometimes a shallow depth of field is exactly what you want.

HYPERFOCAL DISTANCE ⪼

I wanted everything sharp in this scene, from the nearest stones to the distant skyline. The focus point was somewhere between the rocks and the nearest cow.

ISO: 200 *Focal Length*: 21mm
Shutter Speed: 1/160 sec. *Aperture:* f/11

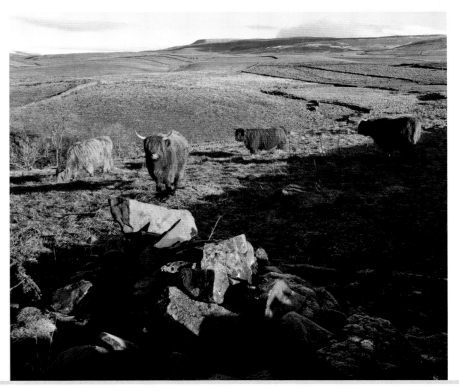

› Photographing motion

While we see movement, a camera (usually) produces still images, but there are many effective ways of portraying movement that can reveal drama and grace that the naked eye (and movie recording) miss.

Freezing the action

Dynamic posture and straining muscles shout "movement," and the pin-sharp definition delivered by a fast shutter speed can enhance this impression. But what does "fast" mean? Should you set the D5100's maximum 1/4000 sec. shutter speed every time?

The second answer is definitely "no," but the first is harder to determine: the exact shutter speed needed to capture a sharp, frozen image depends on various factors, including the speed of the subject, its size, and its distance. For example, it can be easier to get a sharp image of a train traveling at 200mph than of a cyclist doing 20mph, because of the range involved. The direction of movement is another factor,

with subjects traveling across the frame requiring a faster shutter speed than those moving toward or away from the camera if you want a sharp result.

There is no "right" shutter speed, although you can play safe by setting the fastest shutter speed possible under the prevailing light conditions. This is essentially what the D5100's Sports mode does, but for more precise control, Shutter Priority is the obvious choice. You should also review your images on the rear LCD screen whenever possible, and if a faster shutter speed appears necessary, be prepared to increase the ISO setting.

SHUTTER SPEED TO FREEZE MOVEMENT »
This mallard was feeding avidly, so a fast shutter speed was needed to guarantee a sharp image. As I was handholding a 300mm lens the fast shutter speed also helped avoid camera shake.

ISO: 320 ***Focal Length:*** 300mm
Shutter Speed: 1/1800 sec. ***Aperture:*** f/8

Panning

With subjects moving across the field of view, panning is a great way of conveying a sense of movement. By following the subject with the camera, it is recorded relatively sharply while the background becomes a streaky blur. The exact effect varies, so it is worth experimenting, especially before a critical shoot.

Panning usually requires relatively slow shutter speeds. Anything from 1/8 sec.–1/125 sec. can work, although you may find that you need to go outside this range. The general rule is that faster shutter speeds reduce background blur, but give a sharper main subject. This means that Sports mode is not appropriate, and Shutter Priority or Manual is the only option.

Panning is usually easiest with a standard lens or short telephoto lens, but the choice of focal length is often dictated by the working distance (if you are behind barriers at a sports event, for example). Try to maintain a smooth panning action during the exposure—turning from your waist if you are handholding the camera—and follow the subject before pressing the shutter-release button and after the shutter has closed.

PANNING ⌄

A classic panning shot, although a relatively fast shutter speed was used for this subject.

ISO: 400 *Focal Length:* 105mm
Shutter Speed: 1/200 sec. *Aperture:* f/11

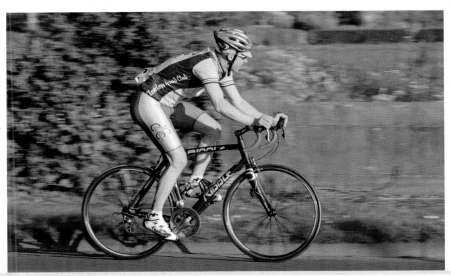

Blur

Movement is naturally conveyed by blur, and in photography this may be a necessity (because you just cannot set a fast enough shutter speed) or it may be a creative choice (as in the silky effect achieved by shooting water with exposures lasting several seconds). To make sure that only the moving elements in a scene are blurred, secure the camera on a tripod or other solid support. You can also try for a more impressionistic effect by handholding the camera. Again, Sports mode is not suitable and Shutter Priority is the obvious choice.

Tip

When you want to embrace creative blur, turn Vibration Reduction OFF on VR lenses.

Camera shake

Sometimes you will move the camera intentionally—panning is the most common example— but unintentional movement is another story. Camera shake can produce anything from a marginal loss of sharpness to a hopeless mess, but careful handling and the use of a camera support can help to alleviate it. If you are handholding the camera, the rule of thumb is to use a shutter speed that is at least the reciprocal of the focal length (1/200 sec. with a 200mm focal length, for example), although Nikon makes several Vibration Reduction (VR) lenses that will allow you to shoot at slower shutter speeds.

BLUR ⌄
A slow shutter speed gives an impressionistic image that conveys movement.

ISO: 200 **Focal Length:** 50mm
Shutter Speed: 1/10 sec. **Aperture:** f/32

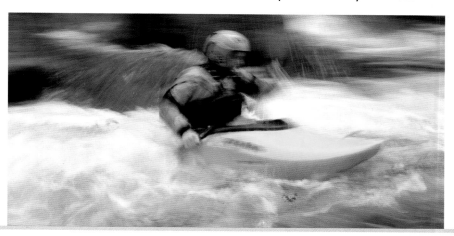

» COMPOSITION

Composition is an innocuous word for something that causes endless frustration and confusion. In its widest sense, it is why some images can be perfectly exposed and focused, but have no emotional or esthetic impact, while others can be technically flawed and yet heart-stopping. Every time you take a picture you make numerous decisions (consciously or unconsciously), such as where to shoot from, where to aim the camera, how wide a view you want, what to include, and what to leave out. These are the essence of composition.

Personally, I distrust the C-word, and prefer "framing," as that relates far better to what photographers actually do. Discarding "composition" also helps us to jettison associated baggage, such as the "Rule of Thirds." Ansel Adams said many wise things about photography, but perhaps none of them was wiser than this: "There are no rules for good photographs, there are only good photographs."

THE WHOLE PICTURE ⌄
Framing is about seeing a picture as a complete entity. There is no single "subject" in this image; every one of these trees plays an important part.

ISO: 320 *Focal Length:* 26mm
Shutter Speed: 1/100 sec. *Aperture:* f/11

Basic principles

Rules are made to be broken, so it is principles that really help. Two basic principles underpin effective framing: know where the edges are, and see what the camera sees. The edges define the photograph, and the picture is everything within them. Our eyes and brains can "zoom in" selectively on the interesting bits of a scene, but the camera will happily and indiscriminately record all of the bits that you didn't even notice. All too often this produces pictures that seem cluttered or confusing, which is why it is important to see what the camera sees, and not just what you want to see.

Looking through a traditional viewfinder is rather like looking through a window, but in Live View mode you are very obviously looking at a screen. One immediate difference is that the screen image is obviously two-dimensional—just like a picture. Intuition suggests that using the LCD screen to frame a shot, rather than the viewfinder, might make it easier to see the whole image, which means the bits you are interested in and the bits that you are not.

However, using the screen continuously is not recommended, as it makes handling awkward, drains the camera batteries, and is not always clear in bright sunlight. The viewfinder is therefore superior for most shooting, but the "Live View/Picture" approach is a worthwhile exercise. When you revert to the viewfinder, make a conscious effort to see it as a picture: look at the whole image, take note of the edges and what's included, and consciously seek out distracting and irrelevant elements.

Note:
The D5100's viewfinder shows only 95% of the width and height of the full image, or a little over 90% of the area. This can mean that distractions that are unseen in the finder can creep in at the edges of the frame. This is not just a trait of the D5100, though—with the exception of a few top professional cameras that give 100% viewfinder coverage, most digital SLRs do not provide full-frame coverage through the viewfinder. Live View does, however, give 100% image coverage.

BREAKING THE RULES »
With prominent lines virtually bisecting the frame, this image seems to break conventional rules of composition, but does it matter?

ISO: 100
Focal Length: 14mm
Shutter Speed: 2.5 seconds
Aperture: f/14

Landscape photography poses special challenges for framing, because there is rarely a single subject. This makes "rules" even less useful. As the landscape is boundless, the first challenge is simply choosing which segment of it you want to photograph. You need to be selective, and look for the essence of a place. Ask yourself what makes it appeal to you, and focus in on that aspect of the landscape: remember the saying: "can't see the wood for the trees."

"Views" are fine, but the landscape is an all-round sensory experience. As a result, many photographs of views end up looking small, flat, or otherwise disappointing. Very often there's a simple reason: a lack of foreground. Foregrounds do many things:

they show texture and detail, evoke sounds and smells, and give the viewer a sense of the rest of the sensory experience. They can also bring life and crispness where a distant scene is hazy or flatly lit, but above all, the foreground connects you to the place, distinguishing your photograph from the detached views that anyone might get from a bus or train.

The foreground can also be used to help convey depth and distance, and strengthen a sense of scale. If you want a photograph of a mountain that reveals its awesome size, zooming in on it may not be the best way. For many people, a shot of a peak in isolation is hard to "read," but if you include relatively familiar objects, such as walls, trees, or houses, it provides a sense of scale and helps make sense of the unfamiliar. Human figures, especially, are ideal, and even tiny figures can be effective, provided that they are still recognizably human. To strengthen foregrounds, get close and look for an "exciting" camera angle—sit, kneel, crawl, or climb if you need to!

VARIATIONS «

Smaller details say much about the landscape. A glimpse of distant ridge under the arch of the bridge helps to link it to its setting.

ISO: 200 ***Focal Length:*** 18mm
Shutter Speed: 1/60 sec. ***Aperture:*** f/11

Wide-angle lenses excel at including both the foreground and a distant vista, but it is important to remember the D5100's 1.5x magnification factor: a focal length of 18mm, gives the same coverage as a 27mm lens would on a "full-frame" digital SLR like the D3. Therefore, photographers looking to exploit foregrounds, or big vistas, may well find that they need something wider, such as the Nikkor 12–24mm f/4G.

FRAMING THE LANDSCAPE ⌄
A wide-angle lens and a very low shooting position allowed me to "lift" the tree above the horizon.

ISO: 200 *Focal Length:* 14mm
Shutter Speed: 1/100 sec. *Aperture:* f/11

However, not every landscape is on a grand scale, and small details can be just as effective at conveying the essence of a place. If the light isn't magical, and distant prospects look flat or hazy, then details and textures, or the miniature landscapes of a rock-pool or forest clearing can save the day. Variations in scale and focus will also help to liven up a sequence of pictures: a set of individually excellent big landscape images will eventually become oppressive if they are seen as an unrelieved sequence.

3 » LIGHTING

What makes a good photograph? For that matter, what makes any photograph? The answer is light. You can take photographs without a lens, and even without a camera, but you cannot take a picture without light. Because it is universal, it is easy to take it for granted and think "the camera will take care of it," and there is a grain of truth to this: the D5100 is very good at dealing with varying amounts of light. However, there is much more to light than whether it is bright or dim, and it is worth tuning in to its endless varieties, as it will generally lead to better pictures and make your photography even more rewarding.

Light sources

Natural light essentially means sunlight (direct or indirect)—even moonlight is reflected sunlight. The sun itself varies little, but before it reaches the camera its light can be modified in many ways by the earth's atmosphere and reflection. As a direct light source, the sun is very small, giving strongly directional light and hard-edged shadows, yet on an overcast day the same light can be spread across the entire sky, providing soft, even illumination. Studio photographers use huge "softboxes" to replicate this effect, but you can create it on a smaller scale with bounced flash.

Beyond the sun and flash are many other artificial light sources, such as incandescent and fluorescent lights. As the color of these can vary enormously, the D5100's white balance controls are important, but the light's other qualities—direction and contrast, for example—can usually be understood in the same way as sunlight and flash.

Contrast and dynamic range

Contrast, dynamic range, and tonal range are all terms that refer to the brightness between the lightest and darkest areas of a scene or subject. Our eyes are very adaptable, and can generally see detail in both bright areas and deep shade, but even the best camera cannot match this. In high-contrast conditions it is common for either the brightest highlights, such as white clouds or snow, to end up pure white, or for the deepest shadows to be recorded as pure black. "Clipping," as it is called, may even affect both ends of the tonal scale simultaneously.

In overcast, or "soft" lighting conditions, contrast is much lower, and although this is rarely ideal for wide landscapes, it can be excellent for detail shots and portrait photography. For some subjects soft light is desirable: photographers who shoot wild flowers, for example, will often carry diffusers to create low-contrast lighting.

The D5100 offers several options for tackling high contrast, notably Active

D-Lighting and D-Lighting. Shooting Raw files also gives you a chance of recovering highlight and/or shadow detail in post-processing, but all of these options have their limits. Sometimes it is impossible to capture the entire brightness range of a scene in a single exposure, and the histogram and highlights display will help

HIGH CONTRAST ⏷

From white clouds and reflective highlights to strong shadows, this image has very high contrast, but the camera managed to capture detail across the range.

ISO: 160 *Focal Length:* 13mm
Shutter Speed: 1/100 sec. *Aperture:* f/14

Tip

For subjects that are close to the camera, such as portraits, you can compensate for high contrast by throwing some light back into the shadows, either by using the D5100's built-in flash (or an accessory flash unit) or a reflector. Dedicated photographic reflectors are available, but you can often improvise with available objects, such as a map or a white wall.

3

you to identify such cases. When these situations occur, one option is to reframe your shot to exclude large areas of extreme brightness/darkness, although it is worth noting that small patches of pure black or white often go unnoticed. Large, featureless areas will be all too conspicuous though.

When the contrast is beyond the range of the camera's sensor, digital imaging offers another solution. This involves making multiple exposures that can then be combined, typically taking one shot that is optimized for the bright areas, another for the midtones, and a third for the shadows. A solid tripod is essential to keep source images aligned, and this approach can become unusable when there is movement in the scene.

The D5100's HDR (High dynamic range) feature applies a similar approach in-camera, but is limited to two source images. For greater flexibility you can shoot several JPEG or Raw images and combine them during post-processing. Dedicated HDR software is available that can partially automate the process, or you can combine the images manually, using Layer Masks in Adobe Photoshop, for example.

MERGING IMAGES ❯❯

This is not one photo, it is two. One exposure was made for the relatively dim interior and another for the much brighter scene outside the window.

ISO: 200 *Focal Length:* 18mm
Shutter Speed: 1 second (interior) and 1/50 sec. (exterior) *Aperture:* f/11

› Direction of light

With direct sunlight or a single flash, the direction of the light source is obvious, but the same subject, seen from different angles, can appear totally different. At the other extreme, under an overcast sky, light comes from a wide area and its quality varies much less with the viewing angle. Completely even lighting is quite rare and there is usually at least a vague sense of direction to it. However, the effects of the direction of light are much easier to appreciate with a single, distinct source such as direct sunlight. At its simplest, we can distinguish between frontal lighting, oblique lighting, and backlighting.

Frontal lighting hits the subject head-on, flooding everything with light—this is what you get with on-camera flash, or when the sun is behind you. The resultant lack of shadows can make everything look flat and uniform, but it can work well for subjects that derive their impact from pure color, shape, or pattern. True frontal lighting does not lead to extremes of contrast, so setting the exposure is usually straightforward.

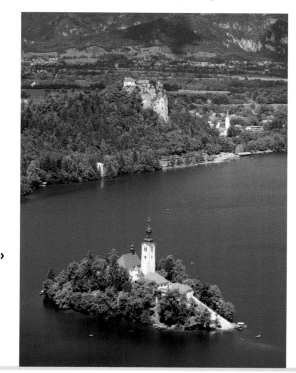

FRONTAL LIGHTING »
Frontal lighting can work well for landscapes and other subjects with strong shapes and colors.

ISO: 200
Focal Length: 66mm
Shutter Speed: 1/250 sec.
Aperture: f/8

Oblique lighting (or "side-lighting") is more complex and is usually far more interesting than frontal lighting. Shadows emphasize form and texture, outlining hills and valleys in landscape shots, for example. At really acute angles, the light accentuates fine details, from crystals in rock to individual blades of grass. This is one reason why dedicated landscape photographers love the start and end of the day, but in hillier terrain, even a high sun may still cast useful shadows. In some places, such as deep gorges, direct light only penetrates when the sun is high, so what is really key is the angle at which light strikes the subject. Oblique lighting is terrific for landscapes, and many other subjects, but it is often accompanied by high contrast, which can make it more difficult to get the exposure right.

OBLIQUE LIGHTING »
Oblique lighting emphasizes the detail and texture of this ancient gravestone.

ISO: 200
Focal Length: 92mm
Shutter Speed: 1/400 sec.
Aperture: f/5.6

Backlighting can give striking and beautiful results in almost any area of photography, but it needs careful handling. By definition, backlit subjects are in shadow and can easily appear as silhouettes. Sometimes this is exactly what you want— bare trees can look fantastic against a colorful sky, for example—in which case meter for the bright areas to maximize color saturation, perhaps using exposure lock or Silhouette mode.

If you do not want a total silhouette then a reflector or fill-in flash can help, and backlighting combined with a reflector is a simple way to get great portraits. Do not overdo the fill, however, or you risk negating the backlit effect. Translucent materials such as foliage and fabric can glow beautifully when backlit, without turning into silhouettes.

BACKLIGHTING ⌄
The combination of hoar frost and backlighting gives a special luminosity to a simple subject.

ISO: 200 *Focal Length:* 150mm
Shutter Speed: 1/100 sec.
Aperture: f/10

A prism in a sunbeam reveals all of the colors of the spectrum, and proves that "white" light is a misnomer at any time. Generally, our eyes adjust automatically to different lighting conditions, so that we see green leaves as green, oranges as orange, and so on. Only at their most extreme—as in the intense red of the setting sun—do the changing hues become really obvious.

Natural light changes color as the light from the sun is filtered by the earth's atmosphere: when the sun is high in a clear sky the light is affected least, but when the sun is low, its path through the atmosphere is much longer. The light is shifted toward yellow and ultimately red, while the "lost," or scattered light turns the sky blue.

The warm color of a low sun is another reason why landscape photographers traditionally favor mornings and evenings. It is not just that we tend to find warm colors more pleasing (if that was all, the

EVENING LIGHT
The warm light of the evening sun contrasts with cool shadows illuminated by the blue sky.

ISO: 200
Focal Length: 75mm
Shutter Speed: 1/125 sec.
Aperture: f/11

effect could be easily replicated with a Photoshop adjustment), but also that sunlit surfaces pick up a warm hue, while shadows receive light from the sky, tinting them blue. This color difference intensifies as the direct sunlight becomes redder, adding vibrancy to morning and evening shots and a unique coloration that filters cannot replicate. This is most obvious in snow scenes, but it is always true to some degree.

When shifting colors are part of the attraction, you don't want to "correct"

them back to neutral. However, if the white balance is set to **Auto** (as it is in 🅰 Auto and the majority of Scene Modes), the D5100 will attempt to do exactly this. Instead, try shooting in one of the user-control modes with the white balance set to **Sunny**. Alternatively, shoot Raw files, as this gives you the option to adjust the color balance later.

The same applies to artificial light; sometimes you will want to correct a color cast, but at other times it is better left alone. Portraits shot under fluorescent lamps often acquire a ghastly greenish hue, which you will surely want to avoid, but when shooting floodlit buildings, these variations in color may be part of the appeal. Results with the white balance set to **Auto** (as in Night Landscape mode) are somewhat unpredictable and may not match what you see or what you want, so experiment with the preset values as well.

Tip

The D5100's Sunset mode is aimed at shooting the evening sky itself, rather than scenes illuminated by a red sun. It can't hurt to try it, but be prepared to try Landscape or Aperture Priority modes as well.

» OPTICAL ISSUES

Today's cameras and lenses are so clever that it is easy to forget that they still handle light and images in a different way to the human eye, and sometimes produce unexpected and/or unwanted results. Some of these issues are related to the way that lenses work—and are common to all cameras—while others are uniquely digital.

Flare

Lens flare results from stray light bouncing around within the lens, and is most prevalent when you are shooting toward the sun, regardless of whether the sun is actually in frame or just out of shot. Flare can produce a string of colored blobs, apparently radiating from the sun, or a more general veiling effect.

Advanced lens coatings, such as those in Nikkor lenses, greatly reduce the chance of flare, so keeping your lenses and filters scrupulously clean is vital. Even so, if the sun is actually in the frame, some flare may be inescapable. It may diminish when the lens is stopped down, but you may find that you need to look for ways to reframe the shot or mask the sun—behind a tree, for example.

If the sun is not in frame, you can try to shield the lens. A good lens hood is essential, but further shading may be required, especially with zoom lenses. You can provide this with a piece of card, a map, or even your hand, but this is easiest to achieve with the camera on a tripod. Be sure to check the viewfinder and/or playback carefully to see if the flare has gone away and, because the viewfinder does not show 100% of the image, make sure that the shade has not crept into shot.

FLARE ⌄
Flare is all too evident in the first shot, but with just a slight change of position it has been eliminated.

ISO: 2000 *Focal Length:* 18mm
Shutter Speed: 1/100 sec. *Aperture:* f/11

Distortion

Distortion means that lines that are straight in the subject appear curved in the image. As lens design continually improves, this is far less of an issue than it once was and the worst offenders are likely to be zoom lenses that are old, cheap, or both. Distortion is often most noticeable at the extremes of the zoom range.

When straight lines bow outward it is called barrel distortion, and when they bend inward it is pincushion distortion. This may go unnoticed when you are photographing natural subjects with no straight lines, but it will be obvious when a level horizon appears in a landscape or seascape, especially close to the top or bottom of the frame. Both distortions can be avoided by activating **Auto Distortion Control** in the Shooting Menu, or you can correct your images after they have been shot by choosing **Distortion Control** from the Retouch Menu. Alternatively, you can correct distortion using image-editing software, but it is worth noting that all of these methods crop the image, so it is better to avoid the issue in the first place by using good lenses.

DISTORTION ⟩⟩
Distortion can be a problem in landscape shooting: you'd never spot it in the foreground of this image, but it is obvious on the horizon.

ISO: 200 *Focal Length:* 29mm
Shutter Speed: 1/60 sec. *Aperture:* f/10

Chromatic aberration

Chromatic aberration occurs when light of different colors is focused in slightly different planes, creating colored fringing when images are examined closely. The D5100 has built-in correction for chromatic aberration during processing, but this applies only to JPEG images. Aberration can also be corrected in post-processing; with RAW images this is the only option..

Ideally, you should use lenses that minimize aberration in the first place, especially because it can be exaggerated by the way in which light strikes a digital sensor. Accordingly, lenses that are designed specifically for digital cameras are often the best option.

Vignetting

Vignetting is a darkening, or fall-off in illumination toward the corners of the frame, which is most conspicuous in even-toned areas such as clear skies. Most lenses display a certain amount of vignetting at maximum aperture, but it should quickly disappear when the aperture is stopped down. As with other optical issues, vignetting can be tackled during post-processing, but it is better to minimize it to start with, so wherever possible you should avoid using unsuitable lens hoods or filter holders, and "stacking" multiple filters on the lens (which is rarely a good idea).

Noise

Image noise is created by random variations in the amount of light recorded by each pixel, and appears as speckles of varying brightness or color in an image. It is most conspicuous in areas that should have an even tone, and is most severe in darker areas. Squeezing more pixels onto a sensor means there is an increased tendency for it to exhibit noise, but improvements in other areas of sensor technology and processing software largely compensate for this.

As a result, despite having more than 16 million photosites on its 23.6 x 15.6mm sensor, the D5100's noise Reduction (NR) capabilities are excellent. NR is often applied to JPEG images as part of in-camera processing, but can also be applied during post-processing, which is normal for Raw files. To minimize noise to start with, shoot at the lowest possible ISO rating and expose carefully: underexposure increases the risk of noise.

Clipping

Clipping occurs when highlight and/or shadow areas are recorded without detail. It is usually indicated by a "spike" at either extreme of the histogram display, and you can also set the D5100 to show highlight clipping during playback by flashing affected parts of the image. Although the D5100 is a good camera, no digital SLR is

totally immune to clipping, so it is worth checking the histogram and highlights display. There is some scope to recover clipped areas if you shoot Raw files, while Active D-Lighting can help with JPEGs.

NOISE ⌄

Shot at the maximum ISO setting with all noise reduction turned off, noise is clearly evident (left). Compare this to the result when the D5100's noise reduction is activated (right).

ISO: 25,600 *Focal Length:* 14mm
Shutter Speed: 1/100 sec. *Aperture:* f/11

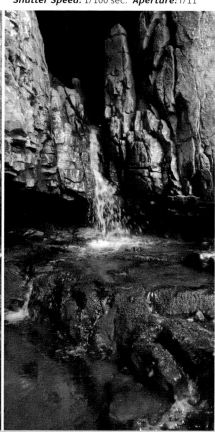

Artifacts and aliasing

When viewing a digital image, we don't usually notice that it is composed of individual pixels, but small clumps of pixels can sometimes become apparent as "artifacts" of various kinds. They are usually more evident in low-resolution images, or at high screen magnification.

Aliasing is most evident on diagonal or curved lines, giving them a jagged or stepped appearance.

Moiré can occur when there is interference between areas of fine pattern in the subject and the grid pattern of the sensor itself. This often takes the form of aurora-like swirls or fringes of color.

To compensate for these artifacts, digital cameras employ a low-pass filter directly in front of the sensor. This works by blurring the image slightly, which is a very effective way to remove artifacts. However, it means that digital images need to be re-sharpened either in-camera or in post-processing.

JPEG artifacts look much like aliasing, but are created when JPEG images are compressed heavily, either in-camera or on the computer. You can avoid them by using the D5100's **Fine** setting for JPEG images that are likely to be printed or viewed at a large size. Repeatedly opening and re-saving JPEG images multiplies the effect of JPEG artifacts, so if repeated edits are anticipated it is advisable to convert the image into a TIFF file at the earliest opportunity, and work with that.

Sharpening images

Because of the low-pass filter, all digital photographs require some sharpening, but too much can produce artifacts of its own, most notably halos along defined edges.

JPEG images are sharpened during in-camera processing, with the sharpening settings accessed through the Picture Controls. The sharpening is therefore pre-determined when using the Full Auto and Scene Modes, while shooting in **P**, **A**, **S**, or **M** modes allows you to change the amount of sharpening.

You should be wary about increasing the level of in-camera sharpening unless your images are destined solely for screen use: it is easy to add sharpening in post-processing when you can judge the effect at 100% magnification on the computer screen, but it is virtually impossible to eliminate artifacts created by over-sharpening at the time of capture. With Raw images, sharpening always takes place on the computer.

Settings

> *ISO:* 125
> *Focal Length:* 23mm
> *Shutter Speed:* 1/125 sec.
> *Aperture:* f/9

The vivid contrast of bright red bilberry and glowing green moss is typical of Finnish forests in fall. I wanted to show the ground-level ecosystem in a wider context, so used a wide-angle focal length and a very low viewpoint. To concentrate attention on the foreground I used a moderate aperture and focused close to the camera, allowing the background to go soft. Near Saariselkä, Finland.

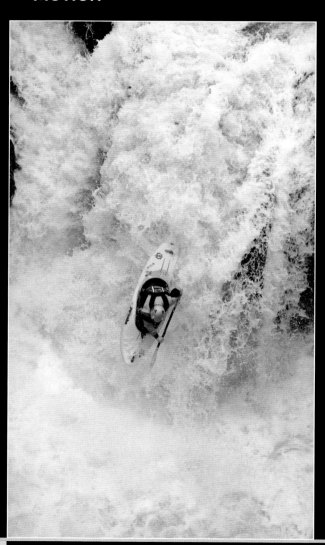

Settings

> *ISO:* 400
> *Focal Length:* 32mm
> *Shutter Speed:* 1/1000 sec.
> *Aperture:* f/8

This kayaker made several runs down this fall, which was fortunate as it took a couple of attempts to get the timing of this shot just right. I didn't need a great depth of field, so the aperture wasn't critical, but a fast shutter speed was vital to freeze the action. Glen Nevis, Scotland, U.K.

This is one of my regular haunts and I've ⌃
photographed it in many different conditions,
but rarely have I had better light than this. The
contrast between the warmth of the direct
sunlight and the blue of the shadows is very
clear on the rocks. In "normal" daylight you
would say the rocks were gray.
Little Cragg, Forest of Bowland, Lancashire, U.K.

Settings

› *ISO:* 200
› *Focal Length:* 16mm
› *Shutter Speed:*
 1/8 sec.
› *Aperture:* f/14

As soon as I saw this huge «
painting of the Matterhorn I
knew it would make a great
backdrop for this portrait of Sir
David Attenborough. I used
flash to freeze the subject's
animated gestures and
expressions—available light
would have given too slow a
shutter speed. I used bounced
flash, partly because it gives a
much more natural result, but
also because it is far kinder to
the subject as it is not firing
directly into their eyes.
Alpine Club, London, U.K.

Settings

> *ISO:* 200
> *Focal Length:* 62mm
> *Shutter Speed:*
 1/30 sec.
> *Aperture:* f/5.6

was important to get this right, and the shooting height was equally critical. It took more than five minutes to get my tripod placed exactly right, and after that I just had to wait a little longer for a patch of blue sky.
Morecambe, Lancashire, U.K.

Settings

› *ISO:* 100
› *Focal Length:* 28mm
› *Shutter Speed:* 1/125 sec.
› *Aperture:* f/14

Chapter 4
FLASH

4 FLASH

The D5100 has great flash capabilities, whether you are using its built-in flash or a more powerful accessory unit. But flash photography still causes frequent confusion and frustration.

To make the most of flash, basic principles must be grasped, starting with two basic facts: aside from studio units, all flashes are small light sources, and all are relatively weak. This is especially true of the built-in flashes found on digital SLRs, while those on compact digital cameras are typically even smaller and weaker.

The small size of a flash gives its light a hard, one-dimensional quality, which is somewhat similar to direct sunlight. However, even the strongest sunlight is slightly softened by scattering and reflection, but with flash used from a relatively close distance this is not the case. The weakness of a flash is even more

fundamental: all flash units have a limited range and if the subject is too far away, then the flash cannot deliver enough light to produce a satisfactory exposure.

While a small size and limited power is common to all flash units, there is a third issue that is specific to built-in flash, which is its fixed position, close to the lens; we will look at this in more detail on pages 152–153.

The upshot is that flash—especially built-in flash—is not the answer to every low-light shot. Understanding the limitations will help you understand when not to use flash, as well as when and how to use it effectively.

D5100 FLASH RAISED **«**

» GUIDE NUMBERS

In the past, determining the exposure and working range when using flash required calculations based on the Guide Number (GN), which relates subject distance to the aperture setting (f-stop) in use. Such computations are rarely needed now, and the D5100's advanced flash metering systems usually provide the correct illumination with very little effort required on the part of the photographer.

The GN does still have a use though—it helps us compare the power and range of different flashes. For example, the GN for the D5100's built-in flash is 39ft/12m at ISO 100, while Nikon's SB-900 has a guide number of 111.5ft/34m, indicating that it is around three times as powerful. This would allow shooting at a greater distance, at a lower ISO, with a smaller aperture, or a combination of the three.

Tip

Guide Numbers are specified in feet and/or meters, and are usually given at an ISO rating of 100. When comparing different units, be sure that the same terms are used—some manufacturers give the GN at ISO 200, which makes it appear higher.

FLASH RANGE ☆
The limited range of the built-in flash is evident, fading away from a bright foreground. The shadow of the lens hood is very obvious too.

ISO: 400 *Focal Length:* 18mm
Shutter Speed: 1/200 sec. *Aperture:* f/13

4 » FILL-IN FLASH

A key application for flash is to provide a "fill-in" light that lifts dark shadows, such as those cast by direct sunlight. This is why professional photographers regularly use flash on bright days, exactly when most people would think it unnecessary. Fill-in flash doesn't need to illuminate the shadows fully, only lighten them a little, which means the flash can be used at a

smaller aperture or a greater distance than when it is the main light. It also means that the built-in flash is often sufficient.

FILL-IN FLASH ⌄
The exposure is the same for both shots, but without flash the foreground tree is almost a silhouette.

ISO: 1000 *Focal Length:* 12mm
Shutter Speed: 1/160 sec. *Aperture:* f/8

i-TTL balanced fill-flash for DSLR

i-TTL balanced fill-flash is part of Nikon's Creative Lighting System (CLS). It helps achieve natural-looking results when using fill-in flash, provided that matrix or center-weighted metering is selected and a CPU lens is attached. It is activated automatically and the flash (either the built-in unit or a compatible accessory flash) emits several near-invisible pre-flashes immediately before exposure. The reflected light from these is analyzed by the D5100's metering sensor, together with the ambient light, to produce the optimum exposure. If Type D or G lenses are used, distance information is also taken into account for even greater exposure accuracy.

Standard i-TTL flash for DSLR

When spot metering is selected, this mode is activated instead of i-TTL balanced fill-flash. The flash output is still controlled to illuminate the subject correctly, but the background illumination is not taken into consideration. This mode is more appropriate when a compatible flash is being used as the main light source, rather than a fill-in light.

BALANCED FILL-FLASH ⌄
It is far from obvious that flash has been used for this shot, but without it the depths of the crevice would be black.

ISO: 320 *Focal Length:* 14mm
Shutter Speed: 1/200 sec. *Aperture:* f/11

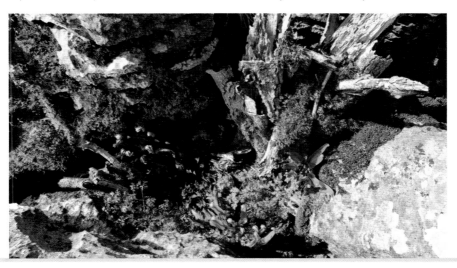

The D5100's built-in flash is small, low-powered, and fixed in position close to the lens axis. As well as limiting its working range, these factors mean it produces a flat and harsh light that is unpleasant for most portraits, for example. It may be better than nothing, but it only really comes into its own when used as a fill-in light.

In ⬛ᴬᵁᵀᴼ Full Auto, and some of the Scene Modes, the D5100's built-in flash is activated automatically when the camera deems it necessary, while in ⊘ Auto (Flash Off) and other Scene Modes, the built-in flash is not available at all. It is only in **P**, **A**, **S**, or **M** (and ¶¶ Food) that you have complete freedom as to whether or not you use the built-in flash.

1) Select a metering method. Matrix metering is advised for fill-in flash, while spot metering is more appropriate when the flash will be the main light.

2) Press ϟ🗲 and the flash will pop up and begin charging. When it is charged, the ready indicator ϟ is displayed in the viewfinder.

3) Choose a flash mode by highlighting the current flash mode in the Active Information Display and pressing (OK). Select the desired flash mode and press (OK) again.

4) Take the photograph in the normal way.

5) When finished, lower the flash gently until it clicks into place.

> ## Auto flash

In ⬛ᴬᵁᵀᴼ Auto and many of the Scene Modes, the default flash setting is **Auto flash**, which simply means that the built-in flash operates automatically if the camera judges that the ambient light levels are too low. Alternative modes that can be set are **Red-eye reduction** and **Flash off**.

In **P**, **A**, **S**, **M**, and Food modes, you must activate the flash by pressing ϟ🗲.

Flash exposure
Whether the shutter speed is 1/200 sec., 1/2 sec., or even 20 seconds, the flash usually fires just once during this time to make the

Tip

The built-in flash is recommended for use with CPU lenses with a focal length between 18mm and 300mm. Note, however, that some lenses may block part of the flash output at close range. Removing the lens hood often helps.

exposure. Therefore it delivers the same amount of light to the subject. If there were no other light, this would mean that the subject would look the same, regardless of the shutter speed used.

Shutter speed only becomes relevant when there is other light around (referred to as "ambient light"), at which point a slower shutter speed will give the ambient light more chance to register.

The aperture setting, however, is relevant to both the flash and ambient exposures. The D5100's flash metering takes this into account, but it is useful to understand this distinction to get a clearer sense of what is happening, especially with slow-sync shots. The shutter speed and aperture combinations that are available when using flash depend on the exposure mode in use.

Exposure mode	Shutter Speed	Aperture
P	Set by camera. The normal range is 1/60–1/200 sec., but in certain flash modes all settings up to 30 seconds are available.	Set by camera.
A	Set by camera. The normal range is 1/60–1/200 sec., but in certain flash modes all settings from 30 seconds to 1/200 sec. are available.	Selected by user.
S	Selected by user. All settings between 30 seconds and 1/200 sec. are available. If you set a faster shutter speed, the D5100 will fire at 1/200 sec. while the flash is active.	Set by camera.
M	Selected by user. All settings between 30 seconds and 1/200 sec. are available. If you set a faster shutter speed, the D5100 will fire at 1/200 sec. while the flash is active.	Selected by user.
AUTO 📷, 🧍, 🌷, 🏃, 🎆, 🐕, 🍴	Set by camera. Range limited to 1/30–1/200 sec. or 1/60–1/200 sec., depending on the mode.	Set by camera.
🌃	Set by camera. The normal range is between 1 second and 1/200 sec.	Set by camera.

The range of any flash depends on its power, the ISO sensitivity setting, and the aperture that is set. The grid below details the approximate range of the built-in flash for selected distances, ISO settings, and apertures. These figures are based on the table in the D5100 manual, which have been confirmed by practical tests. There is no need to memorize these figures, but it does help to have a general sense of the limited range of the built-in flash—in practice, a quick test shot will usually tell you if a subject is in range.

Tip

If the flash appears too weak, or the range is insufficient, turning up the ISO setting may help, but check also that flash compensation has not been applied.

	ISO setting						Range	
	100	200	400	800	1600	3200	meters	feet
Aperture	1.4	2	2.8	4	5.6	8	1.0–8.5	3'3"–27'11"
	2	2.8	4	5.6	8	11	0.7–6.1	2'4"–20'
	2.8	4	5.6	8	11	16	0.6–4.2	2'–13'9"
	4	5.6	8	11	16	22	0.6–3.0	2'–9'10"
	5.6	8	11	16	22	32	0.6–2.1	2'–6'11"
	8	11	16	22	32		0.6–1.5	2'–4'11"
	11	16	22	32			0.6–1.1	2'–3'7"
	16	22	32				0.6–0.7	2'–2'7"

» FLASH SYNCHRONIZATION AND MODES

As its name implies, flash is virtually instantaneous, and lasts just a few milliseconds. If the flash is to cover the whole of the imaging sensor it must be fired when the shutter is fully open, but at faster shutter speeds SLRs do not expose the whole frame at once—a narrow slit is exposed rapidly to achieve the shorter durations. In the case of the D5100, the fastest shutter speed that can normally be used with flash is 1/200 sec., which is the fastest speed at which the entire sensor is exposed to light. This is known as the synchronization or "sync" speed.

The D5100 has several flash modes, and the differences between them largely relate to synchronization and shutter speed. You can choose a flash mode by pressing **⚡ ☒** and rotating the Command Dial, or entering the flash mode options through the Active Information Display.

Standard flash mode (Front curtain sync)

This is the default flash mode in the **P**, **A**, **S**, and **M** exposure modes. The flash fires as soon as the shutter is fully open, so it is activated as soon as possible after the shutter-release button is pressed. This gives a fast response and the best chance of capturing the subject as you see it. However, it can create odd-looking results when you are photographing moving subjects: for these subjects, second curtain sync may be more suitable.

In **P** and **A**, the camera will set a shutter speed in the range 1/60–1/200 sec. In **S** and **M**, you can set any shutter speed down to 30 seconds, making standard flash indistinguishable from slow sync.

SLOW SYNC FLASH ⌄
Slow sync combines a flash image with a motion-blurred image from the ambient light.

REAR CURTAIN SYNC ⌄
With rear curtain sync the motion-blurred elements appear behind the sharp flash image.

Slow sync

This mode allows shutter speeds of up to 30 seconds to be used in the **P** and **A** exposure modes, so that the background can be captured, even in low ambient light. Movement of the subject or camera can result in a partly blurred image combined with a sharp image where the subject is lit by the flash. This may be unwelcome, but is often used for creative effect.

This mode is also available in a limited form (the longest exposure possible is 1 second) by using ![night portrait icon] Night Portrait mode. You cannot select slow sync in **S** and **M** exposure modes, but this isn't necessary, as longer shutter speeds are available anyway.

Rear curtain sync (Second curtain sync)

Rear curtain sync is the opposite of Front curtain sync, and triggers the flash at the last possible instant before the shutter closes. When photographing moving subjects this means that any image recorded by the ambient light appears behind the sharp flash image, like a "speed blur." This looks more natural than having the blur appear to extend ahead of the direction of movement.

Rear curtain sync can only be selected when using **P**, **A**, **S**, or **M**. In **P** and **A** it allows slow shutter speeds (below 1/60 sec.) to be used, at which point it is referred to as **Slow rear curtain sync**.

When using longer exposure times, shooting with Rear curtain sync can be tricky, as you need to predict where your subject will be at the *end* of the exposure. Therefore it is often best suited to working with cooperative subjects, or naturally repeating action such as a race covering numerous laps of a circuit, so that the timing can be fine tuned after reviewing your images on the rear LCD screen.

Red-eye reduction

On-camera flash, especially the built-in unit, is very prone to causing "red-eye," which is where light reflects off the subject's retina. Red-eye reduction works by shining a light on the subject before the exposure is made, causing their pupils to contract. This delay makes it inappropriate for use with moving subjects, and kills spontaneity, so it is generally better to remove red-eye using the Red-eye correction facility in the Retouch Menu or on your computer. Using a separate flash, away from the lens axis (or no flash) will prevent red-eye altogether.

Red-eye reduction with slow sync

This combines the two flash sync modes outlined above, allowing backgrounds to register while reducing the risk of red-eye. This mode is only available when using the **P** and **A** exposure modes and, in a more limited form, ![night portrait icon] Night portrait mode.

» FLASH COMPENSATION

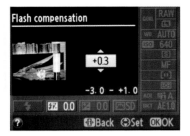

Although the D5100's flash metering system is extremely sophisticated, you may still want to adjust the output of the flash for creative effect. Immediate playback makes it easy to assess the effect of the flash level, allowing compensation to be applied with confidence to further shots.

To use flash compensation, activate the Active Information Display. The flash compensation option is midway along the bottom of the screen and can be set between -3EV and +1EV in ⅓EV increments.

Tip

Flash compensation can also be set by pressing ⚡ *and* **±Z**, *and rotating the Command Dial. However, as the figures are displayed on the screen, it is usually easier to use the Active Information Display. Flash compensation is not available if Custom Setting e1 (Flash cntrl for built-in flash) is set to Manual.*

Positive (+) compensation will brighten the flash exposure, while leaving ambient-lit areas unaffected, while applying negative (-) compensation reduces the brightness of flash-lit areas, again without affecting other areas.

If the subject is already at the limit of the flash range, applying positive compensation will not make the flash exposure any brighter.

FLASH **«**
COMPENSATION
Three shots taken with the flash compensation set to −1EV, 0, and +1EV respectively.

ISO: 800
Focal Length: 38mm
Shutter Speed: 1/1000 sec.
Aperture: f/11

» USING OPTIONAL SPEEDLIGHTS

If you are serious about portraiture or close-up photography in particular, you will soon find the D5100's built-in flash inadequate. Accessory flash units, which Nikon calls Speedlights, extend the power and flexibility of flash enormously with the D5100. Speedlights integrate fully with Nikon's Creative Lighting System, and there are currently five models available, each of which is a highly sophisticated unit aimed at professional and advanced users, and priced accordingly. Independent makers such as Sigma offer alternatives—some of which are compatible with Nikon's i-TTL flash control—but it is fair to say that these "dedicated" units are still far from cheap.

Mounting an external Speedlight

1) Check that the camera and the Speedlight are both switched **Off**, and that the pop-up flash is down. Remove the hotshoe cover.

2) Slide the foot of the Speedlight into the camera's hotshoe. If it does not slide easily, check if the mounting lock on the Speedlight is in the locked position.

3) Rotate the lock lever at the base of the Speedlight to secure it in position.

4) Switch the camera and Speedlight **On**.

> ### Tip
>
> *Speedlights use a lot of battery power, so it is always wise to carry at least one set of spare cells, preferably more.*

D5100 WITH SB-700 SPEEDLIGHT **«**

» BOUNCE AND OFF–CAMERA FLASH

The fixed position of the D5100's built-in flash throws hard shadows on close subjects and gives portraits a "police mugshot" appearance. A separate Speedlight mounted in the hotshoe improves things slightly, but you can make a much greater difference by bouncing the flash off a ceiling, wall, or reflector, or taking the Speedlight off the camera.

Bounce flash

Bouncing the flash off a suitable surface spreads the light, softening hard-edged shadows, and changes its direction to produce better modeling on the subject. Nikon's SB-900, SB-800, SB-700, and SB-600 Speedlights all have heads that can be tilted and swivelled through a wide range of angles, while the SB-400 has a basic tilt capability that allows the light to be bounced off the ceiling or a reflector.

FLASH DIRECTION «

The first shot was taken using the built-in flash, which makes this three-dimensional arrangement look distinctly flat.

The second shot uses indirect flash from the left, with a white card reflector on the right for balance.

The third image uses bounce flash, giving a softer, more even light, but retaining the 3D quality of the subject.

ISO: 800 *Focal Length:* 48mm
Shutter Speed: 1/60 sec. *Aperture:* f/16

Off-camera flash

Taking the flash off the camera gives you complete control over the direction of its light. The flash can be fired using a flash cord, and all of Nikon's dedicated flash cords preserve i-TTL metering.

Painting with light

You can try this intriguing technique using any flash that can be triggered manually. By firing multiple flashes at the subject from different directions, the aim is to build up the overall coverage of light without losing the sparkle that directional light gives. The technique requires trial and error to get right, but that's part of the fun.

1) Set up so that your camera and the subject cannot move during the exposure.

2) Switch to Manual (**M**) and set a long shutter speed such as 20 or 30 seconds, or even Bulb.

3) Set a small aperture such and focus on the subject. Switch the focus to **Manual** so the camera does not try to refocus.

4) Turn out the room lights. (It helps to have just enough background light to see what you are doing, but no more.)

5) Trigger the shutter and fire the flash at your subject from different directions (without aiming it directly into the lens).

6) Review the result and start again! If the result is too bright, for example, use fewer flashes, a lower ISO, a smaller aperture, fire from further away, or a combination of these. If the flash has a variable power setting this could be turned down.

OFF-CAMERA FLASH »
A Speedlight was fired from the side and slightly behind to give some extra light in the depths of this foxglove flower.

ISO: 400
Focal Length: 55mm
Shutter Speed: 1/100 sec.
Aperture: f/11

» NIKON SPEEDLIGHTS

This grid summarizes the key features of all current Nikon Speedlights:

	SB-900	SB-800	SB-700	SB-600	SB-400
Guide Number at ISO 100 (meters/feet)	34/111.5	38/125	28/92	30/98	21/69
Angle of coverage (widest focal length covered) with D5100	12mm	16mm	16mm	16mm	18mm
Tilt/swivel	Yes	Yes	Yes	Yes	Tilt only
Dimensions (width x height x depth mm)	78 x 146 x 118.5mm	70.6 x 127.5 x 93mm	71 x 126 x 104.5mm	68 x 123.5 x 90mm	66 x 56.5 x 80mm
Weight (without batteries)	415g	350g	360g	300g	127g
Use as commander?	Yes	Yes	Yes	No	No

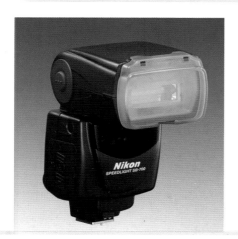

Wireless flash

Nikon's Creative Lighting System includes the ability to control the light from multiple Speedlights through a wireless system. The SB-900, SB-800, and SB-700 Speedlights can all be used as the control flash (or "commander"), and there is also a standalone commander, the SU-800. The D5100 can operate in such a system, but must be physically connected to a commander unit, either by mounting it in the hotshoe, or attaching it via a dedicated flash cord.

» FLASH ACCESSORIES

To add even greater flexibility and control over your flash lighting effects, a wide variety of flash accessories is available. Nikon has an extensive range of its own, but when time is short (or money is tight), some of these can be readily improvised.

Battery packs

Nikon produces add-on power packs for some of its Speedlight models to speed up recycling times and extend battery life.

Color filters

Colored filters can be used over the flash to create striking effects or match the color of the flash to the background lighting. Nikon produces various filters to fit its Speedlight models.

Flash cords

The D5100's built-in flash cannot act as a wireless commander, so you can only maintain full metering and control of an external Speedlight if it is physically connected to the camera, either in the hotshoe or using a flash cord (also known as a sync lead). Dedicated cords such as Nikon's SC-28 allow full communication between the camera and Speedlight, retaining i-TTL flash control.

Flash diffusers

Flash diffusers are a simple, economical way of spreading and softening the hard light from a flash. Some slide over the flash head, while others are attached by low-tech means such as elastic bands or Velcro. Sto-Fen make Omni-Bounce diffusers to fit most flashguns, and an Omni-Flip for built-in flash units. Diffusers reduce the light reaching the subject and while the D5100's metering system will allow for this, the effective range of the flash will be reduced.

Flash extenders

A flash extender slips over the flash head and uses mirrors or a lens to create a tighter beam and extend the effective range of the flash. Again, the D5100's

D5100 WITH A HONL FLASH DIFFUSER. ⌄

metering system will automatically accommodate this. Nikon do not make flash extenders, so a third-party option will be required.

Flash brackets

The ability to mount a flash away from the camera, and therefore change the angle at which the light hits the subject, is invaluable in controlling the quality of light. Nikon's Speedlights can be mounted on a tripod or stand on any flat surface using the AS-19 stand, but for a more portable solution many photographers prefer a light, flexible arm or a flash bracket that attaches to the camera and supports the Speedlight.

MULTIPLE FLASH ʥ

This shot was made using two Speedlights, one to each side of the subject. The D5100's i-TTL metering took care of regulating the lighting very well.

ISO: 100 *Focal Length:* 50mm
Shutter Speed: 1/125 sec. *Aperture:* f/13

Chapter 5
CLOSE-UP

5 CLOSE-UP

Most photography is about capturing what you can see with the naked eye, but close-up photography goes beyond this, taking you into a whole new world—or at least a new way of seeing the world. An SLR camera such as the Nikon D5100 is ideal for this type of photography as its reflex viewing system—once essential for close-up work—is now supplemented by the equally useful Live View.

Depth of field is a key issue in close-up photography, as the closer you get to the subject, the shallower the depth of field becomes. This has several consequences. First, it is often necessary to use small apertures, which can result in long exposures. Second, the slightest movement of either the subject or camera can ruin the focus. A tripod or other solid camera support is therefore often required, and it may also be necessary to prevent the subject from moving (within ethical limits, of course!).

Because the depth of field is so shallow with close-up work, focusing becomes critical. Merely focusing on "the subject" is no longer good enough, and you must decide which part of the subject should be the point of sharp focus—an insect's eye or the stamen of a flower, for example.

With its eleven focus points, the D5100 is capable of focusing accurately within much of the frame, but this is an area where Live View mode comes into its own. By switching to Live View and selecting ⬚ Wide-area AF or ⬚ Normal-area AF

mode, the focus point can be set anywhere in the frame. With its ability to zoom in on the preview image, Live View also makes manual focusing ultra-precise.

Tip

To get as close as possible to the subject use manual focus and set the lens to its minimum focusing distance. Do not touch the focus control again: instead, move either the camera or the subject until the image is sharp. Although slow, this guarantees you are as close as the lens will allow.

UP CLOSE AND PERSONAL

Close-up subjects are everywhere—maybe sometimes a little too close!

ISO: 500 *Focal Length:* 18mm
Shutter Speed: 1/130 sec. *Aperture:* f/4.5

» MACRO PHOTOGRAPHY

There is no exact definition of "close-up," but "macro" is a term that should be used more precisely. Strictly speaking, macro photography means photography of objects at life-size or larger, implying a reproduction ratio of at least 1:1. Many zoom lenses are branded "macro" when their reproduction ratio is around 1:4, or 1:2 at best. While this still allows close-up photography, it is not "true" macro.

Reproduction ratio

The reproduction ratio is the ratio between the physical size of the subject and the size of its image on the D5100's imaging sensor. As the sensor measures 23.6 x 15.6mm, at a reproduction ratio of 1:1 an object of these dimensions would fill the image frame exactly. Of course, when the image is printed or viewed on a screen it may appear many times larger, but that is another story.

A 1:4 reproduction ratio means that the smallest subject that gives you a frame-filling shot is four times as long/wide as the sensor. With the D5100 that would be a subject measuring approximately 94 x 63mm (roughly 4 x 2 ½ inches), or slightly larger than a credit card.

Working distance

The working distance is the distance required to obtain the desired reproduction ratio with any given lens. It is related to the focal length of the lens, so with a 200mm macro lens the working distance for 1:1 reproduction is double that of a 100mm focal length. Because the D5100's sensor is smaller than a full-frame sensor, the effective focal length of any lens is multiplied by a factor of 1.5x. The working distance increases also, and this can be useful with living subjects that are susceptible to being disturbed easily.

Tip

When you are using the built-in flash on close-up subjects, a longer working distance reduces the chance of the lens and/or lens hood casting a shadow across the subject.

1:1 REPRODUCTION »

The minimal depth of field in close-up work is exemplified in this image of pine needles, taken at a reproduction ratio close to 1:1.

ISO: 640 *Focal Length:* 50mm Macro
Shutter Speed: 1/10 sec.
Aperture: f/5.6

» EQUIPMENT FOR CLOSE-UP SHOOTING

Close-up attachment lenses

These simple magnifying lenses screw into the filter thread of the lens. They are light, portable, inexpensive, and fully compatible with the camera's exposure and focusing systems, making them a straightforward option for close-up photography. Nikon's own range of close-up lenses is no longer available, but other manufacturers—namely filter makers—produce them in an array of sizes and strengths.

Extension tubes

Extension tubes are another simple, relatively inexpensive means of extending the close-focusing capabilities of a lens. An extension tube is essentially a tube that fits between the lens and the camera, which decreases the lens' minimum focusing

Tip

Nikon's own extension tubes are no longer listed, but compatible extension tubes are produced by other manufacturers. Some support exposure metering, but they do not allow autofocus with the D5100.

distance and increases its magnification factor. Used on the D5100, you may find that you are restricted to Manual (**M**) mode and exposure determination will be by trial and error, but you can always use the histogram as a guide.

Warning!

Some recent lenses are incompatible with accessories such as extension tubes, bellows, and teleconverters, so you should check the lens manual before use.

Bellows

Bellows work on the same principle as extension tubes, in that they increase the distance between the lens and the camera body. However, they are not restricted to a few set lengths. As with extension tubes, there is no extra glass to impair the optical quality of the lens, but bellows are heavy, expensive, and time-consuming to set up, which is why they are usually employed in studio environments.

Note:
Because extension tubes and bellows increase the physical length of a lens, they also increase the effective focal length. The physical size of the aperture does not change, however. As a result, the lens becomes "slower": a lens with a maximum aperture of f/2.8 starts to behave like an f/4 or f/5.6 lens, for example. This makes the viewfinder image darker, and also affects the exposure required.

Reversing rings

Also known as reverse adapters, or—in Nikon's jargon—"inversion rings," these allow lenses to be mounted in reverse. The adapter screws into the filter thread, and then mounts to the camera to allow much closer focusing. These are the cheapest way to experiment with macro shooting, but can be difficult to find. Reversing rings lose all automatic camera functions.

FOCAL LENGTH �

Longer lenses are very useful for some subjects, especially highly mobile ones!

ISO: 320 *Focal Length:* 125mm
Shutter Speed: 1/400 sec. *Aperture:* f/10

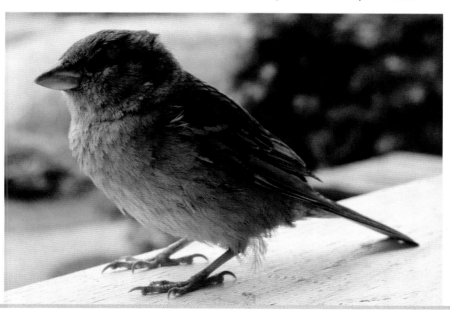

5 » MACRO LENSES

True macro lenses achieve reproduction ratios of 1:1 or better and are optimized for close-up work, although they are normally very capable when it comes to general photography. This is certainly true of Nikon's Micro Nikkor lenses, of which there are currently four.

The most recent addition to the range is the **60mm f/2.8G ED AF-S Micro Nikkor**. Compared to its predecessor, the **60mm f/2.8D AF Micro Nikkor**, it uses ED glass for superior optical quality and a Silent Wave Motor for ultra-quiet autofocus.

60MM F/2.8G ED AF-S MICRO NIKKOR ⋮

The **105mm f/2.8G AF-S VR Micro Nikkor** features internal focusing, ED glass, a Silent Wave Motor, and VR (Vibration Reduction). As the slightest camera shake is magnified at high reproduction ratios, technology designed to combat its effects is extremely welcome, allowing you to employ shutter speeds up to four stops slower than would otherwise be possible.

The **200mm f/4D ED-IF AF Micro Nikkor** is particularly favored for shooting the animal kingdom, as its longer working distance reduces the risk of disturbing your subject. This lens lacks a built-in motor, so cannot autofocus with the D5100, but this is not necessarily a problem for macro work.

Finally, Nikon has produced a Micro Nikkor lens specifically for the DX format: the **85mm f/3.5G ED VR AF-S DX Micro Nikkor.** This (of course) achieves 1:1 reproduction and has VRII, internal focusing, and ED glass.

» MACRO LIGHTING

We've already observed that macro photography often requires small apertures, and that this can lead to long exposure times that can prove to be problematic with mobile subjects. Additional lighting is often required, which usually means flash.

However, regular Nikon Speedlights are not designed for close-up use and, when mounted on the hotshoe, the short working distance means that the lens can often throw a shadow onto the subject. The built-in flash is even less suitable for real close-up work, yet in 🌷 Close-up mode it regularly pops up automatically.

SUNPAK LED MACRO RING LIGHT ⌄

Specialist macro flash units usually take the form of either ringflash or twin-flash units. Because of the close operating distances they do not need high power and can be relatively light and compact. Ringflash units encircle the lens, giving an even spread of light, even on ultra-close subjects. Nikon's (now discontinued) SB-29s may still be found at some dealers, while alternatives come from Sigma and Marumi.

Nikon now favors a twin-flash approach, using its Speedlight Commander Kit R1C1 and Speedlight Remote Kit R1. Both utilize two Speedlight SB-R200 flashes mounted either side of the lens; the difference is in how these are controlled. The R1C1 uses a Wireless Speedlight Commander SU-800, which mounts on the hotshoe, while the R1 requires a separate Speedlight that is used as the commander. These kits are quite expensive (the R1C1 costs only a little less than a D5100 camera body), but they do provide you with a very flexible and controllable light for macro subjects.

An alternative to flash is to use LED lights, such as the Sunpak LED Macro Ring Light. The continuous light output allows you to preview the image in a way that is not possible with flash, but the low power limits it to close, and usually static, subjects.

5

Improvisation

Dedicated macro flash units are not cheap, and may be unaffordable or unjustifiable when you just want to experiment with macro work to see if it is something you want to pursue further. Fortunately, you can do a lot with a standard flash and an off-camera flash cord. With more basic units, you will lose the D5100's advanced flash control, but it only takes a few test shots to establish settings that you can use repeatedly. The other essential is a small reflector—perhaps a piece of white card—that can be positioned close to the subject for maximum benefit.

This setup (used for several example shots in this book) can be more flexible than twin-flash or ringflash, allowing the light to be directed wherever you choose. For static subjects, "painting with light" is also an interesting option.

RING LIGHT «

This shot was taken with the Sunpak LED Macro Ring Light. Note the even illumination on the subject, and the light fall-off on the background: this light is best suited to frame-filling subjects.

ISO: 800 *Focal Length:* 50mm Macro
Shutter Speed: 1/15 sec.
Aperture: f/11

TWO-FLASH SETUP «

An SB-700 on the right was linked to the camera by a remote cord, with a second SB-700 set up to the left.

ISO: 800 *Focal Length:* 50mm Macro
Shutter Speed: 1/60 sec.
Aperture: f/16

NATURAL LIGHT »

Natural light often works perfectly well, but look carefully at your results to see if fill-in flash or a reflector might help.

ISO: 400 *Focal Length:* 50mm Macro
Shutter Speed: 1/200 sec.
Aperture: f/11

Chapter 6
MOVIES

6 MOVIES

The ability to record moving images is now widespread among digital SLRs, but it was only as recently as August 2008 that the Nikon D90 became the first digital SLR from any manufacturer to offer this feature. As the movie mode is really an extension of Live View shooting, familiarity with Live View is a big asset when you start shooting movies.

Movie quality

The D5100 can shoot Full HD (High Definition) movies with a frame size of 1920 x 1080 pixels. These can naturally be played through an HD television, and will look excellent on most computer screens. Many compact cameras and camcorders also deliver HD video, but because the D5100 has a larger sensor, its image quality is superior in many respects. A dedicated camcorder does have ergonomic advantages, however.

In addition to its maximum frame size, you can also record your movies at resolutions of 1280 x 720 pixels and 640 x 424 pixels. The smallest size is fine for YouTube, and many mobile devices, although the latest iPhones have a screen resolution of 960 x 640 pixels and the iPad's screen is 1024 x 768 pixels. The lower settings will allow you to record more video on the same memory card, so while a 4Gb memory card will hold a little over 20 minutes of footage at the highest quality setting, it can store almost 2 hours at the lowest. This could prove useful if space on the card becomes limited.

The D5100 produces its movies in a standard Motion-JPEG format (the file extension is .MOV), which is compatible with media playing software such as *QuickTime* and *RealPlayer*.

Advantages

Although the SLR design was never originally intended for shooting video, cameras such as the D5100 do have certain advantages, including the ability to use the

> **Note:**
> Most digital video cameras claim enormous zoom ranges (often 800x or more), but part of this is "digital zoom," a software function that simply enlarges the central portion of the image. "Optical zoom" is what really matters, and the interchangeable lenses available for the D5100 give it a potential range of at least 50x (12mm–600mm). The widest range currently available in a single lens is 18–270mm.

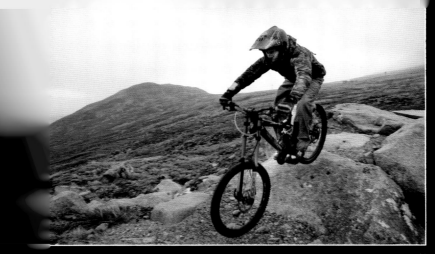

WIDE-ANGLE SHOOTING ⌃
The D5100 allows wide-angle lenses to be used: here I used an 18mm focal length.

DEPTH OF FIELD ⌄
It is far easier to achieve a really shallow depth of field with the D5100 than it is with most video cameras. Here I used a 300mm lens, with an aperture of f/6.3.

entire array of Nikon-fit lenses. This gives a potential focal length range that is difficult to match with any video camera, especially for wide-angle shooting.

Another benefit is that the D5100's larger sensor and compatibility with lenses that have a wide maximum aperture means you can achieve a very shallow depth of field, which is virtually unobtainable with a compact digital camera or a dedicated video camera.

The D5100's high ISO shooting ability (and large sensor) means that results in low light should be better than many of the alternatives, while the full range of exposure settings, Scene Modes, Picture Controls, and other options, give you a high level of creative control.

Digital SLR limitations

Although the D5100's movie mode is among the best of any current digital SLR, some limitations remain. Live View AF is not really slick enough for fast-moving subjects, and the sound quality from the built-in microphone is best described as "moderate" (although you can attach a separate microphone).

There are also a few interesting image effects. In keeping with other digital SLRs, the D5100 captures video with a "rolling" scan, rather than capturing the whole frame at once. This has a peculiar effect when dealing with fast movement, whether it is a rapid pan of the camera or movement of the subject: objects can appear distorted, with rectangular shapes turning into parallelograms and so on. If you rock the camera violently from side to side you can even achieve a remarkable wobbly effect that has become known as "jello-cam." Some movie-editing software can now compensate for this.

LOW LIGHT »
The D5100 scores when it comes to low-light movie recording.

» SHOOTING MOVIES

Preparing to shoot

Before starting to shoot, you should select key settings in the **Movie settings** section of the Shooting Menu. This has two sub-menus: **Movie quality** and **Microphone**.

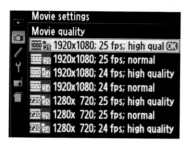

MOVIE SETTINGS: MOVIE QUALITY ⌃

Movie quality sets the image size, frame rate, and quality for movie recording. The size options are **640 x 424** pixels (default), **1280 x 720** pixels, and **1920 x 1080** pixels. The frame rate options vary according to the chosen size and whether PAL or NTSC is selected as the video mode.

Tip

To take a still photo during movie shooting, press the shutter-release button and keep it pressed until you hear the shutter operate. Still frames can also be extracted from movies, but only at the current movie resolution (up to 1920 x 1080 pixels).

Microphone adjusts the sensitivity of the built-in microphone or turns it **Off**.

MOVIE SETTINGS: MICROPHONE ⌃

Shooting

1) Choose the exposure mode, AF mode, and AF-area mode as you would for Live View shooting and, if you are using **A** or **M**, set the aperture as well.

2) Activate Live View with the **LV** switch.

3) Check the framing and initial exposure level (possibly taking a still frame as a test), and set initial focus by applying half pressure on the shutter-release button.

4) Press ●**Rec** to start recording. **REC** flashes on the monitor screen and an indicator shows the maximum remaining shooting time.

5) To stop recording, press ●**Rec** again.

6) Exit Live View using **LV**.

6

› Exposure

When you are shooting movies, exposure control depends on the exposure mode selected before shooting begins. If a Full Auto or Scene Mode is selected, exposure control is fully automatic, although the exposure can be locked using the *AE-L/AF-L* button. This is useful if you want to prevent the main subject appearing to darken if it moves in front of a brighter background, for example.

In **P**, **A**, or **S**, the exposure level can be adjusted by ±3EV using the ⊞ button. In **A** mode the aperture can also be adjusted manually during shooting: the camera will set the shutter speed automatically, and adjust the ISO sensitivity (if necessary) to keep the shutter speed within suitable limits. If you choose to shoot in Manual (**M**), then both the shutter speed and aperture can be adjusted, as long as the **Manual** option in Movie Settings is **On**.

While all of these exposure adjustment options are welcome, actually doing this while shooting is not easy, and not always advisable. Not only is it hard to avoid knocking the camera when you make your changes, but the built-in microphone may also pick up the sounds of you making adjustments. There can also be abrupt brightness changes in the final footage.

› Focusing

If Full-time servo AF (AF-F) is selected, the D5100 will attempt to maintain focus automatically while movie recording is in progress, although it may lag behind rapid camera/subject movements.

If Single-servo AF (AF-S) is selected, the camera will only refocus when you half press the shutter-release button, and this is often all too obvious in the final movie clip. However, you can maintain half pressure on the shutter-release button if you want to lock focus.

Tip

If you study the credits for movies and TV shows you will often see someone called a "focus puller." This is an assistant to the camera operator, whose sole task is to adjust the focus, leaving the lead camera operator free to concentrate on framing, panning, and zooming. While this may seem a long way from shooting simple movie clips on the D5100, the difficulties encountered when using the camera to record movies may mean that it is worth having some assistance, especially if you want to pan or zoom at the same time as adjusting focus.

Manual focusing is also possible while you are shooting movies, but it can lead to wobbly pictures if you are handholding the camera. Yet again, this indicates the use of a tripod, especially with longer lenses where focusing is more critical and any slight camera movement is magnified. You may also find that some lenses have a smoother manual focus action than others, and that the physical design of older lenses—with large and well-placed focus rings—often makes them most suitable.

You do not always have to focus continually—using fixed focus for each shot is often perfectly viable, especially when the depth of field is good. This reduces operations that can make the shot wobbly and avoids distracting mid-shot shifts in focus.

FIXED FOCUS ⊻
Fixed focus is ideal for shots like this, where the climber stays approximately the same distance from the camera.

A golden rule when shooting movies with the D5100—even more than stills—is to think ahead. When shooting still images, you can review a shot, change the camera position or settings, and shoot again within a second or two, but to shoot and review even a short movie clip takes far more time, and you will not always get a second chance to shoot.

Therefore it is important that your shooting position, framing, and camera settings are correct before you start. It is easy to check the general look of the shot by shooting a still frame before you start the movie clip, and this is a good habit to cultivate. However, a still frame does not allow for movement of the subject, the camera, or both. You should not forget that the D5100 has a limited ability to follow focus on a moving subject during movie shooting, especially a fast-moving subject. You can sometimes rely on a small aperture setting and large depth of field to cover this (especially when shooting with wide-angle lenses), but rapid subject movement can be a real problem.

Shooting movies is a complex business, so start with simple shots. There is no point trying to zoom, pan, and change focus simultaneously, if you have not practiced these things on their own, so start by changing just one thing at a time. Many moving subjects can be filmed with a stationary camera: waterfalls, birds at a feeder, and musicians, to name but a few. Equally, you can become familiar with camera movement while shooting static subjects: try panning across a wide landscape, for example, or zooming in from a broad cityscape to a detail of a single building.

Handheld or tripod shooting

Shooting movie clips handheld is a good way of revealing just how shaky you really are, especially as you can't use the viewfinder. Of course, even "real" movie directors sometimes use handheld cameras

Tip

A good photographic tripod with a pan-and-tilt head is a good start for shooting movies, but ball-and-socket tripod heads are best avoided—they are fine for static shots and zooms, but are not suitable for panning. If you are serious about shooting movies, you may want to consider investing in a dedicated video tripod, or tripod head. This isn't necessarily bigger or heavier than its standard counterpart, but the tripod head is specifically designed to move smoothly. The best are fluid-damped for ultra-smooth results.

to create a specific feel, but you would not want every movie to look like that. Using a tripod, or other suitable camera support, is the easiest way to give your movie clips a polished, professional look.

If you do choose to handhold the camera, or need to shoot a clip and have no tripod available, approach it carefully. Pick a spot where you won't be jostled, and look to support the camera as firmly as possible—perhaps by sitting with your elbows braced on your knees.

PANNING ⌄
This is one case where you might want to pan handheld, as the paraglider may not remain at a constant height. A true video tripod would be ideal, though.

› Panning

The panning shot is a mainstay in movie making. While it is often essential for following a moving subject, it can also be used very effectively with static subjects— a panning shot enables you to capture a vast panorama in a way that is impossible in a still frame, for example.

Handheld panning is problematic: while it may be vaguely acceptable if you are following a moving subject, a shaky pan across a grand landscape will definitely annoy your viewers, so you really do need to use a tripod. Not only that, but you need to make certain that the tripod is properly leveled before you begin. If not, you may start panning with the camera aimed at the horizon, but end with it pointing at the ground or sky.

Many tripods have a built-in spirit level, but failing this, you can visually check that the tripod's center-column looks vertical from all sides. Then do a "dry-run" before shooting, to make sure that the camera remains level as you pan across your intended subject. If you are panning to follow a moving subject you also need to think about the subject's expected path: some subjects, such as trains and trams, move along predictable paths, but others do not. Trying to follow a player in a football match can be very challenging, and even seasoned professionals don't always get it right.

Be sure to keep your panning action slow and steady, as panning too rapidly can make your shot hard to "read" and perhaps even make the viewer feel seasick. Smooth panning is easier to achieve with a video tripod, but it is perfectly possible with a standard model: simply leave the pan adjustment slack, but make sure all other adjustments are tight. Hold the tripod head rather than the camera (video tripods have an extended grip for better control) and use the front of the lens as a reference as you track steadily across the scene, rather than looking at the camera's rear LCD screen. With moving subjects, the speed and direction of the pan is dictated by the need to keep the subject in frame, and accurately tracking fast-moving subjects takes a lot of practice.

› Zooming

The zoom is another fundamental movie technique: moving from a wide view to a tighter one is called *zooming in*, and the converse is *zooming out*. As with panning, a little forethought makes all the difference to using the zoom effectively. You should

EXPLORING THE SCENE
The camera can "explore" a scene like this either by panning across it or by zooming in on a specific aspect.

start by considering the zoom direction you want (in or out), and the framing of the shot both at the start and end of the zoom. If you are zooming in to a specific subject, double-check that it is central before starting.

The D5100 and its range of available lenses are not designed specifically for shooting movies and this shows up clearly when it comes to zooming. First, no compatible lens has as wide a zoom range as video camera lenses, although "superzooms" (such as Tamron's 18–270mm) can come in useful. They may lack critical quality for shooting still images, but video has much lower resolution demands.

Second, it is difficult to achieve a totally smooth, even-paced zoom action, and zooming while handholding the camera guarantees a jerky zoom and overall wobbliness. Practice helps, and firmly mounting the camera on a solid tripod helps even more. If you have several lenses available it is worth experimenting to see which has the smoothest zoom action— some are better than others.

When zooming, remember that the depth of field will decrease at the telephoto end of the zoom range. While your subject may appear perfectly sharp in a wide-angle view, it could end up looking quite fuzzy when you zoom in. This may be avoided if the camera refocuses, but the sudden shift in focus can itself be a distraction. Manual focus can avoid this, and it is a good idea

to set the focus at the telephoto end of the zoom, regardless of whether you are starting at this setting and zooming out, or zooming in to end up with a telephoto shot.

Lighting

For obvious reasons, you cannot use flash when shooting movies, but there is an increasing number of LED light units that are designed specifically for digital SLR movie shooting. The D5100's ability to shoot at high ISO ratings is also invaluable if you prefer a more natural look in low-light situations.

Sound

The D5100 has a built-in microphone that will provide you with modest quality mono output, but it is liable to pick up any sound that you make during operation, such as focusing, zooming, and even breathing.

The sensitivity of the mic can be adjusted in **Movie settings**, found in the Shooting Menu, and you always have the option to add a new soundtrack later. However, this can be difficult if your film includes people speaking, so if you want to include dialog or "talking heads," it is best to keep your subjects close to the camera and make sure that any background noise is minimized. Alternatively, the D5100 allows you to attach an external mic, which will automatically override the camera's internal unit.

Importing movies to the computer

Nikon Transfer will recognize and import movies, just as it will still images, and the basic procedure is much the same. However, you will probably want to store your movies in a different folder to your still images, so importing movie clips through your movie-editing software may be the better option. This makes sure that all of your video clips are stored in the same place and the software can locate them easily for editing.

Combining your clips

It is important to understand that the D5100 doesn't shoot movies—like all movie cameras, it shoots movie *clips*. While a single clip, straight from the camera, may occasionally serve your purposes, it is generally the case that a collection of clips needs to be edited together to create a movie that people actually want to see. Specifically, non-linear editing is usually desirable and often required. This simply means that the clips in the final movie don't have to appear in the same order as they were shot: you might shoot a stunning tropical sunset on the first night of your vacation, but use it as the closing shot in your edited movie.

Today's software makes editing movies easier to do than to describe, and the D5100's .MOV movies are a standard format that can be edited in most programs. Even better, if you own a reasonably recent computer you probably already have suitable software.

For Mac users the obvious choice is Apple's *iMovie*, which is part of the *iLife* suite included with all new Macs. The Windows equivalent is *Windows Movie Maker*, which came pre-installed with Windows XP and Vista, but needs to be downloaded from www.windowslive.com if you are using Windows 7. Another excellent option is *Adobe Premiere Elements*.

APPLE iMOVIE ⌄

All of these programs offer non-linear editing, and it is also *non-destructive*. This means that editing does not affect your original clips (unlike cutting and splicing bits of film); the new movie is produced by copying required sections of your clips. During the editing process you work with preview versions of these clips and the software merely keeps "notes" about the edit. A new movie file is only created when you select **Export Movie** (in *iMovie*) or **Save** (in *Windows Movie Maker*).

The two programs work in broadly similar ways and both are easy to grasp. The main difference is that *iMovie* has a largely visual interface, while *Windows Movie Maker* relies slightly more on text-based menus. In both cases, the movie clips you work with are displayed in one pane of the screen and you simply drag the one that you want to the Project pane (*iMovie*) or Timeline *(Windows Movie Maker)*. You can rearrange your clips at any time just by dragging-and-dropping, and you can also trim any clip. A Viewer pane allows you to preview your movie as a work-in-progress at any time.

In addition, you can adjust the look of any clip using basic controls for brightness, color, and so on, as well as adding a range of special effects: you could make your movie look as if it had been shot on film 50 years ago, rather than yesterday with a digital SLR, for example.

WINDOWS MOVIE MAKER ⌄

Tip

It is fun to play with special effects, and non-destructive editing means that you can experiment to your heart's content. However, it is best to use effects sparingly in the final version if you want audiences to enjoy, rather than endure your movie.

Another basic feature offered by most video-editing programs is the *transition*. Instead of simply cutting from one shot to the next, you can apply various effects such as dissolves, wipes, and fades. As with special effects, these are fun to experiment with and can add visual polish to the finished movie, but should complement the adjoining clips and help the narrative flow of the movie, rather than calling attention to themselves. It is generally better to work with just a few transitions in your movie, rather than using every possible option.

Adding to your movie

Both *iMovie* and *Windows Movie Maker* allow you to add other media to your movies, such as still images and sound. With the D5100, adding stills is a natural and easy thing to do, but you can also use photographs from other sources. You can insert them individually at appropriate points, or create slide shows within the main movie. Again, various effects and transitions can be applied to give a dynamic feel as you move from one photo to the next and it is equally easy to add a new soundtrack, such as a voiceover or music.

Storyboarding

Editing can transform a jumbled assortment of clips into a coherent movie, but it can also lead to frustration when you start to wish you had a wider shot of X, or a close-up of Y. Editing can do a lot, but it cannot supply shots that you never took in the first place. This is why most movie productions start with a screenplay, then a storyboard, before a single scene is shot.

A storyboard usually looks like a giant comic strip, with sketches or mock-ups of every shot and scene that's envisaged in the final movie. Things can still change in the edit, but it should at least mean that the director and editor have all the material they need to work with. While you may not want to go quite that far, a bit of forward planning can still help.

Tip

Unless you have recorded your own music, you will need the copyright owner's permission to use recorded music in any public performance. This is especially important if you intend to upload your movie to YouTube, or similar. The same applies to other copyright material, such as other people's photos.

THINKING AHEAD ≫

This is a colorful image with plenty of
movement, but there is clear space where
titles or credits could be added. Planning
or anticipation helps you to make sure that
you have the right material when it comes
to editing.

Chapter 7
LENSES

7 LENSES

There are many reasons to choose a digital SLR such as the D5100 instead of a compact digital camera, but one of the most crucial is the ability to use a vast range of lenses. This includes both Nikon's own legendary system as well as lenses from other manufacturers.

In its basic form, Nikon's F-mount lens mount is now 50 years old, which means that most Nikkor lenses will fit on—and work with—the D5100, albeit sometimes with major limitations. However, there are sound reasons why more recent lenses are most suitable, not least that many older lenses cannot autofocus with the D5100.

Another reason for preferring lenses that have been designed specifically for digital cameras relates to the way in which light reaches the individual photosites on the camera's sensor. Because these are slightly recessed, there can be some cut-off if light hits them at an angle, which can lead to some peripheral loss of brightness (vignetting) and increased chromatic aberration (color fringing). Conversely, Nikon's DX-series and other newer lenses are designed specifically for digital capture, so maintain illumination and image quality right across the frame.

Loss of functions

When older lenses are used on the Nikon D5100, a number of functions may be lost. In particular, autofocus is only available with lenses that have their own built-in motor. Suitable Nikon lenses are designated AF-I or AF-S, but you should check carefully when considering lenses from independent makers. Other AF lenses with a built-in CPU will support some or all of the camera's metering functions and exposure modes, but will need to be focused manually. The electronic rangefinder can be useful here, and the D5100's manual has detailed information on compatible lenses.

Older lenses without a built-in CPU—such as AI and AI-S lenses—can still be attached to the D5100, but the camera's exposure metering will not function. This requires you to set the aperture and shutter speed in Manual (**M**) mode, using either an external lightmeter or trial and error to achieve the correct exposure.

Warning!

Some older lenses, specifically pre-AI lenses, should not be mounted on the D5100 as this could result in damage. Certain other specific (and uncommon) lenses should also be avoided—see the manual for full details.

ISO: 250 *Focal Length:* 18mm
Shutter Speed: 1/320 sec. *Aperture:* f/8

7 » FOCAL LENGTH

The focal length of a lens is a fundamental optical property that does not change. Unfortunately, as if to promote confusion, the lenses on most digital compact cameras are referred to not by their actual focal length, but by their "35mm equivalent," which is the focal length that would give the same angle of view on a 35mm or full-frame camera.

Of course, zoom lenses have a variable focal length—that's what zoom means—but it is important to understand that an 18–55mm zoom is *always* an 18–55mm zoom, regardless of whether it is fitted to a DX format camera such as the D5100 or a full-frame (FX) camera such as the D3. However, because the D5100 has a smaller sensor than the D3, the actual image that is recorded shows a smaller angle of view.

Crop factor

The D5100's smaller sensor (relative to the 35mm/FX standard) means that it has a crop factor or *focal length magnification factor*, of 1.5. If you fit a 200mm lens to a D5100, for example, this means that the field of view equates to a 300mm lens on a full-frame camera (200 x 1.5), although the focal length itself does not change. For sports and wildlife this can be an advantage, allowing long-range shooting with relatively light and inexpensive lenses, but the crop factor makes wide-angle lenses

effectively "less wide." This is unwelcome news for landscape shooters, who may have to invest in ultra-wide (and often expensive) lenses such as the 10–24mm f/3.5–4.5G DX Nikkor for a wide-angle view.

Field of view

The field of view, or *angle of view*, is the area covered by the image frame. While the focal length of a lens remains the same on any camera, the angle of view seen in the image is different for different sensor formats. The angle of view is usually measured diagonally (as shown in the lens charts on pages 207–209).

Perspective

Perspective concerns the visual relationship between objects at different distances. The apparent fading of distant objects due to haze is known as *atmospheric perspective*, while *optical perspective* relates to the changes in apparent size of objects at different distances.

It is often suggested that different lenses give different perspective, but this is wrong: perspective is determined purely by distance. Alternative lenses do lend themselves to different working distances though, and are therefore often associated with different perspectives. A strong emphasis on the foreground, for example, may be described as "wide-angle

This series of images was taken on a Nikon D5100 from a fixed position, using focal lengths from 14mm to 300mm.

ISO: 100
Shutter Speed: 1/200 sec.
Aperture: f/11

Focal Length: 14mm

Focal Length: 28mm

Focal Length: 50mm

Focal Length: 100mm

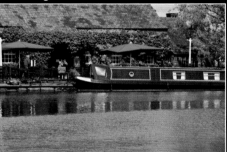

Focal Length: 200mm

Focal Length: 300mm

Focal Length: 200mm

Focal Length: 50mm

Focal Length: 12mm

PERSPECTIVE «

In this series of shots, the subject remains the same apparent size when viewed from different distances with different focal lengths. However, its relationship to the background changes dramatically.

ISO: 400
Focal Length: Various
Shutter Speed: 1/60 sec.
Aperture: f/11

perspective" because a wide-angle lens allows you to move closer to foreground objects. Similarly, the apparent compression of perspective in telephoto shots is a result of the greater working distance with the long lens.

› Prime lenses

Prime lenses have a single, fixed focal length, which makes them relatively light and simple compared to a zoom lens, and they are also usually excellent optically, with a wide maximum aperture. They may appear less versatile than zoom lenses, but this can be a good lesson for a photographer as it teaches them to shift position and actively seek out the best angle and viewpoint, rather than lazily adjusting the focal length on a zoom lens without moving.

› Zoom lenses

The term "zoom" is used for lenses with a variable focal length, such as the Nikkor 18–55mm AF-S DX lens that is often supplied with the D5100. A zoom lens can replace a bagful of prime lenses and cover the focal length gaps between them, so scores highly for weight, convenience, and economy. The flexible focal length also allows for very precise framing.

While once considered inferior in optical quality, there is now little to choose between a good zoom and a good prime lens, although cheaper zooms, and those with a very wide focal length range (18–200mm or 28–300mm, for example) may still be optically compromised. They usually have a relatively small ("slow") maximum aperture as well, but can prove useful for movie shooting.

50mm f/1.4G AF-S PRIME LENS ⌄

AF-S VR ZOOM-NIKKOR 70–300mm ⌄

TURKU, FINLAND «

Zoom lenses have a real advantage when precise framing is required.

ISO: 320 *Focal Length:* 102mm
Shutter Speed: 1/400 sec.
Aperture: f/8

› Standard lenses

In traditional 35mm film photography, a 50mm lens was called "standard," because its field of view approximated that of the human eye. However, because of the D5100's crop factor, the equivalent is around 35mm focal length on a DX format camera. Zoom lenses encompassing this focal length are often referred to as "standard zooms."

NIKKOR 35MM f/1.8G AF-S ⹂
"STANDARD LENS"

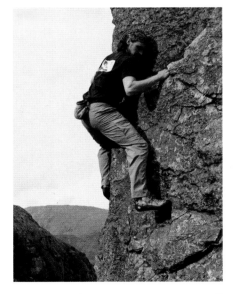

STANDARD LENS «
The standard lens is versatile enough to be used for a variety of subjects.

ISO: 400 *Focal Length:* 40mm
Shutter Speed: 1/400 sec. *Aperture:* f/8

› Wide-angle lenses

A wide-angle lens is any lens that delivers a wider view than a standard lens. For the D5100 this means any focal length shorter than 35mm. Wide-angle lenses are valuable for working close to your subject or emphasizing the foreground. They excel in photographing expansive scenic views, and in cramped spaces where you physically cannot move back to "get more in."

**AF-S DX NIKKOR 10–24mm ⌄
F/3.5–4.5G ED**

› Telephoto lenses

Telephoto lenses, or "long" lenses deliver a narrow angle of view. They are commonly used for wildlife and sports photography, where the working distance is often large, but they can also isolate small or distant elements in a landscape. Moderate telephoto lenses are favored for portrait photography, because they require a "comfortable" working distance that is felt to give a natural-looking result and is less intimidating for nervous subjects. The traditional "portrait lens" is one with a focal length of between 85mm and 135mm (between 60mm and 90mm when the D5100's crop factor is taken into account).

The laws of optics, plus their greater working distance, mean that telephoto lenses produce a limited depth of field compared to wider-angle lenses. This is often welcomed in portraiture, wildlife, and sports photography, as it concentrates attention on the subject by throwing the

**AF-S NIKKOR 300MM »
F/2.8G ED VR II**

background out of focus. However, the size and weight of longer focal length lenses makes them hard to handhold comfortably, and their narrow angle of view also magnifies any movement: fast shutter speeds and/or a tripod or other camera support are often required. Nikon's Vibration Reduction (VR) technology also helps mitigate camera shake.

TELEPHOTO LENS ❯❯
A telephoto lens is ideal when you want to fill the frame with a distant subject.

ISO: 250 *Focal Length:* 300mm
Shutter Speed: 1/50 sec. *Aperture:* f/14

› Macro lenses

For specialist close-up work there is little to beat a true macro lens: for more on these see page 172.

AF-S NIKKOR 105MM MICRO ❯❯
F/3.5D ED VR

› Perspective control lenses

Perspective control (or "tilt and shift") lenses have a unique flexibility in terms of viewing and controlling the image. Their most obvious application is in architecture photography. With a "normal" lens it often becomes necessary to tilt the camera upward to fit a building in the frame, resulting in converging verticals (buildings that appear to lean back or even to one side). However, the shift function on a perspective control lens allows the camera-back to be kept vertical, while the front of the lens is physically "shifted" upward. This helps fit the entire subject (a building, for example) in the frame, but at the same time the vertical lines in the subject will remain vertical in the image. Tilt movements also allow additional control

over the depth of field, enabling it to be extended or minimized at any particular aperture setting.

The current Nikon range features three perspective control lenses, covering 24mm, 35mm, and 85mm focal lengths.

24MM f/3.5D ED PC-E ❯❯

CORRECTED VERTICALS ❯❯
ISO: 100 *Focal Length:* 24mm
Shutter Speed: 1/80 sec. *Aperture:* f/16

Teleconverters are supplementary optics that fit between the main lens and the camera body, magnifying the focal length. Nikon currently offers the TC-14E II, TC-17E II, and TC-20E II, which provide 1.4x, 1.7x, and 2.0x magnification respectively. The advantages are obvious: teleconverters allow you to extend the focal length of a lens with minimal additional weight or cost.

Teleconverters can marginally degrade image quality, and also cause a loss of light: fitting a 2x converter to a 300mm f/4 lens turns it into a 600mm focal length, but effectively reduces its fastest aperture by two stops, to f/8. As a result, the camera's autofocus may become impaired or may not work at all.

AF-S TELECONVERTER TC-20E III ⌄

› Lens hoods

A lens hood has two main purposes: it excludes stray light that might otherwise cause flare and degrade the image, and it helps shield the lens against knocks, rain, and so on. Most Nikkor lenses come with a dedicated lens hood and it is important that you use the right lens hood for the lens as this will maximize its shading effect and avoid vignetting.

Warning!

Some of Nikon's most recent lenses are incompatible with its teleconverters, so you should check carefully before use.

TELECONVERTER «
ISO: 125 **Focal Length:** 105mm plus TC-14E II
Shutter Speed: 1/250 sec. **Aperture:** f/11

» NIKON LENS TECHNOLOGY

Nikon's lenses are renowned for their technical and optical excellence, and many lenses incorporate special features or innovations. As these are referred to extensively in the charts that follow, a brief explanation of the main terms and abbreviations is given here.

ABBREVIATION	TERM	EXPLANATION
AF	Autofocus	Lens focuses automatically. The majority of current Nikkor lenses are AF, but a substantial manual focus range remains.
ASP	Aspherical lens elements	Precisely configured lens elements that reduce the incidence of certain aberrations. Especially useful in reducing wide-angle distortion.
CRC	Close-range correction	Advanced lens design that improves picture quality at close focusing distances.
D	Distance information	D-Type and G-Type lenses communicate information to the camera about the distance at which they are focusing, supporting functions such as 3D Matrix Metering.
DC	Defocus-image control	Found in a few lenses aimed mostly at portrait photographers. Allows control of aberrations and thereby the appearance of out-of-focus areas in the image.
DX	DX lens	Lenses specifically designed for DX-format digital SLRs, such as the D5100.
G	G-Type lens	Modern Nikkor lenses with no aperture ring: the aperture must be set by the camera.
ED	Extra-low dispersion glass	ED glass minimizes chromatic aberration (the tendency for light of different colors to be focused at slightly different points).

ABBREVIATION	TERM	EXPLANATION
IF	Internal focusing	Only internal elements of the lens move during focusing: the front element does not extend or rotate.
M/A	Manual/Auto	Most Nikkor AF lenses offer M/A mode, which allows the seamless transition from automatic to manual focusing if required.
N	Nano Crystal Coat	Said to virtually eliminate internal reflections within lenses, guaranteeing minimal flare.
PC	Perspective control	*See page 203.*
RF	Rear focusing	Lens design where only the rearmost elements move during focusing: makes AF operation faster.
SIC	Super Integrated Coating	Nikon-developed lens coating that minimizes flare and "ghosting."
SWM	Silent Wave Motor	Special in-lens motors that deliver very fast and very quiet autofocus operation.
VR	Vibration Reduction	System that compensates for camera shake. VR is said to allow handheld shooting up to three stops slower than would otherwise be possible, so a shutter speed of 1/15 sec. could be used instead of 1/125 sec. New lenses feature VRII, said to offer a gain of an additional stop over VR, allowing a shutter speed of 1/8 sec. to be used instead of 1/125 sec., for example.

» NIKKOR LENS CHARTS

The following chart lists all Nikkor autofocus lenses that are currently available, starting with the DX-series lenses that are designed specifically for DX format cameras such as the D5100.

	Optical features/ notes	Angle of view with Nikon D5100	Minimum focus distance (m)	Filter size (mm)	Dimensions (diameter/ length) (mm)	Weight (g)
DX LENSES						
10.5mm f/2.8G DX Fisheye	CRC	180°	0.14	Rear	63 x 62.5	300
10–24mm f/3.5– 4.5G ED AF-S DX	ED, IF, SWM	109°–61°	0.24	77	82.5 x 87	460
12–24mm f/4G ED IF AF-S DX	SWM	99°–61°	0.3	77	82.5 x 90	485
16–85mm f/3.5– 5.6G ED VR AF-S DX	VRII, SWM	83°–18.5°	0.38	67	72 x 85	485
17–55mm f/2.8G ED IF AF-S DX	ED, SWM	79°–28.5°	0.36	77	85.5 x 11.5	755
18–55mm f/3.5– 5.6G AF-S VR DX	VR, SWM	76°–28.5°	0.28	52	73 x 79.5	265
18–55mm f/3.5– 5.6GII AF-S DX	ED, SWM	76°–28.5°	0.28	52	70.5 x 74	205
18–70mm f/3.5– 4.5G ED IF AF-S DX	ED, SWM	76°–22.5°	0.38	67	73 x 75.5	420
18–105mm f/3.5– 5.6G ED VR AF-S DX	ED, IF, VRII, NC, SWM	76°–15.3°	0.45	67	76 x 89	420
18–135mm f/3.5– 5.6 ED IF AF-S DX	ED, SWM	76°–12°	0.45	67	73.5 x 86.5	385
18–200mm f/3.5– 5.6G ED AF-S VRII DX	ED, SWM, VRII	76°–8°	0.5	72	77 x 96.5	560
35mm f/1.8G AF-S	SWM	44°	0.3	52	70 x 52.5	210
55–200mm f/4–5.6 AF-S VR DX	ED, SWM, VR	28.5°–8°	1.1	52	73 x 99.5	335
55–200mm f/4– 5.6G ED AF-S DX	ED, SWM	28.5°–8°	0.95	52	68 x 79	255
55–300mm f/4.5– 5.6G ED VR	ED, SWM	28.5°–5.2°	1.4	58	76.5 x 123	530
85mm f/3.5G ED VR AF-S DX Micro Nikkor	ED, IF, SWM, VRII	18.5°	0.28	52	73 x 98.5	355

	Optical features/ notes	Angle of view with Nikon D5100	Minimum focus distance (m)	Filter size (mm)	Dimensions (diameter/ length) (mm)	Weight (g)
AF PRIME LENSES						
14mm f/2.8D ED AF	ED, RF	90°	0.2	Rear	87 x 86.5	670
16mm f/2.8D AF Fisheye	CRC	120°	0.25	Rear	63 x 57	290
20mm f/2.8D AF	CRC	70°	0.25	62	69 x 42.5	270
24mm f/1.4G ED	ED, NC	61°	0.25	77	83 x 88.5	620
24mm f/2.8D AF		61°	0.3	52	64.5 x 46	270
28mm f/2.8D AF		53°	0.25	52	65 x 44.5	205
35mm f/2D AF		44°	0.25	52	64.5 x 43.5	205
35mm f/1.4G AF-S	NC, SWM	44°	0.3	67	83 x 89.5	600
50mm f/1.8D AF		31.3°	0.45	52	63 x 39	160
50mm f/1.4D AF		31.3°	0.45	52	64.5 x 42.5	230
50mm f/1.4G AF-S	IF, SWM	31.3°	0.45	58	73.5 x 54	280
85mm f/1.4G AF	SWM, NC	18.5°	0.85	77	86.5 x 84	595
85mm f/1.8D AF	RF	18.5°	0.85	62	71.5 x 58.5	380
105mm f/2D AF DC	DC	15.2°	0.9	72	79 x 111	640
135mm f/2D AF DC	DC	12°	1.1	72	79 x 120	815
180mm f/2.8D ED IF AF	ED, IF	9.1°	1.5	72	78.5 x 144	760
200mm f/2G ED IF AF-S VRII	ED, VRII, SWM	8.2°	1.9	52	124 x 203	2930
300mm f/2.8G ED VR II AF-S	ED, VRII, NC, SWM	5.2°	2.2	52	124 x 267.5	2900
300mm f/4D ED IF AF-S	ED, IF	5.2°	1.45	77	90 x 222.5	1440
300mm f/2.8 ED IF AF-S VR	ED, SWM, NC	5.2°	2.2	52	124 x 268	2850
400mm f/2.8G ED VR AF-S	ED, IF, VRII, NC	4°	2.9	52	159.5 x 368	4620
400mm f/2.8D ED IF AF-S II	ED, SWM	4°	3.8	52	160 x 352	4800
500mm f/4G ED VR AF-S	IF, ED, VRII, NC	3.1°	4	52	139.5 x 391	3880
500mm f/4D ED IF AF-S II	ED, IF	3.1°	5	52	140 x 394	3800
600mm f/4G ED VR AF-S	ED, IF, VRII, NC	2.4°	5	52	166 x 445	5060
600mm f/4D ED IF AF-S II	ED, SWM	2.4°	6	52	166 x 445	5900

AF ZOOM LENSES						
14–24mm f/2.8G ED AF-S	IF, ED, SWM, NC	90°–61°	0.28	None	98 x 131.5	970
16–35mm f/4G ED VR	NC, ED, VR	83°–44°	0.29	77	82.5 x 125	745
17–35mm f/2.8D ED IF AF-S	IF, ED, SWM	79°–44°	0.28	77	82.5 x 106	745
18–35mm f/3.5–4.5D ED	ED	76°–44°	0.33	77	82.7 x 82.5	370
24–70mm f/2.8G ED AF-S	ED, SWM, NC	61°–22.5°	0.38	77	83 x 133	900
24–85mm f/2.8–4D IF AF		61°–18.5°	0.5	72	78.5 x 82.5	545
24–120mm f/4G ED IF AF-S VR	ED, SWM, NC, VRII	61°–13.5°	0.45	77	84 x 103.5	710
28–70mm f/2.8 ED IF AF-S	ED, SWM	53°–22.5°	0.7	77	88.5 x 121.5	935
28–300mm f/3.5–5.6G ED VR	ED, SWM	53°–5.2°	0.5	77	83 x 114.5	800
70–200mm f/2.8G ED IF AF-S VRII	ED, SWM, VRII	22.5°–8°	1.4	77	87 x 209	1540
70–300mm f/4.5–5.6G AF-S VR	ED, IF, SWM, VRII	22.5°–5.20°	1.5	67	80 x 143.5	745
80–400mm f/4.5–5.6D ED VR AF	ED, VR	20°–4°	2.3	77	91 x 171	1340
200–400mm f/4G ED IF AF-S VRII	ED, NC, VRII, SWM	8°–4°	2	52	124 x 365.5	3360
MACRO LENSES						
60mm f/2.8G ED AF-S Micro	ED, SWM, NC	26.3°	0.185	62	73 x 89	425
60mm f/2.8D AF Micro	CRC	26.3°	0.219	62	70 x 74.5	440
105mm f/2.8G AF-S VR Micro	ED, IF, VRII, NC, SWM	15°	0.31	62	83 x 116	720
200mm f/4D ED IF AF Micro	ED, CRC	8°	0.5	62	76 x 104.5	1190
PERSPECTIVE CONTROL						
24mm f/3.5D ED PC-E (manual focus)	ED, NC	56°	0.21	77	82.5 x 108	730
45mm f/2.8D ED PC-E (manual focus)	ED, NC	34.5°	0.25	77	83.5 x 112	780
85mm f/2.8D ED PC-E (manual focus)	ED, NC	18.9°	0.39	77	82.7 x 107	65

Chapter 8
**ACCESSORIES &
CAMERA CARE**

8 ACCESSORIES & CAMERA CARE

As part of the vast Nikon system, a wide choice of accessories is available for the D5100, with third-party items extending the options further still. These accessories can be grouped under four headings: image modification (filters and flash), camera performance, camera support, and storage.

» FILTERS

Flash and close-up accessories have already been covered, leaving filters as the main product falling under the image modification heading. As a general principle, you should avoid using filters unnecessarily, as adding extra layers of glass in front of the lens can increase the risk of flare or otherwise degrade the image. "Stacking" multiple filters increases this risk even further, as well as that of vignetting, so is most definitely ill-advised.

Some types of filter are almost redundant with digital cameras—variable white balance has virtually eliminated the need for color-correction filters, for example—but it is prudent to keep a UV or skylight filter attached to each of your lenses to protect against damage.

Types of filter

Filters can attach to the lens in several ways: round, screw-in filters are the most common, but you may also encounter slot-in filters and rear, or drop-in filters. Screw-in filters are normally made of high-quality optical glass and screw to the front of the lens. The filter thread diameter (in mm) of most Nikon lenses is specified in the lens charts on pages 207–209, and is usually marked somewhere on the lens beside a Ø symbol. Nikon produces screw-in filters in sizes matching the full range of Nikkor lenses and to the same high optical standards. Larger ranges come from companies such as Hoya and B+W.

Slot-in filters are more economical and convenient if you use filters extensively, as the filters—square or rectangular and made of optical resin or gelatin—fit into a slotted holder. With a simple adapter ring for different lens diameters, one holder and one set of filters can serve any number of lenses. The best-known maker of slot-in filters is Cokin, although Lee Filters are respected by some demanding users.

A few specialist lenses, such as super-telephotos or extreme wide-angle and fisheye lenses with protruding front elements, require equally specialist filters that fit either to the rear of the lens or drop in to a slot in the lens barrel.

UV and skylight filters

These filters are almost interchangeable: both cut out excess ultraviolet light, which can make images excessively cool and blue, although a skylight filter also has a slight warming effect. A major benefit, however, is in physically protecting the lens—replacing a filter is a lot less expensive than replacing a damaged lens.

PROTECTION NEEDED ʤ
A UV or skylight filter helps to protect the lens from snow, dust, dirt, and other hazards.

ISO: 1000 *Focal Length:* 200mm
Shutter Speed: 1/500 sec. *Aperture:* f/6.3

Polarizing filters

Polarizing filters are much-loved by landscape photographers as they can reduce the reflections from most surfaces, helping to intensify colors. They can also make reflections on water and glass virtually disappear, restoring transparency. This is most effective at an angle of around 30 degrees to the surface: rotating the filter in its mount strengthens or weakens its effect.

A polarizer can also "cut through" atmospheric haze (although not mist or fog), and can make blue skies appear more intense. The effect is strongest when the filter is at a right-angle to the sun, and vanishes when the sun is directly behind

or in front of the camera. The results can sometimes appear exaggerated, though, and with wide-angle lenses can vary conspicuously across the field of view. A polarizer should therefore be used with discrimination, and not permanently attached to the lens. It remains useful as its effects cannot be fully replicated in any other way, even in digital post-processing.

POLARIZING FILTER ≫
A polarizing filter can help to intensify colors.

ISO: 500 *Focal Length:* 66mm
Shutter Speed: 1/125 sec. *Aperture:* f/8

Neutral density filters

Neutral density (ND) filters can be either plain or graduated, and reduce the amount of light reaching the lens—"neutral" simply means that they don't affect the color of the light, only its intensity. A plain ND filter is useful when you want to set a slower shutter speed and/or wider aperture, but the ISO setting is already as low as it can go. A classic example is when shooting waterfalls on a bright day, where a long shutter speed is often favored to create a silky blur.

Graduated ND filters (or "ND grads") have neutral density covering half the filter, while the other half is clear, with a gradual transition between the two in the middle. They are widely used in landscape photography to compensate for differences in brightness between the sky and land, although the straight transition of an ND grad filter can be obvious when the skyline is irregular, as in mountainous areas.

If you are happy to invest time at the computer you can often replicate—and even improve on—the effect of a graduated ND filter. However, this will not work unless the original image captures detail in both the highlight and shadow areas, so an ND grad is still an important standby. It can also be useful when shooting movies, where this sort of post-processing is not an option.

Special effects filters

Special effects filters come in many forms, but two common types are soft-focus filters and starburst filters. The soft-focus filter is widely used in portrait photography to soften skin blemishes, but its effect can be replicated and extended—precisely and reversibly—in digital post-processing, so it is now seen less often. Much the same is true of the starburst filter, and most other special-effects filters: it is usually better to capture the original image without filters, and apply digital effects later.

Tip

The **Filter effects** section of the D5100's Retouch Menu replicates the effect of several common photographic filters, including **Skylight**, **Warm filter**, and **Cross screen** (starburst).

NEUTRAL DENSITY FILTER
A plain ND filter can be useful when you want to use really slow shutter speeds, especially in bright conditions.

ISO: 100 *Focal Length:* 18mm
Shutter Speed: 1.3 seconds *Aperture:* f/22

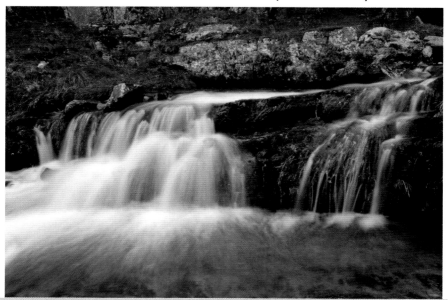

8 » CAMERA PERFORMANCE

Numerous add-ons are available to improve or modify the performance of the D5100. Nikon includes several items with the camera, but these are really essentials, rather than extras.

EN-EL14 battery

Without a live battery, your D5100 is useless, so it is always wise to have a fully charged spare to hand, especially in cold conditions, when using the screen extensively, or when shooting movies.

MH-23 charger

Vital for keeping the D5100's EN-EL14 battery charged and ready.

BF-1A body cap

Protects the interior of the camera when no lens is attached.

› Optional extras

AC Adapter EH-5a/EH-5

Either of these adapters can be used to power the camera directly from a power outlet, allowing uninterrupted shooting during long studio sessions, for example. A Power Connector EP-5 is also required.

Wireless remote control ML-L3

This inexpensive unit allows the camera to be triggered remotely from a distance of up to 16ft/5m.

WIRELESS REMOTE CONTROL ML-L3 ⌄

Remote Cord MC-DC2

Nikon's MC-DC2 remote cord can be attached to the terminal on the left side of the D5100, allowing you to trigger the shutter without touching the camera.

GPS Unit GP-1

Dedicated Nikon global positioning system.

ME-1 stereo microphone

Greatly improves the D5100's sound quality during movie shooting.

Viewfinder lenses

The D5100's viewfinder has built in dioptric adjustment, but if your eyesight is beyond its range, Nikon produces a series of viewfinder lenses with strengths between -5 and $+3$ m^{-1}. It is usually easier (and cheaper) to wear contact lenses or glasses.

› Camera support

There is much more to camera support than a tripod, although these remain a staple for most photographers.

Tripods

Nikon's VR lenses and the D5100's ability to produce fine images at high ISO settings tend to encourage handholding the camera when you shoot, but there are still many occasions where a tripod is a better option. While light weight and low cost always appeal, beware of tripods that simply aren't sturdy enough to provide decent support, especially with longer lenses. A good tripod is an investment that will last many years, and the best combination of low weight and good rigidity comes from titanium or carbon fiber models. These are, however, very expensive, making aluminum tripods the most popular compromise.

Monopods

Monopods can't match the stability of a tripod, but they are lighter, easier to carry, and quicker to set up. As a result, sports photographers, who need to react quickly while using long, heavy telephoto lenses, prefer them to a tripod.

Other camera support

There are many other solutions for supporting your camera, ranging from proprietary products to improvised alternatives. It is hard to beat the humble beanbag, which can be either homemade, or bought from various suppliers.

TRIPOD ⌄

Tripods are ideal for a wide variety of subjects.

ISO: 400 *Focal Length:* 14mm
Shutter Speed: 1/2 sec. *Aperture:* f/11

A HOMEMADE BEANBAG ⌄

» STORAGE

Memory cards

The D5100 stores images on Secure Digital (SD) memory cards, including the latest SDHC and SDXC variants. On long trips it is easy to fill even high-capacity memory cards, so it is advisable to carry spares. Look for cards with fast write speeds, as these will accelerate the camera's operation, which is important for shooting movies.

Portable storage devices

Memory cards rarely fail, but that does not mean that they *never* fail. For that reason it is always worth backing up your images as soon as possible. Many photographers use some sort of dedicated photo storage device, such as the Epson P-7000, which comprises a compact hard drive along with a small screen for reviewing your shots. However, you may already own something suitable: an Apple iPod or iPad. Not all iPod models are suitable, so investigate carefully, and if you want to use an iPad, you will also need an iPad Camera Connector.

Tip

SD cards are small, easily mislaid, and although robust, they are not indestructible. Cards filled with irreplaceable images should be stored securely in the safest possible place.

» CAMERA CARE

The Nikon D5100 is a solid, well-made camera, but it is packed with highly complex and potentially vulnerable electronic and optical technology. A few simple, and generally commonsensical precautions should make sure that it keeps functioning perfectly for many years.

Keeping the camera clean is fundamental. The camera body can be cleaned by first removing dust and dirt with a blower, and then wiping it with a soft, dry cloth. After exposure to sand and salt at the beach, wipe it carefully with a cloth that has been lightly dampened with clean water (ideally distilled or deionized water), and then dry it thoroughly. As prevention is better than cure, keep the camera in a case when it is not in use.

Lenses require special care, as glass elements and coatings are easily scratched and this will degrade your images. Remove dust and dirt with a blower, and fingerprints and other marks using a dedicated lens cleaner and a soft cloth, preferably one of an optical grade. Again, prevention is better than cure, so using a skylight or UV filter to protect the lens is advisable, and lens caps should be replaced as soon as possible when a lens is not in use.

There is no screen protector for the D5100's foldout LCD screen, so this will need cleaning periodically. Use a blower to remove loose dirt, and then wipe the

surface carefully with a soft, clean cloth or a swab designed specifically for the purpose. Do not apply pressure and never use non-specialist cleaning fluids.

Storage

If the camera will go unused for an extended period of time, remove the battery, close the battery compartment cover, and store both the camera and battery in a cool, dry place. Avoid extremes of temperature, high humidity, and strong electromagnetic fields.

› Cleaning the sensor

Although people talk about "cleaning the sensor" on a digital SLR camera this is, strictly speaking, incorrect—the sensor is protected by a low-pass filter, and it is this filter that attracts specks of dust and dirt that appear as dark spots in the image.

Unless you never change lenses at all, some dust will eventually find its way into the camera, and subsequently need removing. Fortunately, the D5100 is well equipped to keep dust at bay. Its Airflow control system minimizes the possibility of dust settling on the sensor in the first place, while automated sensor cleaning usually shifts most of the dust that does end up there.

These measures greatly reduce the occurrence of dust spots and the need for invasive cleaning, but stubborn spots

may still appear on the low-pass filter, raising the prospect of manual cleaning. This requires a clean, draught-free area with good light, preferably using a lamp that can be directed into the camera's interior from a safe distance.

To clean by hand, first make sure that the camera's battery is fully charged, or the camera is plugged into a power outlet. Remove the lens, switch the camera **On**, and select **Lock mirror up for cleaning** from the Setup Menu. Press the shutter-release button to lock up the mirror.

Warning!

Any damage to the low-pass filter from incorrect use of a cleaning swab could invalidate your camera's warranty. If you are in any doubt, consult a professional dealer or camera repairer and have them clean your sensor for you.

CLEANING THE SENSOR: STRICTLY FOR ⊗ THE CONFIDENT!

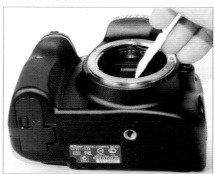

With the mirror locked up, you should first try using a hand-blower (not compressed air or other aerosol) to blow dust from the exposed low-pass filter/sensor array. If this appears ineffective, consider using a dedicated sensor-cleaning swab. If you do, follow the instructions supplied with it very carefully. Do not use other brushes or cloths and never touch the very delicate low-pass filter. When cleaning is complete, turn the camera **Off** and the mirror will reset.

Tip

If, despite your best efforts, dust spots do appear on the image, they can be removed in most image-editing programs with a Cloning tool or similar. In Nikon Capture NX2 *this process can be automated by creating a Dust-off reference image in-camera, while spot-removal can be applied across batches of images in* Adobe Lightroom.

Coping with the cold

Nikon specify an operating temperature range of 32–104°F (0–40°C) for the D5100, but this does not mean that the camera cannot be used when the temperature is outside this range. Keeping the camera in an insulated case or under outer layers of clothing between shots will help to keep it warmer than the surroundings in cold

conditions. If it does become chilled, the battery life may be severely reduced and, in extreme cold, the LCD display may become erratic or disappear. Ultimately, the camera may stop working altogether, although if allowed to warm up gradually, no permanent damage should be done.

Heat and humidity

Extremes of heat and humidity (Nikon stipulate over 85%) can be even more problematic than cold, and more likely to lead to long-term damage. In particular, rapid transfers from cool environments to hot, humid ones can lead to condensation. If such conditions are anticipated, pack the camera and lens(es) in airtight containers with sachets of moisture-absorbing silica gel. Allow your equipment to reach the ambient temperature before taking it out of the container and using it.

COLD ⌄

Winter can be great for photography, but challenging for your camera.

ISO: 100 *Focal Length:* 70mm
Shutter Speed: 1/1600 sec. *Aperture:* f/4.5

Water protection

The D5100 does not claim to be waterproof, but brief exposure to light rain is unlikely to do any permanent harm. Exposure should be minimized, however, and the camera wiped regularly with a microfiber cloth. Avoid using the built-in flash if it is raining or splashing is likely, and double-check that all access covers on the camera are properly closed—and perhaps taped over—before using the camera.

Salt water is particularly harmful to electronic components, so take extra care to avoid contact. If this does occur, clean the camera carefully and immediately with a cloth that has been lightly dampened with fresh water, preferably distilled/deionized water. As prevention is the best option, you could also protect the camera with a waterproof cover. A simple plastic bag will provide reasonable protection from water, although purpose-made rain-guards are available. True waterproof cases provide complete protection from the elements, but care is needed when they are used as splashes on the lens-glass can be very obvious.

Dust protection

To minimize the ingress of dust into your camera, take great care when changing lenses. Aim the camera slightly downward and stand with your back to any wind. In really bad conditions it is better not to change lenses at all, and to protect the camera with a waterproof (and therefore dust-proof) case. Dust that settles on the outside of the camera is relatively easy to remove with a hand-operated or compressed-air blower, so get into the habit of doing this before changing lenses, memory cards, or batteries.

Camera cases

In all conditions, a case is highly advisable to protect the camera when it is not in use. The most practical is a simple drop-in pouch that is usually worn on a waist-belt. Excellent examples come from a wide range of manufacturers.

PROTECTION ⌄
A raincover offers wet weather protection.

> **Note:**
> There seems to be no evidence that modern airport X-ray machines have any harmful effect on either digital cameras or memory cards.

Chapter 9
CONNECTIONS

⑨ CONNECTIONS

Connecting to external devices—especially computers—is not an extension of digital photography, it is central to it, allowing you to store, organize, view, and print your images. The D5100 is designed to facilitate all of these operations, and the main cables that are required are included with the camera.

» CONNECTING TO A GPS

Nikon's GP-1 GPS (Global Positioning System) unit can be mounted on the hotshoe or clipped to the camera strap when you shoot. It links to the camera's accessory terminal using a supplied cable and allows information on latitude, longitude, altitude, and heading to be added to the image metadata. This information is displayed by the D5100 as an extra page of information on playback.

When the camera has established a connection and is receiving GPS data, **GPS** will be displayed in the Information Display. If this flashes, the GPS is searching for a signal, and data will not be recorded. The **GPS** settings in the Setup Menu provide you with three options:

Auto meter off. If this is **Enabled**, the exposure meters turn off automatically after a set period (see Custom Setting c2), which reduces battery drain. You will need to make sure that pressing the shutter-release button halfway before taking shots activates the meters, otherwise GPS data may fail to record. If this option is **Disabled**, the exposure meters will remain on as long as a GPS unit is attached, and GPS data will always be recorded.

Position displays the current location information as reported by the GPS device.

Use GPS to set camera clock allows the camera's clock to synchronize with the time from the GPS device.

» CONNECTING TO A TV

The supplied EG-CP14 cable is used to connect the D5100 to a normal television or VCR. You can also connect the camera to an HDMI (High Definition Multimedia Interface) TV but you will need an HDMI cable (not supplied). Aside from the different cables, the connection process is the same.

1) Check that the camera is set to the correct mode in the Setup Menu (PAL or NTSC for standard televisions and VCRs, or HDMI).

2) Turn the camera **Off**. (It is important that you always do this before connecting or disconnecting the cable.)

» CONNECTING TO A PRINTER

3) Open the cover on the left side of the camera and insert the cable into the appropriate slot (AV-out or HDMI). Connect the other end to the TV.

4) Tune the television to its Video or HDMI channel.

5) Turn the camera **On** and press ▶. The camera's monitor will be blank, but you can use the TV screen and navigate images/play movies in the usual way. The Slide show facility can also be used to automate playback.

The most flexible and powerful way to print photographs from the D5100 is to transfer them to a computer. The memory card can also be inserted into a compatible printer or taken to a photo printing outlet, or the camera can be connected to any printer that supports PictBridge, allowing images to be printed directly.

To connect to a printer:
1) Turn the camera **Off**.

2) Turn the printer **On** and connect the supplied USB cable. Open the cover on

OPTIONS NAME	OPTIONS AVAILABLE	NOTES
Page size	Dependent on printer	Options will be limited by the maximum size that the printer can print.
No. of copies	1–99	Use ▲ or ▼ to choose the number of prints and press (OK) to select.
Border	Printer default Print with border No border	If **Print with border** is selected, the border will be white.
Time stamp	Printer default Print time stamp No time stamp	Provides you with the option to print the time and date when an image was taken.
Crop	Crop No cropping	Prints selected area to size selected under **Page size**. Resizing/repositioning the crop area is very similar to using Trim in the Retouch Menu.

the left side of the camera and insert the smaller end of the cable into the USB slot.

3) Turn the camera **On**. You should see a welcome screen, followed by a PictBridge playback display. There is now a choice between **Printing pictures one at a time** or **Printing multiple pictures**:

Printing pictures one at a time

This process is very straightforward, particularly if you are already familiar with navigating the D5100's playback screens.

1) Navigate to the photo you wish to print, and press (OK). This brings up a menu of printing options. Use the multi-selector to navigate through the menu and highlight specific options and press (OK) to access them.

2) When the options have been set, select **Start printing** and press (OK). To cancel at any time, press (OK) again.

Printing multiple pictures

You are not limited to printing a single image directly from the D5100: you can print several pictures at once, and create an index print of all of the JPEG images (up to a maximum of 256) that are currently stored on the memory card. With the PictBridge menu displayed, press **MENU** and the following options will be displayed:

Print Select: Use the multi-selector to navigate pictures on the memory card (displayed as 6 thumbnails at a time). To see an image full screen press ⊕, and to choose the currently selected image for printing, hold ⊖ and press ▲. The picture is marked with a 🖶 and the number of prints set to 1. Keep ⊖ pressed and use ▲ to change the number of prints. Repeat this process to select further images and choose the number of prints required from each.

When you have made your selections, press (OK) to display the PictBridge menu and select your **Page size**, **Border**, and **Time stamp** options. Select **Start printing** and press (OK).

Select date: Prints one copy of each image taken on a selected date.

Print (DPOF): Prints images already selected using the **Print set (DPOF)** option in the Playback Menu.

Index print: Prints all JPEG images (up to a maximum of 256) on the memory card. If more than 256 images exist, only the first 256 will be printed. Options for **Page size**, **Border**, and **Time stamp** can be set as already described.

» CONNECTING TO A COMPUTER

Connecting to a Mac or Windows PC allows you to store and backup your images. It also helps you exploit more of the power of the D5100, including the ability to optimize image quality from Raw files.

› Computer requirements

Most modern computers are more than capable of handling the D5100's images, but you will need a USB port for connecting the camera (or card-reader), unless you connect wirelessly using an Eye-Fi card.

You can install Nikon's software for the D5100 from the supplied CD, or download it from the Nikon website. Both *Nikon Transfer* and *Nikon View NX2* require one of the following operating systems: Mac OS X (Version 10.4.11 or later); Windows 7; Windows Vista (Service Pack 2); Windows XP (Service Pack 3). Older computers, or those running a different operating system,

Tip

If your computer runs slowly when working with large image files, the most likely cause is insufficient memory (RAM). RAM can usually be added to a computer both cheaply and easily. A shortage of free space on the hard disk may also cause your computer to slow down.

CONNECTED ≫
A D5100 connected to a computer.

CARD READER ≫

will still be able to transfer and view the D5100's images using third-party software, but older systems may run very slowly when dealing with the large images produced by the D5100, especially its Raw files.

› Backing up

Until they are backed up, your images exist solely as data on the camera's memory card. Memory cards are robust, but they are not indestructible, and you will want to format and reuse them. When your images are transferred to the computer and the card is formatted, those images still exist in just one location: the computer's hard drive. If anything happens to that drive—fire, theft, or hardware failure—you could lose thousands of irreplaceable images. The simplest form of backup is to a second hard drive: *Nikon Transfer* can backup automatically as images are imported, or

your computer's operating system may have an automated backup facility.

› Color calibration

A major headache for digital camera users is that images can look one way on the camera's screen, different on the computer screen, different again when you email them to friends, and different still when they are printed—despite the same image file being used and viewed.

To achieve consistency across different devices, it is therefore vital that your computer screen is correctly set up and calibrated. This may seem complex and time consuming, but ultimately it will save a great deal of time and frustration. There is not the space to go into greater detail here, but more in-depth information can be found in the *Digital SLR Handbook* (from this author and publisher).

BACKUP ❯❯

Apple's Time Machine maintains backups automatically.

CALIBRATION SOFTWARE ❯❯

The Display Calibrator Assistant in Mac OS X.

› Connecting the camera

The following assumes that you have already installed *Nikon Transfer* from the CD supplied with the D5100 and will be using it to import your images onto your computer. If you prefer to use *Nikon View NX2, Nikon Capture NX*, or third-party software such as *iPhoto* to import images then the procedure is likely to be similar in outline, but different in detail, so consult its manual or Help menu.

1) Turn the computer **On** and let it boot up fully. Open the cover on the left side of the camera and insert the smaller end of the supplied USB cable into the USB slot. Insert the other end into a USB port on the computer (unpowered USB hubs or ports on the keyboard will not work).

2) Turn the camera **On** and *Nikon Transfer* will start automatically, unless you have configured its Preferences otherwise. A window similar to the one illustrated here will appear on the screen.

3) The *Nikon Transfer* window offers various options, although the following are the most important.

4) To transfer selected images only, use the check box below each thumbnail to select/deselect as required.

5) Click the **Primary Destination** tab to choose where your photos will be transferred. You can create a new subfolder for each transfer, rename images as they are transferred, and so on.

6) Click **Backup Destination** if you want *Nikon Transfer* to backup automatically during transfer.

7) Switch the camera **Off** when the transfer is complete, and disconnect the cable—*Nikon Transfer* will close automatically.

Using a card-reader
Rather than connecting the camera directly to the computer, it is often more convenient to transfer your photographs by inserting the memory card into a card-reader.

Many computers now have built-in SD card slots, while separate card-readers are cheap and widely available. Be aware that older readers may not support the recently developed SDHC or SDXC cards, however.

Insert the memory card and, when *Nikon Transfer* starts, proceed from step 3, as outlined above. When the transfer is finished, remove the card from the system as you would any other external drive: use *Safely Remove Hardware* in Windows, or *Command+E* or drag the D5100 icon to the Trash if you are using a Mac.

Eye-Fi

Eye-Fi looks and operates in the same way as a conventional SD memory card, but it includes an antenna that enables it to connect to Wi-Fi networks. This allows the wireless transfer of images to a computer (assuming the computer also has a Wi-Fi connection). Eye-Fi cards are supplied with a card reader, and when the card and reader are plugged into any recent Mac or Windows PC the supplied software will install automatically. An automatic registration process follows and, once configuration is complete, you can insert the Eye-Fi card in the camera and use the **Eye-Fi Upload** option in the Setup Menu. The camera will upload images automatically if you remain within signal range of the network, or start uploading once you are back in range.

» SOFTWARE

› Nikon software

The D5100 is bundled with *Nikon Transfer* and *Nikon View NX2* software. *Nikon Transfer* is a simple application that does one job well enough: transfer images from the camera to your computer.

Nikon View NX2 is a broader package that covers many of the main functions that a digital photographer will require. Specifically, it allows you to transfer images, view them individually or browse through multiple photographs, save them in other formats, and print them. However, *View NX2* is slow, and not very intuitive when it is compared to programs such as *iPhoto* or *Photoshop Elements*.

NIKON VIEW NX2 ⌃

Using Nikon View NX2

1) From a browser view such as the thumbnail grid, click on a Raw image to highlight it. Image Viewer shows the image in more detail, plus a histogram, while Full Screen allows you to see the image full size.

2) Panels at the right side of the screen reveal Metadata (detailed info about the image), and the Adjustment palette, which allows a range of adjustments to be made to the exposure, white balance, and so on. It also has access to Nikon Picture Controls.

3) Click away from the image and you will be asked if you want to save any adjustments. You do not need to export or convert the file immediately.

4) To export the file as a TIFF or JPEG that can be viewed, edited, and printed by most other applications, choose **Convert Files** from the File menu. Here you can set a new size for the image if required, and also change its name.

5) The **File Format** drop-down menu in the Convert Files dialog offers three options: **JPEG**, **TIFF (8-Bit)**, and **TIFF (16-Bit)**.

NIKON VIEW NX2 CONVERT FILES OPTIONS

JPEG	Choose compression ratio: Excellent Quality; Good Quality; Good Balance: Good Compression Ratio; Highest Compression Ratio.	Suitable if extensive further editing is not envisaged. Choose **Excellent Quality** unless storage space is at a premium, or you know the image will only be used as an email attachment or similar.
TIFF (8-Bit)		Creates larger file sizes than JPEG, but is a better choice if subsequent editing is envisaged. However, **TIFF (16-bit)** is advised for extensive retouching work.
TIFF (16-Bit)		The best choice when further editing is anticipated. Images can be converted to 8-bit after editing, halving the file size.

Nikon Capture NX2

Nikon Capture NX2 is an optional piece of software that is fully compatible with the D5100 and is a far more complete editing package than *View NX2*. For a full range of editing options, especially in relation to Raw files, *Nikon Capture NX2* or one of its third-party rivals is essential. One potentially important point is that, unlike image-editing programs such as *Photoshop Elements, Capture NX2* can *only* open Nikon Raw files.

Camera Control Pro 2

In the studio, and other controlled settings, *Camera Control Pro 2* allows almost all of the D5100's functions and settings to be accessed and operated directly from a computer. *Camera Control Pro 2* also integrates with Live View mode, allowing detailed examination of the image on the large computer screen.

NIKON CAPTURE NX2 ≫

› Third-party software

Adobe Photoshop is the industry standard image-editing program, and is currently on version 12 (referred to as *Photoshop CS5*). The program's power is enormous, and this is reflected by the price: the full version of *Photoshop CS5* costs about the same price as a D5100 body. However, the program is also more than most photographers need, and many prefer *Photoshop Elements,* which costs around one tenth of the price, but does not lose out on the sophisticated editing features, including the ability to open the D5100's Raw files.

Photoshop Elements also includes something that *Photoshop* does not—its Organizer module, which allows photos to be sorted into "albums" and "tagged" in different ways. Some sort of organizer or cataloging software becomes essential as you amass thousands of images.

ADOBE PHOTOSHOP ≫
ELEMENTS' ORGANIZER

Mac users have another excellent choice in the form of *iPhoto*, which is pre-loaded on new Macs. Similar to *Photoshop Elements*, *iPhoto* combines organizing and editing abilities and there is no easier imaging software to grasp. The Adjust palette provides quick and flexible image-editing too. *iPhoto* can open Raw files from the D5100, but—unlike *Photoshop Elements*—cannot edit in 16-bit depth, which is recommended for best results.

If you regularly shoot Raw, there are two alternative solutions that are worth considering: Apple's *Aperture* (Mac only) and Adobe's *Lightroom* (Mac and Windows). Both applications combine powerful organizing/cataloging tools with sophisticated and non-destructive image editing. Essentially this means that any changes you make to your image—color, density, cropping, and so on—are recorded alongside the original Raw file

Note:
*Older versions of **Adobe Photoshop** will not recognize Raw files created by the D5100, as they require the **Camera Raw** plug-in, version 6.4, which is incompatible with versions of **Photoshop** prior to CS5. To work around this—without a costly upgrade—use the free **Adobe DNG Converter** to convert the D5100's Raw files into the "universal" DNG format. These can then be opened with older versions of **Photoshop**, as well as many other programs. Similar limitations apply to older versions of **Photoshop Elements**, but an upgrade here is much less costly.*

without the need to create a new TIFF or JPEG. TIFF or JPEG versions of the image, incorporating all the edits, can be exported as and when needed, while the original Raw file stays untouched.

iPHOTO'S ADJUST OPTIONS ⌄

ADOBE LIGHTROOM'S DEVELOP MODULE ⌄

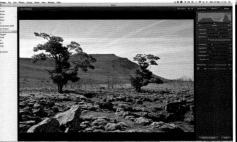

›› GLOSSARY

8-bit, 14-bit, 16-bit *See* bit depth.

Aperture The lens opening that admits light. Relative aperture sizes are expressed in f-numbers.

Artifact Occurs when data is interpreted incorrectly, resulting in visible flaws in the image.

Bit depth The amount of information recorded for each color channel. 8-bit, for example, means that 8 bits of data, or 256 levels of brightness, are recorded for each channel, while 16-bit images recognize over 65,000 levels per channel, allowing for greater freedom in editing. The D5100 records Raw images in 14-bit depth, which can be converted to 16-bit when imported onto the computer.

Bracketing Taking a number of otherwise identical shots in which just one parameter, such as exposure or white balance, is varied.

Buffer In-camera memory that temporarily holds image data until it is written to the memory card.

Burst A number of frames shot in quick succession; the maximum burst size is limited by the size of the buffer.

CCD (Charge-Coupled Device) A type of image sensor that is used in many digital SLR cameras.

Channel The D5100, like other digital devices, records data in three separate color channels (*See* RGB).

Clipping Complete loss of detail in highlight or shadow areas (or both), leaving them pure white or black.

CMOS (Complementary Metal Oxide Semiconductor) A type of image sensor used in many digital cameras, including the D5100.

Color temperature The color of light, expressed in degrees Kelvin (K). Confusingly, "cool" (bluer) light has a higher color temperature than "warm" (red) light.

CPU (Central Processing Unit) A small computer in the camera (also found in many lenses) that controls most or all of the unit's functions.

Crop factor (*See* focal length multiplication factor.)

Diopter Unit expressing the power of a lens.

dpi (dots per inch) A measure of resolution: should strictly be applied only to printers (*See* ppi).

Dynamic range The range of brightness from shadows to highlights within which the camera can record detail.

Exposure Used in several senses. For example, "an exposure" is virtually synonymous with "an image" or "a photograph": to make an exposure = to take a picture.

Also refers to the amount of light hitting the image sensor, and to systems of measuring this. *See also* overexposure and underexposure.

EV Exposure Value A standardized unit of exposure. 1EV is equivalent to 1 "stop" in traditional photographic parlance.

Extension rings/Extension tubes Hollow tubes that fit between the camera and lens, used to allow greater magnifications.

f-number Lens aperture expressed as a fraction of focal length; f/2 is a large aperture and f/16 is small.

Fast (lens) Lens with a wide maximum aperture, for example f/1.8. An aperture of f/4 might be considered fast for long telephoto lenses.

Fill-in flash Flash used in combination with daylight, often with backlit or harshly side-lit subjects, to prevent dark shadows.

Filter A piece of glass or plastic placed in front of, within, or behind the lens to modify light.

Firmware Software that controls the camera: upgrades are issued by Nikon and can be transferred to the camera via a memory card.

Focal length The distance (in mm) from the optical center of a lens to the point at which light is focused.

Focal length multiplication factor As the D5100's sensor is smaller than a frame of 35mm film, the effective focal length of all lenses is multiplied by 1.5.

fps (frames per second) The number of exposures (photographs) that can be taken in one second.

Highlights The brightest areas of the scene and/or the image.

Histogram A graph representing the distribution of tones in an image, ranging from pure black to pure white.

Incident light metering Measuring the light falling on to a subject, usually with a separate meter, rather than the light reflected off it.

ISO (International Standards Organisation) ISO ratings express both film speed and the sensitivity of digital imaging sensors.

JPEG A compressed image file standard. High levels of JPEG compression can reduce files to around 5% of their original size, but there may be some loss of quality.

LCD Liquid Crystal Display A flat screen display technology, as used in the D5100's rear monitor.

Macro A term used to describe close focusing and the close-focusing ability of a lens. A true macro lens has a reproduction ratio of 1:1 or better.

Megapixel *See* pixel.

Memory card A removable storage device for digital cameras.

Noise Image interference manifested as random variations in pixel brightness and/or color.

Overexposure When too much light reaches the sensor, resulting in an overly bright image.

Pixel Condensed from "picture element." The individual colored dots (usually square) that make up a digital image. One million pixels = 1 megapixel.

ppi (pixels per inch) Should be applied to digital files rather than the commonly used dpi (*See* dpi).

Reproduction ratio The ratio between the physical size of an object and the size of its image on the sensor.

Resolution The number of pixels for a given dimension, for example 300 pixels per inch. Resolution is often confused with image size. The native size of an image from the D5100 is 4928 x 3264 pixels; this could make a large, but coarse, print at a resolution of 100 dpi, or a smaller, but finer, one at 300 dpi.

RGB (Red, Green, Blue) Digital devices, including the D5100, record color in terms of the brightness levels of the three primary colors.

Sensor The light-sensitive chip at the heart of every digital camera.

Shutter The mechanism that controls the amount of light reaching the sensor by opening and closing when the shutter-release button is pushed.

Speedlight Nikon's range of dedicated external flashguns.

Spot metering A metering system that takes its reading from a small portion of the scene.

Telephoto lens A lens with a long focal length and a narrow angle of view.

TIFF (Tagged Image File Format) A universal file format supported by virtually all image-editing applications.

TTL (Through The Lens) Typically refers to any viewing or metering system that uses the light passing through the lens.

Underexposure When insufficient light reaches the sensor, resulting in an overly dark image, often with clipped shadows.

USB (Universal Serial Bus) A data transfer standard, used to connect to a computer.

Viewfinder An optical system used for framing the image; on an SLR camera such as the D5100, it shows the view as seen through the lens.

White balance A function that compensates for different color temperatures so that images may be recorded with the correct color balance.

Wide-angle lens A lens with a short focal length and a wide angle of view.

Zoom A lens with a variable focal length range, giving a number of viewing angles. To zoom in is to change focal length to give a narrower view and to zoom out is the converse. Optical zoom refers to the genuine zoom ability of a lens, while a digital zoom crops part of an image to produce an illusion of the same effect.

» USEFUL WEB SITES

NIKON-RELATED SITES

Nikon Worldwide
Home page for the Nikon Corporation
www.nikon.com

Nikon UK
Home page for Nikon UK
www.nikon.co.uk

Nikon USA
Home page for Nikon USA
www.nikonusa.com

Nikon User Support
European Technical Support Gateway
www.europe-nikon.com

Nikon Info
User forum, gallery, news and reviews
www.nikoninfo.com

Nikon Historical Society
Worldwide site for study of Nikon products
www.nikonhs.org

Nikon Links
Links to many Nikon-related sites
www.nikonlinks.com

Grays of Westminster
Revered Nikon-only London dealer
www.graysofwestminster.co.uk

GENERAL SITES

Digital Photography Review
Independent news and reviews
www.dpreview.com

Thom Hogan
Real-world reviews and advice
www.bythom.com/nikon.htm

Jon Sparks
Landscape and outdoor pursuits photography
www.jon-sparks.co.uk

EQUIPMENT

Adobe
Photoshop, Photoshop Elements, Lightroom
www.adobe.com/uk

Apple
Aperture and iPhoto
www.apple.com/uk

Aquapac
Waterproof cases
www.aquapac.net

Bogen Imaging
Kata rain-covers, Gitzo and Manfrotto tripods
www.bogenimaging.co.uk

Sigma
Independent lenses and flash units
www.sigma-imaging-uk.com

PHOTOGRAPHY PUBLICATIONS

Ammonite Press
Photography books
www.ammonitepress.com

**Black & White Photography magazine,
Outdoor Photography magazine**
www.thegmcgroup.com

**Photography books, Black & White
Photography magazine, Outdoor
Photography magazine**
www.pipress.com

» INDEX